Powered
by Love

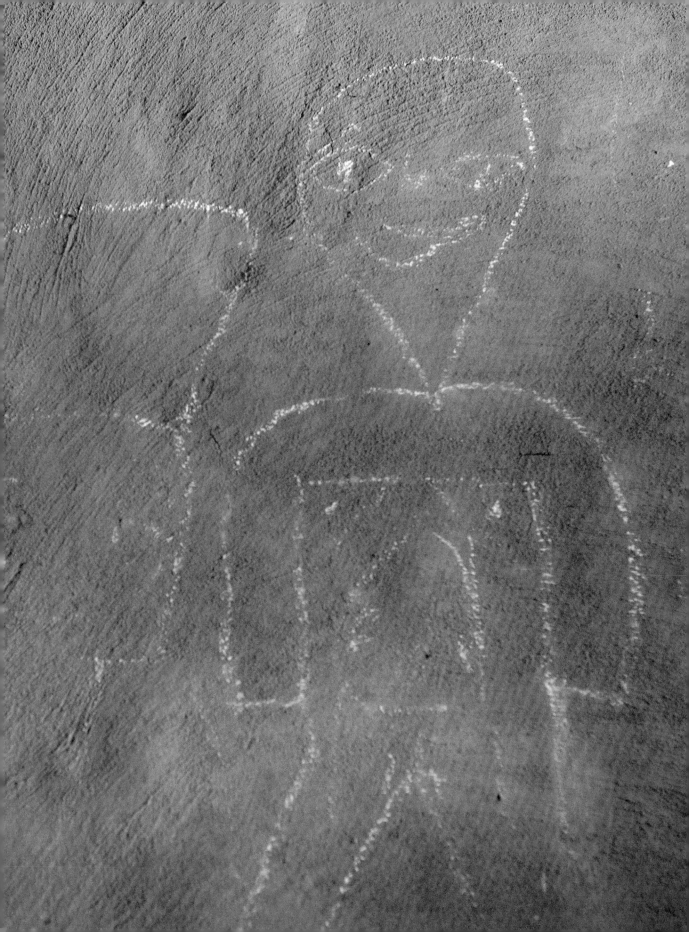

A Grandmothers'
Movement to End
AIDS in Africa

Powered by Love

Joanna Henry with **Ilana Landsberg-Lewis**

edited by **Michele Landsberg**
photographs by **Alexis MacDonald**

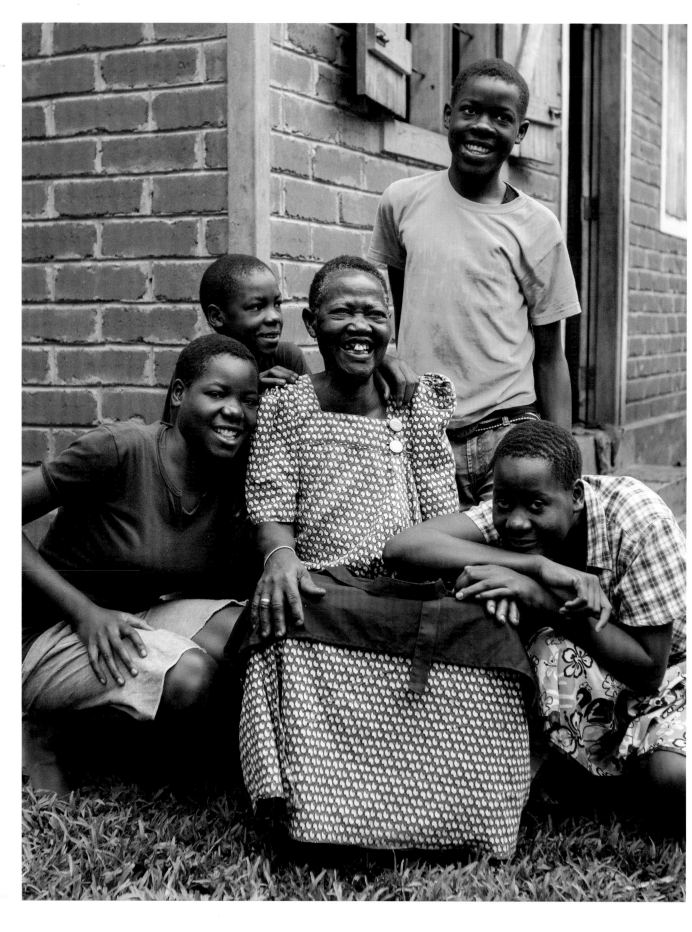

PREVIOUS PAGE: A son's self portrait for his ailing mother so she will not forget what he looks like (see p. 194). *Bukalo, Namibia*

FACING: Monica with grandchildren. *Jinja, Uganda (with PEFO)*

A grandmother is a person who fills her basket with all that she has and hangs it low for everyone to see it. Many people have so much more, but they hide their baskets away. But a grandmother always ties her basket where anyone—even the smallest child—can reach in and take what she needs.

Ruth, Phoebe Education Fund for AIDS Orphans and Vulnerable Children (PEFO), Jinja, Uganda

Our hearts change with each grandchild. I think our hearts get a little bit bigger, our eyes become a little more open. And there is a deep connection somehow with other grandmothers.

Brenda, Gogo Grannies of Cranbrook, Cranbrook, BC

Contents

Foreword by Stephen Lewis *9*

Preface by Ilana Landsberg-Lewis *12*

Introduction by Joanna Henry *14*

1 A Grandmother's Inheritance in the Wake of AIDS *17*

2 "We Are Not Alone" *49*

3 A Gathering of Grandmothers *63*

4 Canadian Grandmothers Build a Campaign *89*

5 A Movement Emerges *113*

6 The Centrality of Relationship *139*

7 African Grandmothers on the Move *161*

8 Grandmothers at the Heart of the AIDS Response *189*

9 An African Grandmothers' Gathering:
 From Basic Needs to Basic Rights *217*

10 African Grandmothers' Tribunal: "It's About Rights, Not Charity" *243*

11 Grandmothers' Rights, Right Now *259*

12 The Decade Ahead *279*

Acknowledgements *294*

FACING: Tree yarn-bombed with crocheted granny
squares. *Hillcrest, South Africa (with* HACT*)*

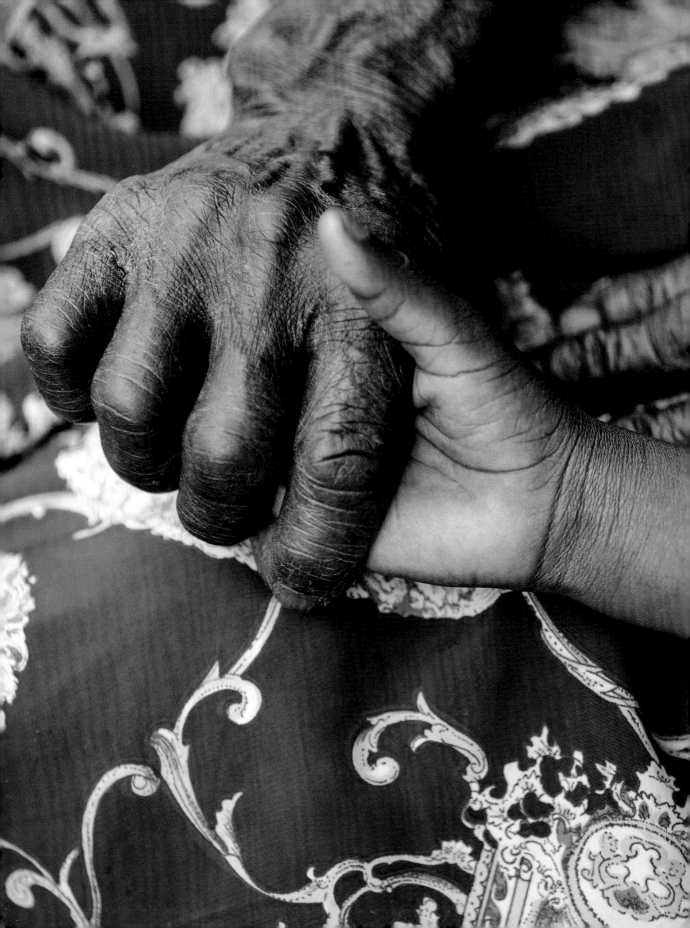

Foreword

by STEPHEN LEWIS
Co-founder and Chair of the Board, Stephen Lewis Foundation (SLF)
UN Special Envoy for HIV & AIDS in Africa from 2001 to 2006

The setting: a little copse of bushwillow trees outside the Children's Clinic in Alexandra Township, Johannesburg, 2005.

The inhabitants: some 20 grandmothers, perched on fragile benches, all of whom had buried adult children and were looking after scores of orphaned grandchildren.

The conversation: poignant stories, one after another, of crushing family loss and heartbreaking treks to the cemetery.

The holdout: everyone spoke except one woman—Agnes by name. No amount of cajoling could get her to come forward until, by inspired happenstance, a sweet song of collective commiseration brought Agnes back to the surface of life. Her story was brief and devastating. In a two-year period, she had buried all five of her own children, three daughters, two sons, and was left with four grandchildren.

They were all HIV positive.

The aftermath: I raced home to tell my daughter Ilana about the encounter. This was not the first time grandmothers had emerged, for me, at the centre of the pandemic. I remembered a visit, just a few weeks earlier in Lesotho, the little mountain kingdom surrounded by South Africa. Trudging down the mountain in search of water, pain and despair etched in her face, was a bent, frail 90-year-old grandmother, with 19 grandchildren trailing behind. Nineteen. I never quite got over it.

Five things happened after I returned from my trip to Johannesburg.

First, Ilana acted with a rapidity and creativity that was astounding. She instantly organized a press conference in Toronto, with two of the grannies that I had met in Alexandra Township, sitting side by side with two Canadian grandmothers: Shirley Douglas, film, television, and

FACING: Safina with granddaughter.
Mukono, Uganda (with ROTOM)

stage actor, and daughter of Tommy Douglas; and Adrienne Clarkson, former Governor General of Canada.

The press conference was riveting, haunting, and it managed, successfully, to put the issue on the map. Ilana was emboldened.

Second, she brought one hundred African grandmothers to that famous "Grandmothers' Gathering" on the eve of the International AIDS Conference held in Toronto in August of 2006. Two hundred Canadian grandmothers joined the proceedings. It was a hotbed of intense discussion and emotional bonding. The African grandmothers ran the entire agenda. The statement at the end of the Gathering was the first ever, in the history of the virus, to put grandmothers at the centre.

Moreover, the grandmothers, African and Canadian, became one of the hits of the International AIDS Conference: their singing and dancing was projected onto vast CinemaScope-type screens in every venue of the conference proceedings.

The grandmothers' movement was born.

Third, Ilana suddenly realized there was an enormous group of grandmothers ready to be mobilized. The Canadians underwent a kind of religious conversion and determined to spend much of the rest of their lives understanding African grandmothers, helping African grandmothers, learning all there was to know about the orphans, and, above all, raising funds to confront the ravages of HIV & AIDS wherever the grandmothers lived and laboured. The Canadian grandmothers were incandescent with energy.

Fourth, the African grannies couldn't get over it. Suddenly, in response to the carnage of the pandemic came thousands of helping hands, showing a solidarity that Africa could never have imagined. Health, housing, food, school fees, counselling, home-based care—it all flowed in, from a cornucopia of sisterly love.

It was never enough, of course. It's still never enough. But it saved thousands of lives and conveyed the first glimmers of hope.

Fifth, gradually, irreversibly, like some contagion of liberation, the African grandmothers gained huge quantums of confidence. They saw their grandchildren thrive. No longer would they accept the mere necessities of life. No longer would they accept isolation. They wanted more. They wanted their human rights.

And that's what it's come to. From those early days in 2006 has emerged a movement bracing for freedom from the shackles of the virus, a vision that hearkens back to the early days of feminism, a cry to embrace the contemporary wave of gender equality.

It's really quite remarkable to see what time and generosity and compassion have wrought. Out of the despair of AIDS has come a powerful social movement, uniting two continents in unabashed solidarity.

If you had told me 10 years ago that this was possible, I would have replied with dismissive, Olympian cynicism. But all you have to do is listen to the voices and look at the photographs that illumine these pages to know that miracles are possible when the human spirit is unleashed.

Preface

by ILANA LANDSBERG-LEWIS
Co-founder and Executive Director, Stephen Lewis Foundation (SLF)

I remember sitting at my desk in 2006 in Toronto when the lightning bolt struck: grandmothers were the key to the solution.

At the same time that my father was sharing urgent observations about African grandmothers he was encountering through his role as UN Special Envoy for HIV & AIDS in Africa, our foundation was receiving wave after wave of proposals from African community-based organizations desperate to provide new programs to "caregivers." These programs ranged from providing basic necessities like food to delivering health care and counselling, as well as parenting workshops.

Who were these caregivers? I called some of the groups to ask if they were talking about grandmothers. Yes! they all said. Of course. Gogos, jjajas, yayas, mamas, nya nyas, bagogos—all grandmothers caring for the escalating numbers of orphaned children. I was puzzled. Why hadn't they simply said this?

The answer was uniform: because no one wants to give to older women. They're not a "target group," they're not "sustainable," they're not a good investment.

That night I watched my mother with my son—her first grandchild. I was struck by the fierce love and joy that I saw there and suddenly realized how rarely we name and acknowledge this powerful force in our midst: the profound love and unbreakable bond grandmothers have with their grandchildren. Surely, I thought, this breathtaking reality—so many grandmothers burying their adult children, forced to push aside their grief and find the emotional resilience to care for traumatized orphans—would resonate with Canadian grandmothers—any grandmother—if they only knew the magnitude of the tragedy unfolding in Africa.

What I could never have anticipated was how Canadian (and now Australian, American, and British) grandmothers would leap to respond! Since its beginnings in 2006, the Grandmothers to Grandmothers Campaign has exploded into an unstoppable movement of dynamic women who, alongside the Stephen Lewis Foundation (SLF), developed an entirely new model of development, built on a mutual respect and a deep appreciation for the dignity, intelligence and courage of African grandmothers while devoting countless hours and boundless ingenuity to raising more than $25 million along with a great deal of attention along the way.

Over the years, I've met with staff from many mainstream organizations who want to know how to start a similar movement of support for their cause. I always give the same answer: I don't know how you do it if you aren't working with women, if you don't understand the tenacious nature of women's organizing power. This isn't a gimmick or a clever fundraising campaign—it is a democratic, self-powered movement of grandmothers and "grandothers." Their fundraising and awareness-raising activities are not run by the SLF. They work *with* us, as a cherished part of the SLF, ensuring that their agenda is driven by the African grassroots groups who are the experts on what will work best for their communities.

If the devastating legacy of 30 years of AIDS in Africa is to be overcome, the know-how of the African grandmothers must be heeded, not ignored. This Grandmothers to Grandmothers Campaign constitutes a new approach to international co-operation and solidarity. It's a story that must be told, and the world has yet to hear it directly from them. This book sets out to rectify that.

Introduction

by JOANNA HENRY

The first interview for this book took place in October 2012 in Zimbabwe. I was there with photographer Alexis MacDonald to meet a group of grandmothers who were receiving support through Mavambo Trust, a community-based organization in Harare.

 Chairs were set up under a large tree. The 20 grandmothers seated there went around the circle clockwise; they introduced themselves and told their stories, one by one. All had lost children to HIV and were raising grandchildren. They all spoke of the destitution and isolation they suffered before Mavambo Trust and how joining their grandmothers' group radically transformed their lives. As the hours passed, the sun crept across the sky, and our circle, inching inwards to remain in the shade, grew closer and more intimate. The grandmothers shared with unguarded rawness and when one cried, another quietly took her hand or rubbed her back and sang to her until she could continue with her story. They laughed together at the absurdity of their challenges, and they cheered and clapped when a grandmother shared an accomplishment, such as completing a course of training or seeing a grandchild graduate from school. Their laughter was tough and ached around the edges, and their exuberant singing and dancing at the end of the meeting was filled with equal parts joy and defiance.

It was a breathtaking encounter—the kind that rips one's heart wide open—and it was repeated over and over and over again, underneath trees, in community centres, and in homes, as I travelled to eight countries and interviewed hundreds upon hundreds of grandmothers from across sub-Saharan Africa. The interviews took a year, but the conversations with the grandmothers and their support organizations lasted another four years as we communicated back and forth, sending quotations to each woman for editing and approval, including changing or withholding names as requested, whatever it took to ensure that what appears in the following pages are the words and images that each grandmother wants to share.

The process was repeated across Canada as well, as interviews were conducted with hundreds of Canadian grandmothers from over 50 groups. Here, too, we were met with astonishing honesty, intimacy, and no small measure of humour.

In all of our discussions, the most striking and inspiring truth that the grandmothers brought to the fore is that this movement is powered by love: unabashed, unsentimental, unapologetic, and inspirationally potent love. Words cannot truly capture how humbling it feels to have had the honour of being invited into these conversations over the years, being entrusted with such precious pieces of so many remarkable women. We can't wait for you to meet them yourselves in the pages of this book.

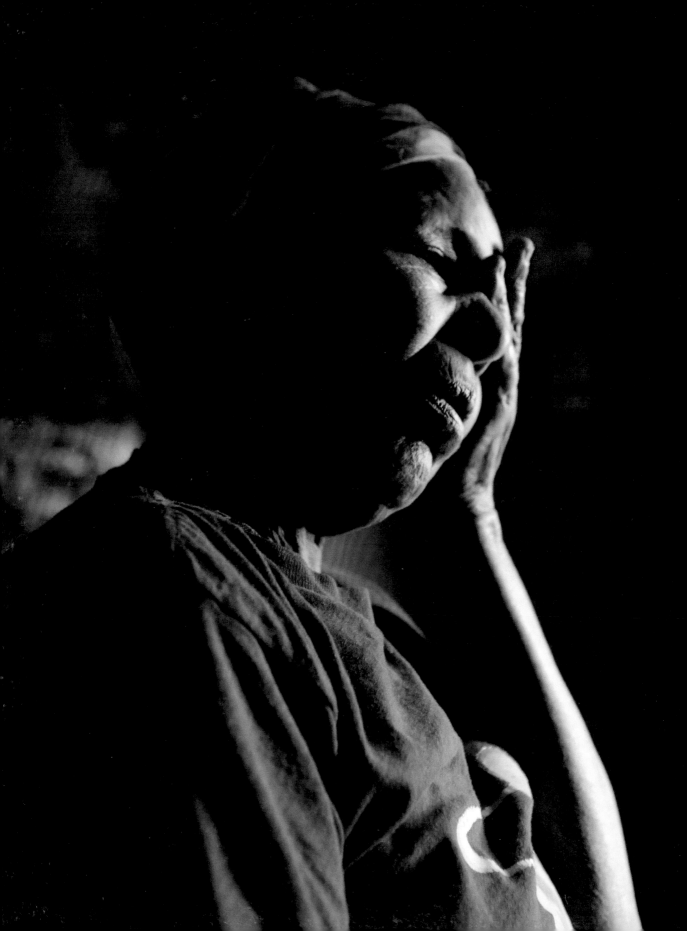

You cannot understand my journey if you are just joining me at this place on the road. You have to look back and see the long dark way I have come. Then you can understand why I am triumphant, planted with my feet here. Kenyan grandmother (PENAF), Kenya

1

A Grandmother's Inheritance in the Wake of AIDS

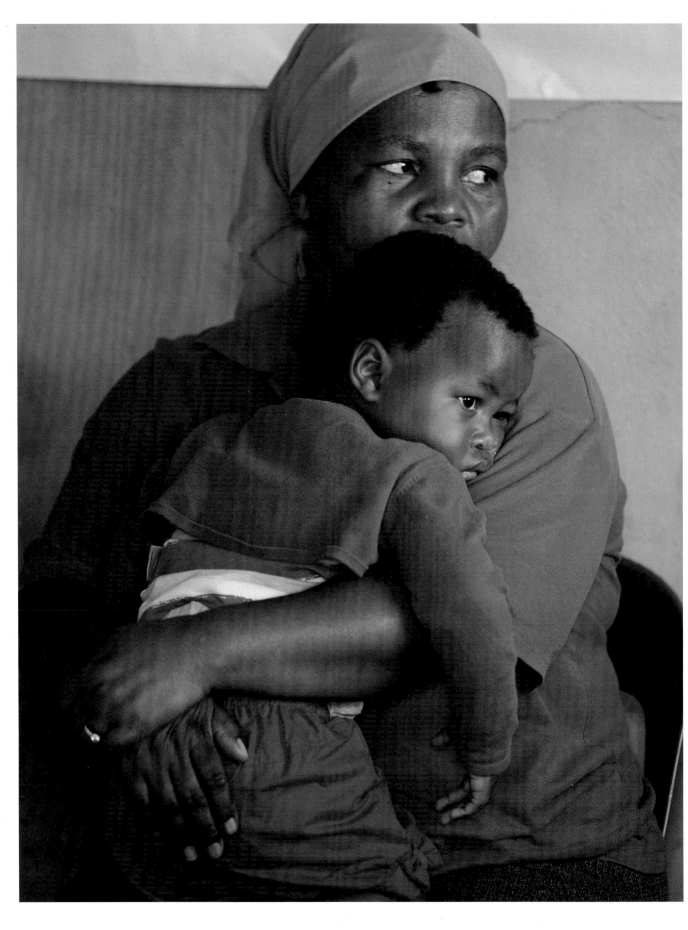

Back Down the Long Dark Road

This is the untold story of AIDS in Africa.

This book chronicles how African grandmothers moved through the agony wrought by AIDS and are mobilizing to claim their human rights. How, out of the despair of this pandemic, a powerful social movement has emerged, led by older women.

The voices of the women in these pages are unlike any you have heard before. This is not one grandmother's story. This is a collective story—the voices of many grandmothers, who came together, in country after country in sub-Saharan Africa, supported by grassroots organizations, to survive the ravages of AIDS.

At the turn of the twenty-first century the AIDS pandemic was burning like a wildfire through sub-Saharan

Africa. This was a decade before treatment would trickle down to African communities, and in some countries like Botswana and Swaziland the infection rate was reaching between 20 and 30 percent of the adult population. Hospitals overflowed and severely taxed health infrastructures buckled. Patients died at home, mostly in secret, so great was the fear and social stigma around the disease, their deaths reported as malaria, tuberculosis, anything but AIDS. As such, the millions of deaths from AIDS that were actually being reported still only represented a fraction of the lives claimed by this virus.

The vast majority were adults in their prime—resulting in the double blow of millions of children suddenly orphaned. UNAIDS figures show that in 2001 there were 7.5 million children orphaned by AIDS in sub-Saharan Africa. By 2009, the number of children in sub-Saharan Africa who had lost one or both parents to AIDS had risen to 12.3 million.*

At the very heart of this crisis were the grandmothers, burying their adult children and taking in their grief-stricken grandchildren to begin parenting anew. The magnitude of the catastrophe, coupled with the stigma surrounding AIDS, meant in household after household the grandmothers were tackling these hardships, often in isolation.

AIDS in Africa was the catalyst that set everything in motion and so this is where we must begin—as difficult a beginning as it is.

Losing Children and Gaining Hardship

The stunning loss of multiple adult children to AIDS is a shared trauma for millions of African grandmothers. We spoke to hundreds of women. Each of them had experienced the loss of at least one child, and all went on to raise grandchildren orphaned by the pandemic.

I lost my two sons in a matter of five months, and I nearly lost my mind. There I was, my two children gone, in charge of a child, a grandson who was only six months old. It was very, very hard. I still have not fully recovered. Ethiopian grandmother (DFT†), Ethiopia

* UNAIDS AIDSinfo Database. http://aidsinfo.unaids.org/.AIDS Orphans (0-17). In 2001 there were 5.4 million orphans in east and southern Africa and 2.1 million orphans in west and central Africa. In 2009, the number had risen to 8.7 million orphans in east and southern Africa and 3.6 million orphans in west and central Africa. Accessed May 3, 2017.

† For the full names of organizations see page 294.

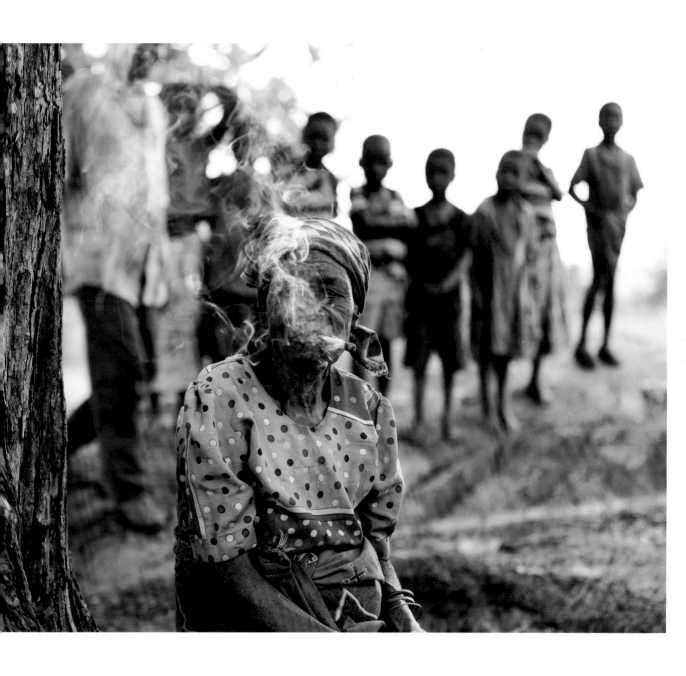

Nakhoni. *Nathenje,*
Malawi (with HOFE*)*

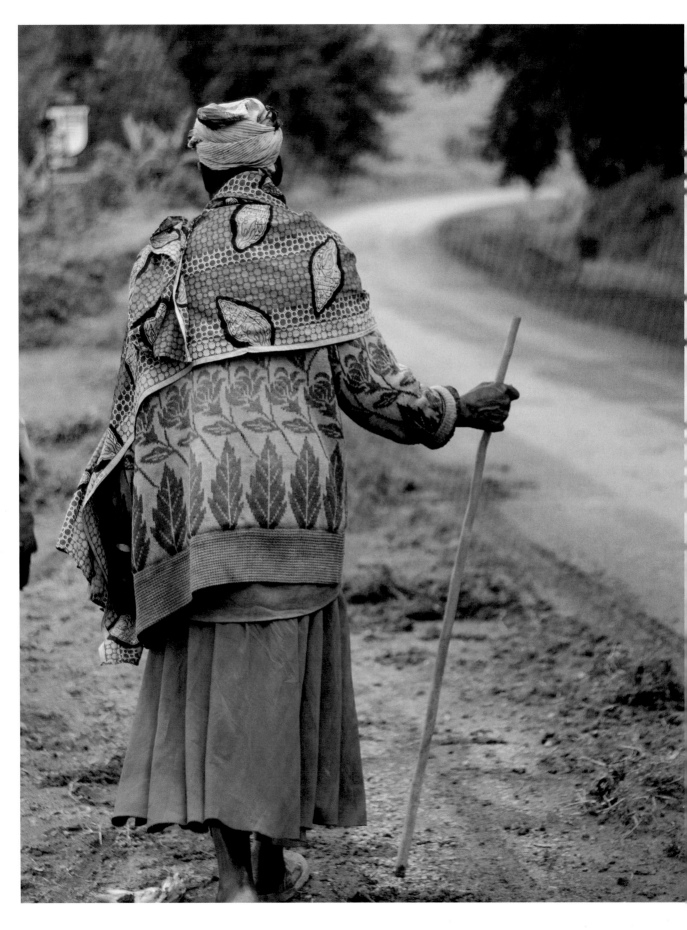

I lost my three sons, who were the breadwinners. I lost two daughters and my husband. I am left with one child, a daughter, who is married and living somewhere far with her husband's family. So I am staying with my grandchildren, nobody working at home—and my only income is my small pension. South African grandmother (HACT), South Africa

Successfully launching a child into the world is, for all mothers, the fruit of a lifetime's labour. These women, raising children in an environment of poverty, expended every last bit of their resources to see them through precarious early years, keep them in school, and, if extremely fortunate, watch them graduate and get steady jobs in cities nearby. Then, when their children seemed safest and most secure, they were struck down. During the interviews, the grandmothers rarely cried. But reflecting on this devastating betrayal of their hopes most often shattered their disciplined composure. Their tears sprang from the realization that the future was erased.

My daughter was grown and had already gotten employment and was able to make good money. She would come and visit me on her holidays with huge gifts of butter and spices for the family. I was so proud of her and I expected big things from her. That daughter of mine not only died but also she left behind orphaned children who I am struggling with. I think about my daughter day and night and miss her so much. Ethiopian grandmother (DFT), Ethiopia

There was a girl, she was an orphan, but I took her in as my daughter. I wasn't able to go to school myself as a girl, but I always told my daughter, "Just get an education, you have to do something and become somebody." We didn't have extra money for school fees but we struggled and sacrificed and she managed to graduate with a diploma from the university! She was excited about what job she would get and how she would be helping the family. Her graduation was in September, we had an occasion—eating, dancing, and everything. Everyone was here. By November of the next year, we were all back here for her funeral. All that remains is her diploma on the wall. Mariam (PEFO), Uganda

FACING: Eseridah. *Kabale, Uganda (with ROTOM)*

Financial Catastrophe

When an African grandmother loses her adult children, her personal economy crashes. She is drained of her lifelong investments and hope for the future. In their place, she gains debt, trauma, stress, ill health, and stigma. She becomes the parent to her traumatized grandchildren, and together, sometimes reluctantly, they find a way to become a new family that must contend with this bitter inheritance.

The one boy who died, my son who drove a boda boda [taxi], he used to take care of me and he loved me so much. I wouldn't have suffered like this if he lived, and I wished we had died together. Safina (ROTOM), Uganda

Our systems of support in Africa have always been the family—they have always been our safety net—but what do we do when our family of twenty-five becomes two? African grandmother delegate at 2006 Grandmothers' Gathering, Toronto

During the apex of the pandemic, as the number of sick skyrocketed, with no treatment in sight, the fragile health care systems in countries across sub-Saharan Africa were strained well beyond capacity and still the sickness escalated. Without access to adequate public health services, grandmothers stepped in to care for their ailing and dying children—a full-time job that often forced them to leave fields fallow and withdraw from paying work.

Four of my sons died in one year, with just a few months in between. I was left to care for them myself. I was there night and day. Sophia (MASO), Zimbabwe

My daughter was admitted to a hospital in Eastern Cape, which is far from here. So I retired from nursing and travelled up there to be with her. I stayed by her side until she passed. Zodwa (Siyaphambili), South Africa

The caregiver spends so long at the sick bed, busy taking care of the patient. There is no time for other work like planting our crops so we can eat. Malawian grandmother (WOLREC), Malawi

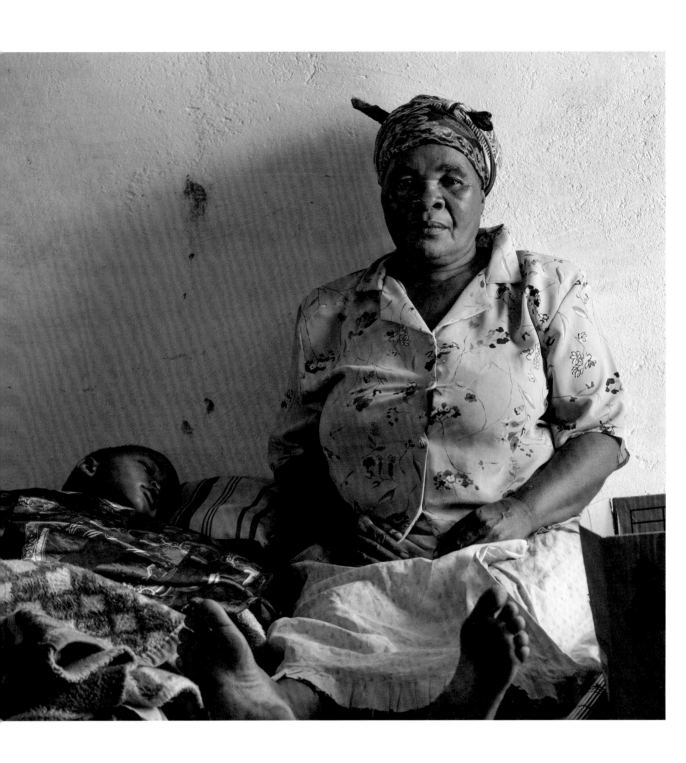

Name Withheld. *KwaZulu-Natal, South Africa (with Siyanqoba Support Group)*

At the same time, expenses soared: there were more mouths to feed and there were new costs such as medicine and doctor's visits, transportation to distant clinics, special food, requirements for palliative care—and the funerals that inevitably followed.

To manage, grandmothers sold assets, and many incurred debt for the first time in their lives. Most did not possess official ID that would allow them to open bank accounts. Their debt was informal, as they borrowed from neighbours and local leaders. This added to their vulnerability. They became people to be wary of if they came knocking at your door—not an enviable or safe position to be in, especially in communities where every household was strained to the breaking point.

We were so desperate we had to try all avenues, even traditional healers. Travelling took a lot of money, the treatments took a lot of money, but all this was trying to save the lives of the sick. Then, we didn't know it was HIV. Malawian grandmother (WOLREC), Malawi

I nursed 10 of my children here in this house. At that time the house was not even plastered and there were no chairs, no beds—people were sleeping on the floor. We were losing so many family members that we constantly needed things for funerals. I used to go and borrow from other people but it was so embarrassing, and that is why I started buying things for myself like plates and cups. We had no furniture in this house full of people, but we had funeral supplies, because they were becoming so routine. Nokuthula (HACT), South Africa

Because of HIV, debt and poverty has really increased in our communities. It takes time for us grandmothers to pay all the debts because we can only get some money through piecework. We can hoe a person's garden, make bricks, carry their water from the well, but the payment is so small and we have so much to do at our own homes with these children! Sometimes, if grandmothers can't pay back fast enough someone can get impatient and go to the police. Or they take matters into their own hands and treat the grandmothers harshly. Malawian grandmother (WOLREC), Malawi

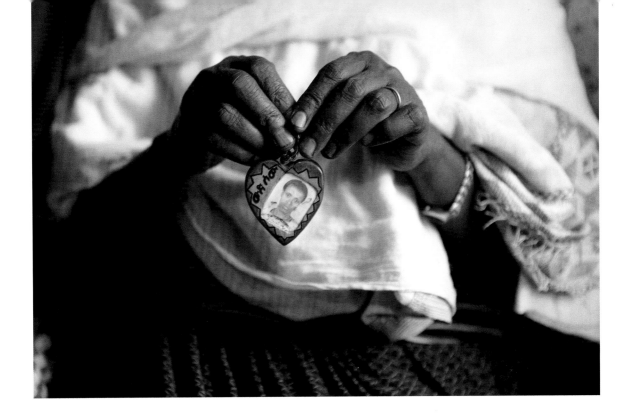

Tied to a "Strange Land"

Many of the grandmothers with whom we spoke followed the cultural practice of joining the husband's family upon marriage. If the husband was from another region, this often meant relocating. A dissolution of their marriage, even through death, often severed the ties with in-laws, who more often than not, suddenly became competitive for resources such as her home and land. Returning to her own community of origin was frequently the most logical recourse, but many would not leave the place where their children were buried.

Somebody asked me, "Why are you staying in your husband's place? For you this is a strange land. Why don't you go back to your family where you were born; at least there you may find relatives, you may find support?" I said, "No, I am here because I lost all my family members here. I raised and buried my children here, so I am going to stay in this place and be buried next to them." South African grandmother (HACT), South Africa

Bizunesh. *Debre Sina, Ethiopia (with* DFT*)*

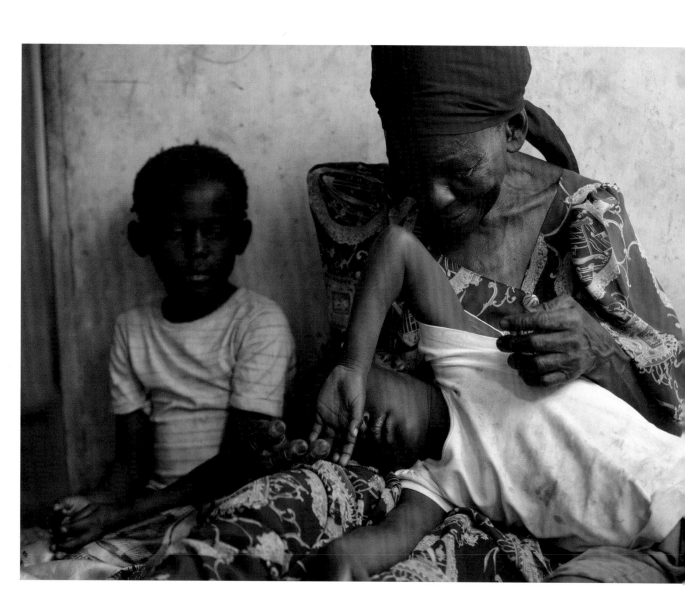

Safina with grandchildren.
Mukono, Uganda (with ROTOM)

Stigma—Straining the Ties That Bind

Almost as crushing as impoverishment, debt, and family breakdown was the overwhelming stigma of AIDS. At the height of the pandemic, in the years before antiretroviral (ARV) medication was available, intense fear of anything to do with HIV & AIDS cast a dark shadow over suffering communities. As a result, patients and their families endured this death sentence in secrecy.

HIV stigma also spread to family members and support workers of a patient. In their moment of greatest crisis, grandmothers saw neighbours turn against each other in anger and families implode in blame and fear. At the same time that they were losing their children, they were losing their support networks. They were truly alone.

Most of my children and people died of AIDS. Actually, they all died—my brothers, sisters, mother, all my relatives died, and I was left alone. Wherever I would go, everyone would tell me, "Your people died of AIDS, we don't want your AIDS here, do not bring your AIDS here." They actually ended up nicknaming me AIDS. Safina (ROTOM), Uganda

My daughter got sick. I had to be home to look after her so I left work. People would come like they were visiting and sympathizing with us but then they would go out and gossip. Eventually I lost her, and then after that my son got sick, but I would not allow anybody to come into my house. When my son passed on, I was alone, with no work, having lost two children, and I closed the door on everyone I knew. South African grandmother (HACT), South Africa

When all of my sons became sick with the virus everyone abandoned them, even their wives—my daughters-in-law. I was so hurt because they were like my own daughters to me. Where did they go? It really broke my heart.
Sophia (MASO), Zimbabwe

Mercy receives a home-based care visit. *Nairobi, Kenya (with WOFAK)*

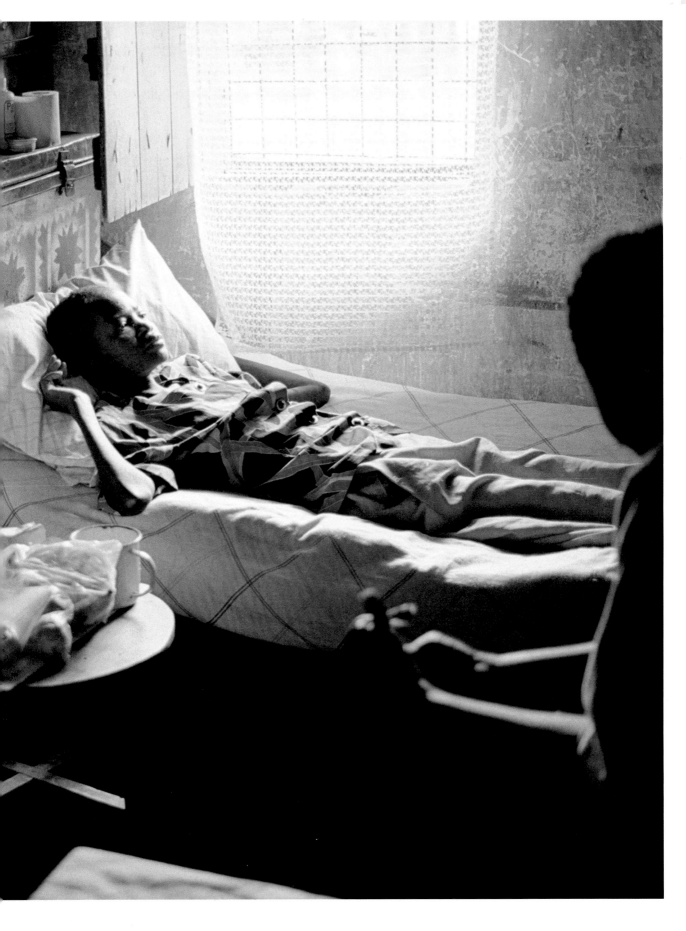

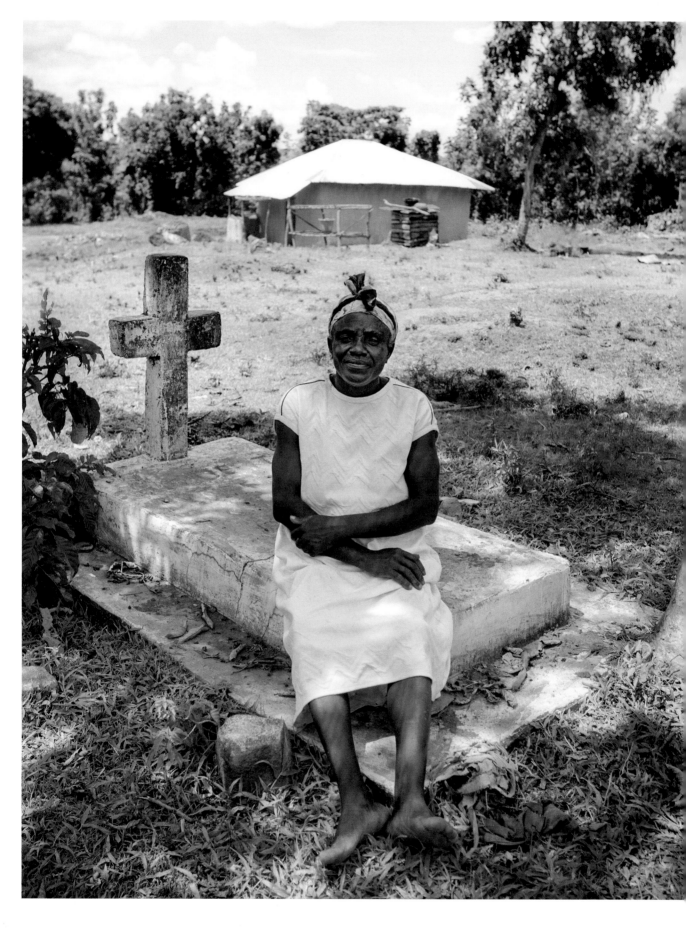

Burnout

Death from AIDS is drawn-out and agonizing. In later stages, patients are ravaged both physically and mentally. As the primary caregivers, grandmothers bore the brunt of the confusion and rage their children felt during their last days of life. This would be horror enough once in a lifetime, but countless women found themselves trapped in this nightmarish cycle. The strain manifested in emotional trauma and health complications.

The first time the doctor told me my child had AIDS, I went to the toilet. I thought my intestines were dropping. And then when they told me of the second one, it was the same. And then the third, the fourth, the fifth. I looked after all my children here in this small hut. They are buried here. That's why I became an outcast, because five children, same home. I used to take care of them, therefore I stopped relating with people, I disliked people. I became very thin; I would not talk. My relatives told me, "You are burned black like the bottom of a saucepan." Waziko (PEFO), Uganda

I lost all four of my sons. It was a very painful experience to start taking care of an adult man, preparing diapers and cleaning them when they were bedridden. And then in the end, they don't even know you. You even think they hate you. I developed a heart problem that year when my sons passed away and sometimes it is so painful that I have to go and see a doctor. And the doctor asks me why I am having this problem, there is nothing he can see, and I tell the doctor maybe it is just those memories of the deaths of my children. Sophia (MASO), Zimbabwe

The Ultimate Penalty: HIV

Grandmothers were not immune to contracting HIV through their caregiving roles. During a pandemic it can be difficult to identify exactly how and when a person becomes infected, but grandmothers know how vulnerable they were in the years before treatment, and before information was available about HIV's transmission and spread. This was especially true when the patient had progressed to having AIDS, a stage when the virus is more contagious.

The scenarios are not difficult to imagine: a grandmother with a wound on her hand and an immune system compromised by months of unrelenting stress cleans the open sores on her dying child or comes into contact with his or her bodily fluids. As primary and often sole caregivers, grandmothers risked possible exposure multiple times a day, for months, sometimes years.

When you go to the hospitals, you will find grandmothers at the bedsides of their sick children and grandchildren. But the government's HIV & AIDS education campaigns do not target grandmothers, they target youth, who may have acquired the virus through unprotected sex. They are busy distributing condoms, but you don't see them handing out gloves. So you find the grandmothers get infected because they are left on the sidelines. Mariam (PEFO), Uganda

I got it from caring for my daughter. My husband was negative, he tested three times. I was one of the lucky ones because my husband understood this. Many women can be beaten and thrown out of their homes when they test positive, but I brought home some educational material from TAC [Treatment Action Campaign], and my husband said to me one day, "You know why you got infected? I read your books. You were caring for both of our children when they were sick and I did not. Maybe that is how you got it." I said to him, "I am glad you know that. I am a nurse, I understand this, but other people do not." Zodwa (Siyaphambili), South Africa

Often, a grandmother is the last adult standing, the one keeping her grandchildren from living in a child-headed household. If she is diagnosed with HIV it rocks everyone's foundation.

When a grandmother is infected and gets sick, the grandchildren feel it in so many ways. First of all, they must take over everything the grandmother used to do for them. When the child comes home from school, there is nothing prepared for them. But what is worse is they see the grandmother now as their mother and now she is sick; they will get the mentality of saying, "Now as my parents passed away, Gogo is also going to die." They cannot concentrate at school. Children even just stay home, no longer attending school. It is really too much. And as for the grandmother, she is ever thinking, "What will become of my grandchildren if I die?" Mariam (PEFO), Uganda

Tapping Their Internal Wealth

Through these stories of unbearable loss and hardship, a rich portrait materializes of these women's internal resources and the depth of their personal capacity. Over and over they demonstrate that what they lack in material resources they make up for in compassion, courage, tenacity, and seemingly bottomless emotional reserves.

I loved my children so much. I used to wish that my love was enough to make them better, but it could not be. My first child died, whom I loved so much, and the second became sick. I loved him and cared for him but still that child died. Everyone was dying but I never stopped.

Every time they would gain consciousness or wake up, the first thing they would ask is, "Where is Mum?" And I would say, "Yes, what do you need? What do you need? Should I give you some tea? What would you like me to get you?" At the end they struggled to take tea, to take their medicine, but I was by their side. And that is how they died, all five of them. They died knowing that I love them and that I cared for them. They died in friendship. Waziko (PEFO), Uganda

Gogo Nasilia Mphatha Rich in Love

Hope for the Elderly (HOFE) · Nathenje, Malawi

"IF ON this planet, there is somebody who is poor, I am one of them," declared Gogo Nasilia as we entered her small home, made of hand-moulded bricks and a packed-mud floor. Windows were boarded shut, creating a twilight stillness inside even though the midday sun was blazing. Her home was unfurnished, with not even a grass mat for sitting. Nasilia pulled a tattered mosquito net from the bedroom and spread it on the floor and settled onto it. The only lighting was a flashlight cleverly fashioned from a tiny bulb, two Double-A batteries, duct tape, and a small wire. "My grandchildren made it," she explained, waving her hand nonchalantly, though her face betrayed her pride in their resourcefulness.

Nasilia shared the three-room home with her three grandchildren and three goats that she had just received from the community-based organization Hope for the Elderly (HOFE), situated in Lilongwe, the capital city of Malawi. HOFE began providing HIV prevention education several years ago to Nathenje village where Nasilia lives and recently started working in earnest with the grandmothers in this region. They have made tremendous strides, launching several grandmother support groups and some income-generating projects. For Nasilia, both the support group and the goats signalled a new chapter, a re-emergence of emotional and physical support, where there had been neither for so long.

Living in a community hard hit by AIDS—where every home is struggling—Nasilia suffered a double blow: the sudden loss of her son, an only child, in a car accident, and the prolonged, painful death of her cousin to AIDS. Nasilia was her cousin's sole caretaker during her final days, and it was here that she wanted to begin.

My cousin was like my real sister. We grew up together—we shared everything and we always had each other. Even when we were grown and moved to separate homes, when one of us was in luck, we would share with the one in need. Whenever we were in trouble we would stand together. We had a great love for each other.

When she got sick every relative of hers was saying, "No we can't take care of her

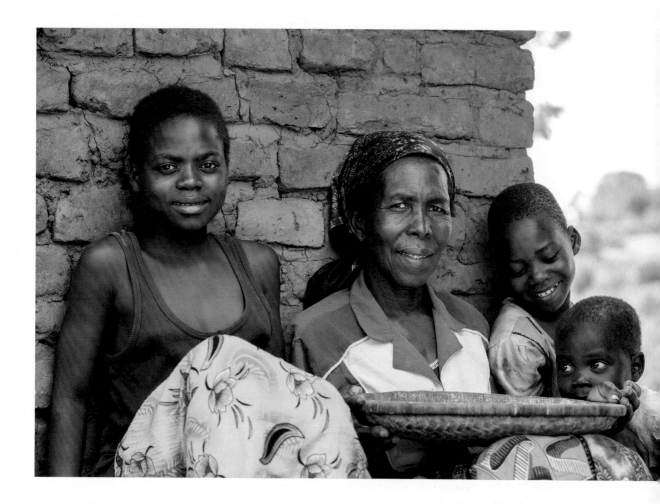

otherwise we will contract HIV & AIDS." So she was abandoned by her whole family.

When I took her in she was critically ill. There was nobody to counsel me or sympathize. I was the only caretaker. I tried to take her to hospital many times. She was so weak. I would take her in the ox cart to the small clinic, which would refer us to the hospital in the city. Somehow I had to pay for all this transport. I sold this and that. And at the hospital they were just saying, "Go home and buy this type of food for the patient." They were mentioning things that would cost me a lot of money, but I did not have a single penny. We would stay in the city for two or three days, and they'd discharge us. But when we came back here, a few days later the sickness was worse again. So it was on and off, on and off. There was nobody I could lean on in that time. If my son was alive, he would have helped me, but the devil took him away from me and I was alone.

Nasilia with grandchildren, May (15), Akini (13), and Chisomo (5). *Nathenje, Malawi*

It was not easy. I took care of my cousin, bathing her, feeding her, washing her clothes, for a period of six months. When I went down to the river to do her laundry, this is when I would cry, because I knew she was going to die. There was no medication and she was deteriorating each day, getting weaker and weaker.

She was so close to me and I grieved; I could not bear the death of my cousin. Her husband came to my home only after she passed in order to take all of her belongings, but I managed to keep her bucket. It is broken, but it is all I have left of hers.

I remained alone for so long, just remembering my cousin and caring for my late son's three children. I did not have anybody to discuss my problems with. But now there are these gogos at HOFE. We gogos, we have different problems but they are similar somehow. This was a surprise to me. So we share and discuss our problems, and when I hear them I think, "Oh, it is not only me who is going through this," and I get relief or forget my own problems for a while.

But I can honestly say, even now, I am always thinking about my cousin. I do not regret taking her in. Everybody else abandoned her, but I could take her into my home and care for her. This is what I have; I have love. And I will also take care of other people in the future. I know I am a poor woman, but perhaps you could say if I have any riches, it is the love inside me. Perhaps you could say that.

Raising Grandchildren in Trauma's Shadow

For the grandmothers living at the epicentre of the AIDS pandemic, the loss of their adult children was emotionally agonizing and financially crippling— but this was not the end of it. The orphaned grandchildren who filled their homes soon became the source of their greatest anxiety in those early days. They were rushing into the future with fewer resources, fractured psyches, and a whole new family construct. There was no time for grieving, only for coping with the unfolding crisis.

After the loss of a child, you go through a phase where you can't even show love, and yet we grannies find ourselves with these small grandchildren who are as desperate as anything. During the funeral, people are there with you to comfort you, but the moment those people leave the burden only remains with you and now you are alone. Zimbabwean grandmother (Chiedza), Zimbabwe

My daughter died and left two who are so young. When I go out to the field to work, I go with a baby on the back, a baby in one arm, and a hoe in the other arm. Evelyne (ROTOM), Uganda

Grandmothers who have invested a lifetime in raising their own children are achingly aware they do not have another one to offer their grandchildren.

I spent my strength raising my own children. Now, at this time of life, not only is the energy gone, but even the resources. If I was younger, it would be possible to find the resources, but without money or strength it becomes very hard to raise the grandchildren. Malawian grandmother (WOLREC), Malawi

We grandmothers are nearing the end of our journey. At the back of our minds, we know that we will die. What will happen to those left behind? Munetsi (MASO), Zimbabwe

I am always warning my relatives, "When I pass away, leave my grandchildren here because I don't want anybody else to have this house. They must grow up here." I am worried about them just coming and grabbing the property, abusing my grandchildren. I am always saying, "Please, God, just keep me for a little while, just until they are old enough." Gladys (GAPA), South Africa

Grandmother after grandmother spoke candidly about the complexity of her relationship with her grandchildren. Almost all reflected upon how painful it was to love these children so deeply, yet simultaneously feel they were a burden. They agonized about how exhaustion, hunger, and grief manifested as anger between grandmother and grandchild, and at times, escalated into verbal and even physical abuse. Having two such disparate generations of traumatized people under one roof sometimes felt like near disaster.

My grandsons discontinued school because they were so dejected about losing their parents, and I was unable to sustain the costs. They stay alone in their parents' home, refusing to live elsewhere, but I worry about their safety. They come here for meals—only last time there wasn't anything in the house and they were very upset with me. They fail to understand that I am short of resources. When they come here in anticipation of at least getting some food and I am not able to provide it, that breaks my heart. Bizunesh (DFT), Ethiopia

Grannies without food, children without food—they all get frustrated. The children, sometimes they cry and say, "Oh, I wish my mother and father were here. You are not a parent; you are just a grandparent." And the grannies, too, end up saying bad words to the children, telling these poor little things, "I didn't kill your mother!" It's on both sides. Ethiopian grandmother (DFT), Ethiopia

I had one friend whose children had all died and she was raising her grandson. This little boy, do you know what he said to her? "You killed my mother so you can get the house. You take everything and give me nothing." And this grandmother came to me and she was crying. It can be very painful. Ethiopian grandmother (DFT), Ethiopia

I woke up in the morning and I went to look for food. The garden was very small so we never got enough. When the orphans came back from school and demanded, "Jjaja, we need food, we want porridge," at times I ended up beating or slapping them because I didn't have it. Paulina (Kitovu Mobile), Uganda

My grandchildren are all boys, so when they came home and there was nothing to eat they beat me sometimes. They didn't understand. Malawian grandmother (WOLREC), Malawi

I had to face the challenges of looking after the children and, at the same time, I was in pain from losing my own children. It affected our relationship with each other so negatively. During those early days, I would spend the whole day just sitting and during the night I would go to bed, but I couldn't sleep.

Irene (Mavambo Trust), Zimbabwe

For most grandmothers, in the early days of raising their grandchildren, long exhausting days of hard labour were inevitably followed by long sleepless nights plagued by worry.

Karmela (centre) and her family.
Kampala, Uganda (with Reach Out Mbuya)

Sleepless Nights

I sit at the end of the day and start to think about how to feed these children. I am all day alone and spend that sleepless night.

Malawian grandmother

I think about how to send all these grandchildren to school. I spend that night sleepless because I do not know what the next day will bring.

South African grandmother

At night I start worrying because my grandchild is sick and I don't have money to go and buy medicine, so I cannot sleep.

Kenyan grandmother

When the food is not enough, they cry, and I'm sorry for their tears. I feel that pain that is deep in their hearts. All night I stay awake on my bed and think and think but never solve.

Kenyan grandmother

I think of those who have gone, who I miss so much, and all the children that remain. This gives me sleepless nights.

Ugandan grandmother

FACING: Prisca. *Masaka, Uganda (with Kitovu Mobile)*

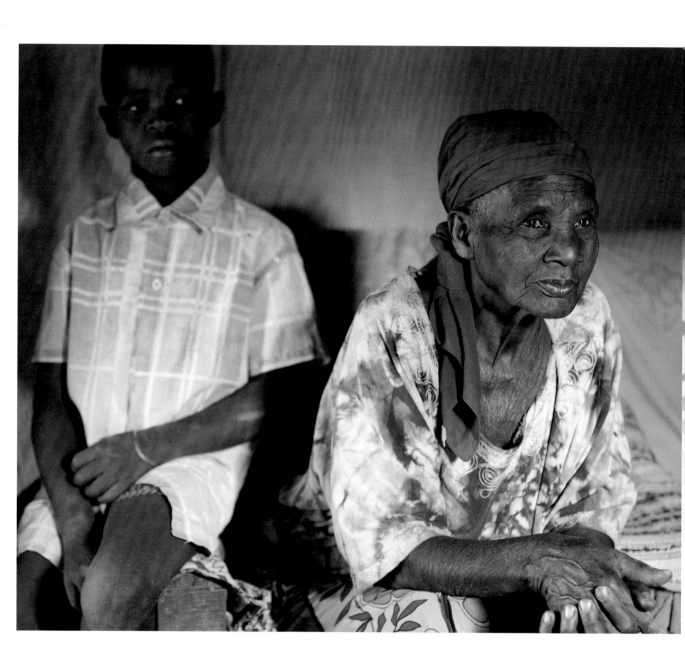

Names Withheld.
Kisumu, Kenya (with PENAF)

A Cycle of Silence

Children came to the grandmothers in deep distress, leaving every grand-mother, without exception, feeling overwhelmed and unequipped to negotiate this unknown terrain of trauma. The children's profound sorrow made the grandmothers' own grief almost impossible to bear.

After his mother's death, the oldest would come back from school in tears and then off he went to bed. Then the girl, the young one, seeing her brother crying and sleeping would come and sleep next to him, and they will do that just right through the day. South African grandmother (GAPA), South Africa

One day, one of the grandchildren was asking, "Where is the cellphone?" The youngest one said, "I brought the phone to the graveyard and left it on the grave because Mum is going to phone." So then I had to explain that Mum will never phone us again and that was almost too much for me. South African grandmother (GAPA), South Africa

At the graveyard when my three-year-old grandson saw his mother's coffin in the ground he began crying so hard because we put her in a hole. From that moment he was afraid of holes. If there is a hole outside he will run away. He is always saying, "She is there, we left her there, she is in that hole." But we don't discuss this with him. We just keep quiet because it seems best to try to let him forget. Gladys (GAPA), South Africa

Many grandmothers admitted that, faced with having deeply difficult conversations with children so young—even as they themselves grieved—they turned to silence. Not talking also kept the secrets that their children had died trying to protect.

Many don't understand what happened to their parents. Maybe they are afraid to admit that to us. As grannies, we are also worried to say anything. We tell them, "Your parents died, but we don't know what killed them, maybe it was malaria," because we don't want our grandchildren to get scared if they know it was AIDS. Evelyne (ROTOM), Uganda

In many homes, if the children were young enough, grandmothers, aunties, and even older sisters, attempted to pass themselves off as birth mothers. It was a complicated kindness—it seemed a mercy to spare the children from the weight of orphanhood and the knowledge that their parents had died of a shameful disease. But inevitably, it brought its own problems.

After my eldest daughter passed away, the child was young, so we told her that my youngest daughter, her auntie, is her mother so she wouldn't have to think of herself as an orphan. Her auntie is too young to be her mother but maybe she will never realize this. But sometimes she has a memory from the time with her real mother. If I ask her about it, she just stays quiet.
South African grandmother (Siyaphambili), South Africa

As children grow into teens, many grandmothers have come to suspect that their youngsters know more than they are letting on. With each passing year, the complexities of these silences emerge, resulting in families struggling to maintain the pretenses initially meant to protect them.

I never told my grandson that his mother died of HIV, but recently he asked me to take him for a test. The test came negative. He is cleared. But maybe he is suspecting something from the death of his mother. I feel that he is not ready to hear that because when we play the DVD of his mother's funeral, I can see that the anger and the crying, all of that is bottled in him.
South African grandmother (GAPA), South Africa

I cared for my sister when she had HIV. When she passed I just took her child as my child. He always called me "Ma." Some months back he had to get ID for secondary school and came to know I am not his real mother. It is difficult for him to accept this. I can see he is deeply troubled and he won't stay at the house with me. He asked me, "Why keep this quiet?" I just say nothing. I don't know what to say. I don't know if he can forgive me because he learned this so late. Kenyan grandmother (PENAF), Kenya

Despite all odds, grandmothers across sub-Saharan Africa were holding the tattered threads of their lives and families together, alone and largely invisible. There was, however, another force awakening within their communities. The emergence of African grassroots organizations would soon ensure that the grandmothers were not alone.

FACING: Etabezahu with great-granddaughter.
Debre Sina, Ethiopia (with DFT)

You can't fight if you are one and don't know that there are other grannies who have got the same problem. But if you are together you can release everything that is inside. You turn that anger into a direction for action. Olga (GAPA), South Africa

2
"We Are Not Alone"

FACING: Etabezahu consoled by grandmothers after her grandson accidentally burned down her home. *Debre Sina, Ethiopia (with DFT)*

| 49

Grassroots Organizations Unifying the Grandmothers

As AIDS was unfolding as a full-scale health crisis across sub-Saharan Africa in the early 2000s, new community-based organizations began to emerge within countries hardest hit by the pandemic. Their HIV & AIDS response programs were spurred on by urgent need and the lack of assistance from their own governments and the international community.

Frequently the initiatives were founded by individuals or small groups of people, most of them women, some of them HIV positive themselves, all of them prepared

to sacrifice their time, resources, and emotional reserves to carry out their work. Most began with no financial backing apart from whatever personal savings the founders brought with them.

As these nimble grassroots organizations began implementing their programs in home-based care, HIV education and training, and support for the multitude of orphaned children, they began to take notice of the grandmothers in their communities—the true first responders, shoring up the yawning generation gap in their families. They recognized that effective interventions would rely on the participation of the grandmothers, so they adapted accordingly and started forming grandmothers groups. Most would later admit that they had no idea the force they were about to unleash when they first brought the grandmothers together.

In the year 2003, my husband and I were busy doing a lot of training for HIV prevention in Meru County, which was my home. There were no other organizations there that were responding to the AIDS pandemic, which is why we left our jobs in the city and moved home to do something, for as long as our savings permitted. This is how Ripples started.

We kept coming across children who were being abandoned. With so many dying of AIDS, people in the community were afraid to take care of them. They were afraid the child had HIV and would infect them, and no one wanted the expense of nursing a child who would probably die. I would say 80 percent of the orphaned children were living with their grandmothers. So we narrowed our focus to working with the children and the grandmothers in order to be as effective as possible with the resources we had. Mercy Chidi, co-founder and executive director, Ripples International, Kenya

I started working with Hillcrest in 2003 on a project of training home-based care workers because the hospital couldn't cope with the surge of patients. During our home visits we realized that young adults were dying, leaving children with their grandparents. So we started the grandmothers' project in 2006 and from the beginning we had a focus on it being led by the grandmothers themselves—which proved key to its growth and success. Cwengi Kile Myeni, granny groups manager, RN, Hillcrest AIDS Centre Trust (HACT), South Africa

A woman named Kathleen was doing research on HIV at the university in Cape Town, and she brought together 10 grandmothers so we could meet like a focus group. I was one of the 10. When Kathleen said it was finished, we said, "No, you can't do that." So she went back to the university and said, "Hey, I've got a problem. The grannies don't want to leave."

She came back to us and said, "Sorry, the university cannot help you." And so the 10 of us continued to meet in my house and then we went to the other grannies in the community. Groups kept forming and the word kept spreading. And that is how we started GAPA. Constance Sohena, co-founder and grandmothers group member, Grandmothers Against Poverty and AIDS (GAPA), South Africa

We started SWAPOL in 2001, as people living with HIV, for people living with HIV. Our office was the back seat of my car. In Swaziland there were no drugs at that time. We were providing HIV education, income-generating projects, and help with crops production in the rural community. The pandemic was so severe that you could bury today two, tomorrow three, and there were no interventions to support the orphans who were left behind. We saw it was the grandmothers who were both nursing the sick and then keeping their grand-children with them, so in 2003 we began to incorporate the grandmothers in our programs. We started by providing education for them around orphan care and palliative care. That was the starting point, but it certainly moved from there! Siphiwe Hlophe, co-founder and executive director, Swaziland Positive Living (SWAPOL), Swaziland

African grandmother support programs began springing up in all manner of ways—small pinpricks of light appearing across the continent, not yet connected, not yet aware of each other, just starting to find each other and find their way forward.

Strength in Numbers

The first step for many of these organizations was to bring local grandmothers together. Many of the women already knew each other, but they didn't know what was happening inside one another's homes. They were living in an environment of crisis and scarcity, which made it extremely difficult to connect with each other individually in a meaningful way.

Sometimes you try to go and share with a friend, so you can share the burden. But she may think you want to ask for help, and she is also in poverty, so she shuts the door. Joanna (HOFE), Malawi

The creation of grandmothers groups as structured neutral spaces was key to breaking the isolation that was imprisoning these women.

I went to church, and I felt ashamed to say anything because they could say my faith was weak. And then I went to counselling and there was nothing for me to feel better. But when I came here and heard the stories from everybody I said to myself, "I mustn't blame anyone, I mustn't ask, 'Why only me?' because this can happen to anyone." South African grandmother (GAPA), South Africa

When I am together with the other grannies, we understand each other, we are at the same level in terms of age and the experiences that we are going through. It's very different than talking to somebody younger, they cannot understand you. And it is not like talking to a counsellor either, it is more like talking to your sisters. Isabella (Chiedza), Zimbabwe

African grandmothers commonly described joining their group as a life-altering experience. From the moment they stepped into the circle, the stigma and silence that had circumscribed their lives began to fall away.

I was hiding because I was afraid. I kept myself away from the community for two years, and nobody knew about me. It was painful thinking that all the troubles are only in my house—my husband left me, I was infected, my son died and daughter is infected, and I am raising my grandson. But when I joined NLK and could see other members, I realized that I was not the only one and that it is not only my problem, but the world's. From that day I began changing. I realized I could survive, I could live with it. Meaza (NLK), Ethiopia

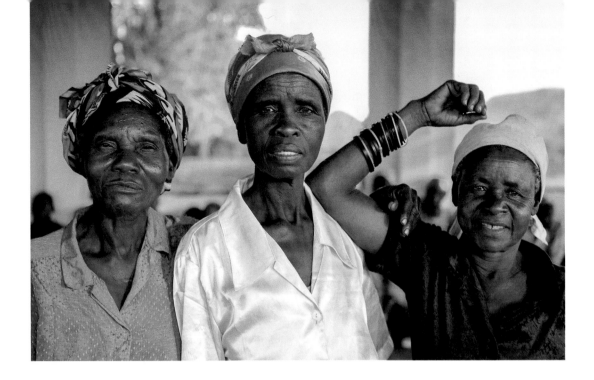

Before I came to GAPA, I was so angry and I didn't talk to anyone. My child was sick and I was nursing her. She was fading away day by day until she died and there was nobody who cared. But when I arrived here and saw the other grannies, they were saying, "I lost one child," or, "I had four children and I have got none." I felt that anger changing its direction. I said, "No, this is a disease and it is killing our children, so we must get together so we can fight it."
South African grandmother (GAPA), South Africa

Whatever the original purpose of their groups—whether income generation, HIV education, or orphan care—when the grandmothers came together they found a space for psychosocial support that proved transformative.

I'm in a group where we are saving money together, but we don't just talk about our savings and loans. We ask each other how we are feeling, how our grandchildren are doing, and we give advice to each other. I am telling you, it transformed my life so much. Irene (Mavambo Trust), Zimbabwe

In the early days, we met to learn more about HIV education, but we also shared the challenges we go through. Sometime we ended up sharing tears. After, we felt somehow stronger because we told our stories, but also because now we have each other. Modesta (ROTOM), Uganda

Linayi, Kamduki, and Mnyangu.
Nathenje, Malawi (with HOFE)

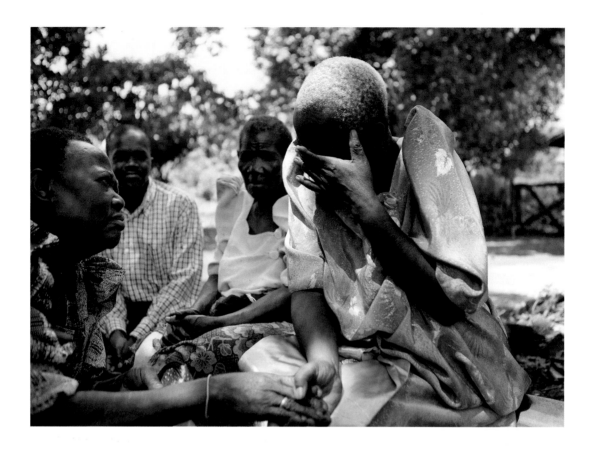

How can I ask God, "Why me?" when there is someone who says, "I found my child hanging in my house"? You find yourself weighing your situation differently, being grateful for what you have. These other women are our strength. Their story is deep and hurting, but it lifts us up and gives us hope. South African grandmother (GAPA), South Africa

I used to live in the dark. I couldn't turn on the light because my grandson hung himself from the only light in the middle of the room. Then when I came here, when I heard the stories from everybody it was like a revelation—that it's not only me. You cannot stay a victim when you realize you are just one of many. Instead you think, "We can do something together to make a change. Together we are powerful, not just one old granny." So I found my hands could start working. That is when I started laughing again and I was happy. South African grandmother (GAPA), South Africa

Grandmother group meeting (Monica and Waziko in foreground. Justine and Jalia in background). *Jinja, Uganda (with PEFO)*

Gogo Gladys Tyophol Tonight We Will Talk

Grandmothers Against Poverty and AIDS (GAPA)
Khayelitsha Township, South Africa

GLADYS COULD be the poster granny for a typical South African gogo, with her sharp, twinkling eyes, fondness for ample hugs and quick tongue for praising or lashing depending on the situation. She is a self-made business-woman who exudes a no-nonsense air while being approachable and warm. We visited her at her home, located in Khaye-litsha township outside of Cape Town.

Outside, fresh laundry was strung on lines, and inside, the doors to her grand-children's bedrooms were flung open showing perfectly made beds and unclut-tered floors. The air was heavy with the smell of stew and dumplings simmering on the stove.

Mother's Day had just passed and when asked how her grandchildren—18-year-old twins Msuthu and Nobesuthu and their 11-year-old brother Lwando—marked the day, Gladys rolled her eyes.

My cellphone woke me at five in the morn-ing. I answered and it was one of the twins: "Happy Mother's Day." Calling from the bedroom, imagine! Then the next one did the same, and they kept taking turns calling me on their cellphones from their beds. I told them, "Look here, why don't you bring me a coffee?" but they said they were sleeping.

All three children are her son's—her only child, who died of AIDS in May of 2005. Within a matter of months his wife followed, and Gladys was left with the full-time care of her grandchildren.

I woke up early and I took them to a nursery and then took the train to work. I picked them up at night and took them to my home. It was hard but I was strong enough. But now, as they are growing up, things are getting harder. The memory comes to them of what happened to their parents and they are starting to ask questions.

Like so many overwhelmed grandmothers, when it came to the loss and trauma they all had suffered, Gladys defaulted to silence, hoping that the painful memories would lose their grip on her grandchildren over time.

On the day of their mother's funeral, Lwando, who was three, was sitting on my lap crying, asking, "Where is Ma?" I said, "She passed away," but he didn't understand and I didn't discuss these things with him because I hoped that he was young enough to forget.

Her eldest grandson, Msuthu, was home, listening to Gladys with a quiet intensity as she talked. He was 10 years old when his parents died. Asked if he would like to share how he felt on that day, he nodded and then was quiet for several minutes. When he finally spoke it was in a low voice, eyes straight ahead.

I could not show it by crying, but I felt that void, that big gap, that now I don't have a father. Come my mom's death, it was even worse. Now I don't have parents. But I could not show it.

A framed photo of Msuthu's father hung on the wall above the sofa. Along the bottom was printed, "May 13, 2005." It was a recent addition to the room—Msuthu and his sister had hung it there just a few days ago—and for Gladys, its sudden appearance signalled that her long-held strategy of silence was beginning to break down. Asked about the photo, Msuthu replied:

I put it there to remember. Every year on the 13th of May I look at this photo and remember my father. And when I feel a bit down and hurt, I will take that photo to give me strength. So drawing from that fatherly love I know that I must be strong for my siblings and protect them. I know I must set a good example. I am taking on these responsibilities. But I always feel that gap. I always miss my father.

Gladys. *Khayelitsha Township, South Africa*

Msuthu excused himself to go and escort his siblings home from school. Once she felt free to talk, it was clear that Gladys, too, carried wounds that have not healed during those many silent years.

I remember the day I realized my son was sick. It was sunny outside that morning; he was standing there and he was getting so thin and his skin seemed a bit grey. I could see him so clearly in the sunlight. It was a shock. I said, "Can you see? You are sick!" and he said to me, "Ma, what have I got?" He was challenging me and he was angry. So I didn't press him.

He didn't tell me what was wrong with him—even up until the time he passed away. I learned later that he told my sister his diagnosis but he didn't tell me. Why didn't he say, "Mummy, I've got this"? How could my only son keep quiet to that extent? I always think that there is something I could have done to help him. And to this day that is what makes me angry. But understand, I was angry at myself.

And then my daughter-in-law got sick. My sister and I went to her and said, "We must go to the hospital because we are going to help you," but she said, "No, what have I got?" Just like my son. Nobody wanted to be out with this virus. For many years it was not very safe if you were positive, so she was denying it to our faces. But we could have helped her, and these three grand-children would not be orphans. And that really kills me.

So I kept busy over the years with the grandchildren and running my own busi-ness, but inside, the anger didn't leave me. I never told them about what happened to their parents, but they have started asking now that they are becoming teens, especially Msuthu. He keeps asking me, "Gogo what was wrong with them?" I tell him, "Didn't you hear that I said it's pneumonia? What else do you want? It's tuberculosis." And they just keep quiet. I don't know whether they believe.

Early last year, my friend Pat came to me and said, "Hey, please, my friend, you are not well. Come to GAPA." I said, "I don't want to go to a place where I am going to talk, talk, talk. I have no time for that." Then she said something I couldn't forget. She said, "I can see you just think of your son. It is still on your face." OK, that was the day I went to GAPA. It was a Tuesday.

That first day I met those grannies I got a shock. I heard them talking about their stories—no one was hiding anything. There was even a woman there who was living with the disease that killed my son. She just came out saying, "Look at me, I am surviving through this sickness." But she was just normal, just like us, and I was shocked by that. And suddenly it is my turn and I start telling them about what has happened to me, that I have lost my child through this thing, through this HIV.

You notice that this word, "HIV," doesn't come out of my mouth easily. For so many years, no one dared to say this word. But at GAPA I suddenly found myself saying that word out loud. And then I cried, I cried, I cried, and I cried. Afterwards I felt very light, and when I came home, I was happy because I felt that I had taken this heavy thing that was in me and given it to those grandmothers. The clot that was blocking my heart was gone.

So from that moment I started changing. But up until today, I have never said the word "HIV" here in my house. This is the very first time, but it won't be the last time—probably not even the last time today.

I knew if I accepted to do this interview that it would raise so many questions from the grandchildren. They will ask me why you are here and what we were talking about. They will ask about their parents. I am sure of it. It is time to discuss everything with them. No more just staying silent. I think the question they will have for me is "Why did you keep so quiet for such a long time, Gogo?" I will say, "I didn't want to hurt you. I didn't want to hurt you. But now you are old enough." I am nervous, but I want to do this now. I don't want to hurt them the way my son and daughter-in-law hurt me. Tonight we will talk. Tonight I will tell them.

Gladys with grandchildren, Lwando (11), Msuthu (18), and Nobesuthu (18).
Khayelitsha Township, South Africa

An Invisible Force in the Global AIDS Response

Demand for the grandmother support programs increased dramatically, thanks to their early successes. The staff's ingenuity, perseverance and dedication allowed the community-based organizations to operate programs well beyond the scope of their budgets. Yet this alone could not offset the ever increasing need for more resources. Finding funding partners would lift their greatest impediment to growth, but in the vast multi-dimensional scope of the global AIDS response, grandmothers simply did not exist. Older women were not listed among the priority populations affected by HIV & AIDS, grandmothers were not recognized as caregivers, and the lack of attention to HIV-positive women over 50 meant there were no targeted funds set aside for them.

Within this environment, African grassroots organizations were attempting to secure new funds and urgently forging a new language to explain the unfolding phenomenon that was the grandmothers.

It was at precisely this moment that Stephen Lewis was crisscrossing Africa as UN Special Envoy and Ilana Landsberg-Lewis was beginning to notice the flood of circumspect references to the grandmothers in new proposals coming in from SLF partner organizations. It was clear that a continent in tatters was being stitched back together by the grandmothers and community-based organizations understood this.

A strategy needed to be developed to bring grandmothers front and centre, and so an astonishing plan began to form that would gather everyone together in one place to see if, together, they could generate something entirely new.

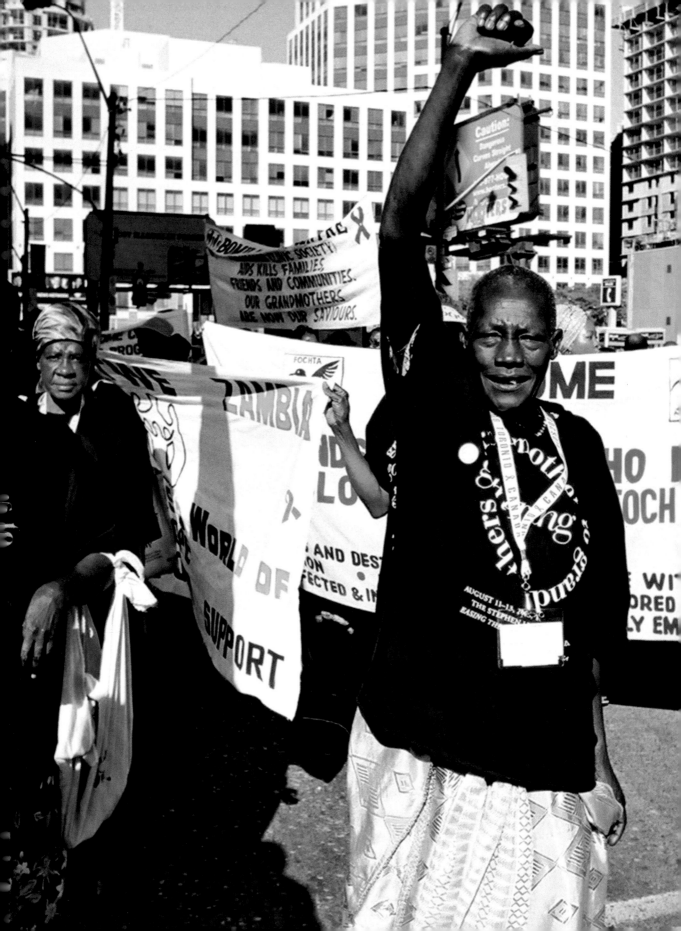

When I first heard of the idea to hold a gathering for grand-mothers I was thrilled and astonished. The first question that came to my mind was "How?" How will the African grannies be able to get passports and board flights? Will the Canadian grannies actually come? We will all be talking different languages, how will we understand each other? This idea is crazy, but if it works this could change everything! I must get on a plane and see this for myself! Siphiwe Hlophe, co-founder and executive director, SWAPOL, Swaziland

3
A Gathering of Grandmothers

FACING: Grandmothers from across Africa and Canada assemble for their first march—celebrating the launch of the Grandmothers to Grandmothers Campaign. *Toronto, ON, 2006*

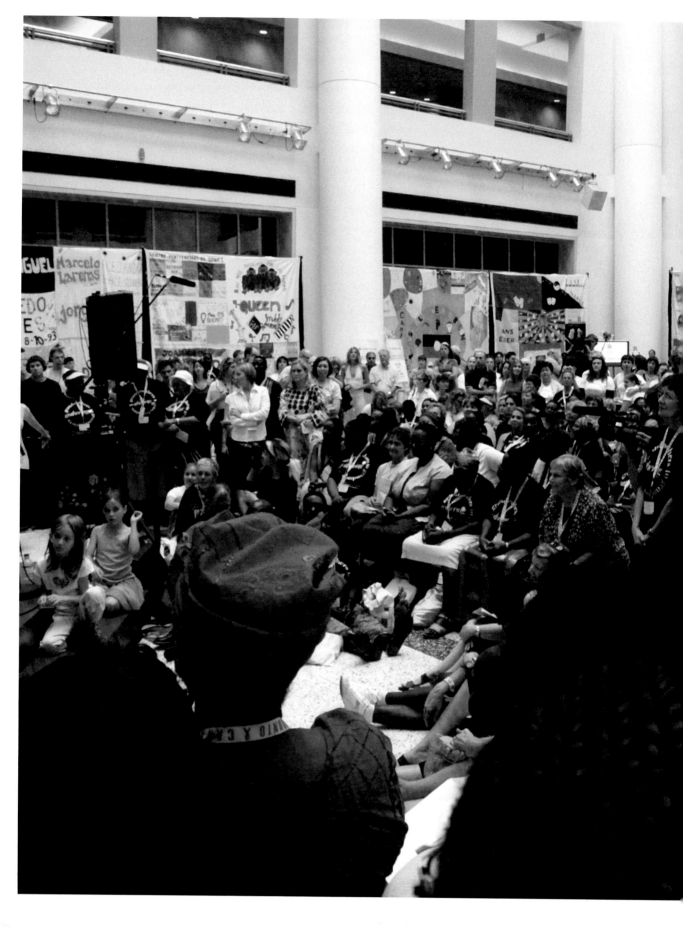

Forging the African and Canadian Connection

The 2006 Toronto International Grandmothers' Gathering was an ambitious plan hatched by Ilana Landsberg-Lewis and Stephen Lewis to bring 100 African grandmothers from 11 of the countries hardest hit by AIDS to Toronto.

They would be joined by 200 Canadian grandmothers who represented a growing number of women across the country who had heard Stephen Lewis addressing the issue of the African grandmothers through his role as Special Envoy and were responding to his call for action.

This event, timed to coincide with the XVI International AIDS Conference in Toronto, would be the launch for the Grandmothers to Grandmothers Campaign—a grandmother-driven response to address the crisis unfolding for the African grandmothers.

A gathering like this had never been seen before. Over the course of three days, participants met in small groups, ate together, and attended more than 40 workshops, all designed, selected, and run by and for African grandmothers. The topics ranged from grief and depression management to orphan care and fundraising.

It was a grand and slightly audacious experiment, but they came—African grandmothers, support staff, and leaders from their community-based organizations, Canadian grandmothers from across the country, and the Stephen Lewis Foundation. They came to hammer out models of program support and funding agreements.

A small-group session during the
Grandmothers' Gathering. *Toronto, ON*

We wanted to give the African grandmothers a forum to speak about their lives, voice their concerns, and help inform the international support that can and must come. We wanted to give Canadian grandmothers the chance to hear that testimony in person. And we wanted to offer both groups the opportunity to become acquainted, to pool their knowledge and wisdom, influence, creativity, insights, commitment, and determination, and just possibly to plot an end to the suffering together. Ilana Landsberg-Lewis, co-founder and executive director, Stephen Lewis Foundation

The African grandmothers who had come, in the midst of their agony, loss, and fear, discovered there were many more women in the same situation than any of them could have imagined. They also began to test their voices in an international forum and realize they had a lot to say.

Canadian grandmothers came prepared to listen, to *really* listen to the African grandmothers, to actively bear witness to their stories—which were at times almost unbearable—but also to their strength and joy. In the process, Canadian grandmothers began to realize that they could never again see their African counterparts as victims or people to be pitied. They saw them as they truly were: anxious but courageous, battered but still moving forward, the best hope of Africa's next generation, and, finally, as sisters.

The African Grandmother Delegates

The travel of 100 grandmothers from 11 African countries to Toronto posed an astonishingly difficult logistical challenge. Most grandmothers lived outside of capital cities, far from airports, and their transportation requirements extended well beyond a plane ticket. They needed visas, passports to put those visas in, and at times, birth certificates in order to register for their passports.

For many of the grandmothers, life changed at the very moment they were chosen as delegates. The chance to travel to another country and take part in this event was described like winning the lottery. Each woman's identity expanded as she moved from invisible to visible within her

grandmothers group, and also within her family and community, signalling an unfurling of new possibilities.

Oh, I was very excited to be selected to go! It was like receiving love that was not even given to me by my husband. I remember one Saturday before we left, the TV people came around—early, at half past five. They found everyone sleeping! We were surprised because no one had ever wanted to talk to us before and now… the TV! Nokuthula (HACT), South Africa

I couldn't sleep. I even shed tears. I went to all my relatives and told them and they were so happy for me. When I got the passport, there was my name, there was my picture, I was official! I remember going to the airport, getting on the plane. "Oh!" I thought to myself, "Well, this is me going to the airport, going on the steps, to get on the plane." I couldn't believe it. Could this be me? This important lady? Isabella (Chiedza), Zimbabwe

I was one of those in Toronto. I was there! I felt so big, standing for all my fellow grannies who were home. I wanted to make them proud. Constance (GAPA), South Africa

Building on the strength they had found among one another in their local groups, these grandmothers were suddenly exposed to a more panoramic view of the impact of HIV & AIDS across the continent of Africa. Throughout the gathering the energy was frenetic as they poured out their stories, grieving, comforting one another and drawing strength from each other.

I remember landing in Canada and meeting all these grannies from 11 countries—tall, thin, fat—we were one big family. We shared together, talked about our families, our country, and how we manage life. After losing my home and all those children, it was hard for me, very hard. But when I went to Canada and met with all these grannies in a similar situation I was very comforted. It really did me a lot of good. Isabella (Chiedza), Zimbabwe

When we all came together we were talking about the death of our children and how we were left with grandchildren. It was almost like once we started we couldn't stop. There was a massage centre at the conference, and I remember I was getting a massage, and from the other side of the curtain

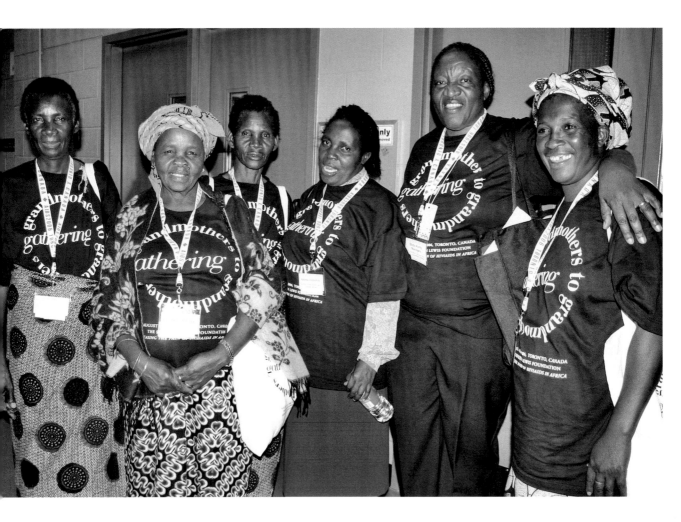

another granny started asking me about the children I have lost. We started sharing right there through the curtain. That's what the environment was like, the whole time. Nokuthula (HACT), South Africa

I met grandmothers from all over Africa. We were all explaining how AIDS is killing our children because it was like a bomb. And when I saw those grannies from all over Africa and heard them talking about HIV—the children that are orphans, they have no mothers or fathers, the grandmothers that have no daughters or sons—oh, I was so surprised! I thought that it was only in South Africa. I said, "Wow, this is a big problem." Constance (GAPA), South Africa

African grandmother delegates
at the Toronto Gathering

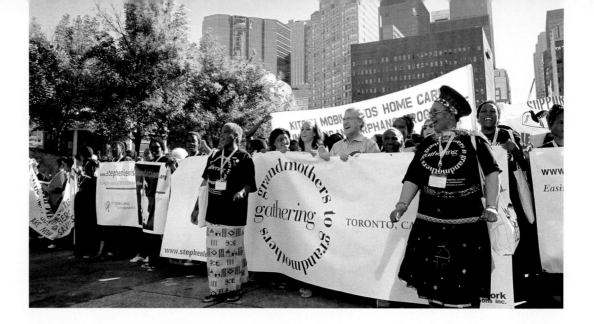

Toronto, Canada

August 13, 2006

ON THE eve of the 16th International AIDS Conference, the city was bursting with philanthropists and policy-makers, drug companies and doctors, activists and scientists, world leaders and celebrities—the who's who in the field of HIV & AIDS.

The day before the opening session that would include a welcome from Bill Gates and Bill Clinton, there was a disturbance on the street. It was heard before it was seen—hundreds of voices singing and chanting along with the banging of drums. When they came into view, the sight was astonishing: grandmothers by the hundreds, marching.

Among their ranks were one hundred grandmothers from Kenya, Malawi, Mozambique, Namibia, Rwanda, South Africa, Swaziland, Tanzania, Uganda, Zambia, and Zimbabwe, and two hundred grandmothers from across Canada, as well as staff from numerous African grassroots organizations and celebrities and social activists such as Angélique Kidjo and Alicia Keys. They marched together, bringing a resounding message to the international AIDS community: Grandmothers would no longer be the invisible face of AIDS. It was time to place them at the centre of the solution, time for the world to deliver support to the grandmothers of Africa, who were keeping their families and communities afloat, and who were going to be heard until they were seen.

Grandmothers' Gathering
march. *Toronto, ON*

The Canadian Grandmother Delegates

In the weeks and months leading up to the International Grandmothers' Gathering, older women across Canada were also preparing for their trip to Toronto. Applications to attend the Grandmothers' Gathering came streaming into the Stephen Lewis Foundation from every corner of Canada, from artists and activists, health care workers, educators, and civil servants. They came from women who ran businesses and households, some who were retired and some who were not. Many were grandmothers, but certainly not all. They were united by a powerful inner drive to do something.

I received an email from the Stephen Lewis Foundation saying, "We're having this Grandmothers' Gathering." I saw the notice and I thought, "OK, I have to be there—for my work as an artist, but also for myself." It was that certain and that clear for me. Louise (SAGE*), Mahone Bay, NS

I had gone online and saw that Stephen Lewis was bringing over one hundred grandmothers from Africa and I thought, "Oh! I'm going." And it was a huge impulse—I'd never felt anything like it before or since. So I bought my ticket, and then I got an email from the Foundation saying, "Don't buy your ticket. We've had so many people apply that we're not sure who will be able to come." And I thought, "I don't care! I'm going!" And I even worked out that I could get in through the kitchen and then make my way up to wherever things were taking place. Fortunately, I didn't have to do that because I was chosen. But I knew I would stop at nothing to be there. Jesse (South Fraser Gogos), Ladner/Delta, BC

The Foundation had asked the Canadian delegates to form grandmothers groups in their communities in preparation for the fundraising activities that would follow. As a result, the majority of Canadian grandmothers were members of newly minted groups, each one with its own name and burgeoning identity. There were a few representatives, however, from groups that had been operating for up to two years before the Gathering and had provided the initial inspiration to the Foundation for the idea of Canadian grandmothers groups.

* For the full names of grandmother groups see pages 294–95.

| 71

Our grandmothers group formed in 2004 when Stephen Lewis gave an address at the university here. Afterwards a few grandmothers got together and we had an idea there could be pods of grandmothers all over the country. When we reached out to the Stephen Lewis Foundation I remember being quite surprised to learn that other grandmothers groups had already started forming. It was just spontaneously happening in little pockets across the country. When I think about the group that listened to him at the university, it wasn't just older women—it was the community. But who responded? It wasn't the men, it wasn't younger women, it was the grandmothers.

Canadian grandmother (Can Go Grannies), Kamloops, BC

Canadian grandmother delegates
at the Toronto Gathering

I got to hear Stephen Lewis speak in the fall of 2004. The situation was so urgent but you know it wasn't really in the media very much. And we would get together over lunch and lament about it. "Isn't this a terrible thing?" and "Why is no one doing anything?" And there we were. So we thought, "That's us, we are the ones responsible for this." So we made a group and coined the name Grandmothers 4 Grandmothers.

The local media got word of what was happening and soon we were being contacted by grandmothers not just from Saskatchewan, but from places from Victoria to Halifax, who wanted to join or start a group. The response was so exciting, but we realized that because of time constraints and resources it was impossible for us to manage the emerging interest. When the Stephen Lewis Foundation launched the Grandmothers to Grandmothers Campaign in 2006 we were pleased to give them that list. It gave all those grandmothers an opportunity to get involved.

We were honoured in the June 19, 2006, issue of *Time* magazine Canada along with 10 other "Canada's Heroes" for the part we played in seeing the potential of grandmothers. Sharon and Orla (G4G Saskatoon), Saskatoon, SK

The Building Blocks of Solidarity

Like everyone at that first meeting in Toronto, the Canadian grandmothers were not quite sure of what to expect or how it would work, but they came equipped with a strong desire to try. They would try to circumvent language, cultural, economic, and experiential differences and reject stereotypes, in order to forge a new type of relationship—one that dismantled the power imbalance inherent in donor-beneficiary interactions, one founded on listening.

As for the African grandmothers, from the moment they set foot in the room, they made it clear that they had the courage to break new ground, yet again, and they were ready to shatter a few stereotypes while they were at it.

The thing that stands out the most for me was the moment of sitting in the auditorium waiting for the African grandmothers and I was trying to imagine what they must be feeling like. They'd come from the other side of the world,

most of them had probably never flown. And I just had this picture in my mind of these little scaredy things, sort of how I felt in Toronto—I'm overwhelmed by Toronto. And in they came, boom! Just singing and dancing and hooting and hollering. They all came up into the auditorium spread out, and one African woman came up to where I was sitting and she picked up my hand and kissed it. So I was toast. Toast! Jesse (South Fraser Gogos), Ladner/Delta, BC

I was unprepared for what to expect. They were unbelievable. Every single one of them was just made of steel. Steel and love, I would say. Canadian grandmother (Can Go Grannies), Kamloops, BC

African grandmothers were equally moved and surprised by their encounter with the Canadian grandmothers. In these women they discovered another dimension of how they were not alone. The Canadian grandmothers did not share their circumstances, but they would voluntarily come along and share their burdens.

In addition, the African grandmothers were, for the first time, testing the power of their voices in an international forum. They could see that the Canadians were listening and were committed to action.

It was hard at times to talk about those things troubling us. Sometimes we could just cry remembering our daughters, our sons. We felt so surprised that those grannies from Canada were crying with us. Isabella (Chiedza), Zimbabwe

Here, in South Africa, it often feels that our community doesn't care, the government doesn't care, nobody but GAPA cares. We gogos could be invisible. But we were very proud being with the Canadians because they have seen us! They heard us! We were so excited, you know, knowing that there were some people who cared. When we came back we were bold now to talk to everyone in our group and in our community. Constance (GAPA), South Africa

In most national events you will not see a space for a grandmother to share her experience. You won't be in an HIV forum and hear them say, "Let's ask the grannies to share." There is just no space for a grandmother. So really that was a breakthrough. Then we have Canadian grannies who are committed to listening to us and supporting us so that we can actually access resources. Cebile Dlamini, program coordinator (SWAPOL) Swaziland

The courage and strength of the African grandmothers as they shared their deepest hardships and worries was truly remarkable. So much so that it could have been easy to overlook the quietly courageous act being undertaken by the Canadian grandmothers in the room—that of bearing witness.

They suspended their assumptions and listened. And more than simply listening, the Canadian grandmothers opened themselves to the African grandmothers—to be pierced by their grief, moved by their strength, and delighted by their joy.

This led to a fundamental shift in how the Canadians saw and related to the pandemic in Africa. Following the Gathering, whenever statistics

Joyce (with Participatory Development Initiative, *Nairobi, Kenya*) and Jo-Anne (Toronto Grandmother's Embrace, *Toronto, ON*), reading the Toronto Statement at the Gathering

were being rattled off about African lives claimed by AIDS—numbers so large they border on meaninglessness—the Canadian grandmothers felt it in the core of their being. These were not anonymous deaths. They were the husbands, daughters, sons, and grandchildren of the women they had hugged and cried with—they were the people who had been held, kissed, and nursed in their final days by the African grandmothers.

I was not prepared for it. I don't think a person could ever be prepared. The stories were so heart-wrenching, and they were so brave. And every chance I had, at lunch breaks, noon breaks, wherever there was one or two or three grandmothers from the African delegation sitting, I would go and ask if I could sit with them, and I would listen to their individual stories. The rapes, the violence, HIV, whatever they had to say, I was ready to listen. Pat (G4G Shellbrook), Shellbrook, SK

I started out in the workshops taking notes like crazy, and then I couldn't keep up. Eventually, I just put down my pen and listened. Mary (Grandmothers Embrace South Simcoe), Alliston, ON

Honestly, I was just blown away by them. They bury their children; I can't think of anything worse. I know how it brings you to your knees when someone dies, and all these people... all the people who had died. I just thought, "I've gotta do something." JoAnne (Grandmothers and Grandothers), Barrie, ON

Building the Grandmothers to Grandmothers Campaign

All participants at the Gathering knew they wanted to build a campaign founded on the principles of equity and solidarity—but what did this look like in action? Invaluable ideas and lessons came out of each workshop and session at the conference and piece by piece, a new development model was being forged. The urgency of the need was on everyone's mind and what to do next was on everyone's lips. Canadian grandmothers were determined to go home with a plan and a direct course of action, and conversations turned to popular Western fundraising methods: twinning, adopting, and pen-palling.

Theo Sowa, senior advisor to the SLF and member of the African Advisory Board, and Ilana Landsberg-Lewis organized a special session to address these issues and invited leaders from African partner organizations to discuss their experience with different forms of donor support. Insightful and refreshingly frank, they spoke about what worked and what didn't. It was a rare chance to hear directly from the experts about fundraising impacts and why some models favoured among Western donors tended to be problematic for African communities during implementation.

Group twinning was perhaps the most vigorously discussed topic. African community-based organizations were unanimous that twinning programs are unfair, inefficient, and often lead to disharmony in the community.

The number of granny groups in Africa greatly outnumbers the possible donor groups. Not only does this create privilege for a select few, it limits the ability of the African organizations to grow. We cannot establish new groups unless there is a new "twin" to support them. Cebile Dlamini (SWAPOL), Swaziland

I had just gone through a twinning program for three years with another donor. It was a total disaster, destructive and expensive. This model of giving harms groups and breaks their bonds. Each group is at the mercy of what their twin decides to send them, which creates dependency and nurtures jealousy between groups. They can't take on new members because they are splitting limited resources between themselves. They can even end up fighting within the group. I always say, when twinning starts, in a very short time, trouble is following. That was the one thing I hoped everyone could hear loud and clear. Mercy Chidi (Ripples), Kenya

Another model discussed at length was pen-palling. Community-based organizations were sensitive to the fact that Canadian and African grand-mothers had now formed some very meaningful friendships and that these relationships would be the engine driving the campaign. They were also aware of the limitations and strains inherent in pen-palling.

We had a pen-palling program with the United States recently. Trying to coordinate communication with the grandmothers is very difficult. First of all, it is expensive because it uses up a lot of staff time and resources. Secondly, these grandmothers can't write. So we had to have at least one person per group who will communicate on their behalf, which opens up potential for taking advantage—or being falsely accused of not representing everyone fairly. I have dealt with this, and there goes more staff time and resources, and there goes the trust and bond between group members that need each other to survive. This lack of accountability is hard on the donors, too. Donors send photos and want photos in return. They want emails. They get frustrated and suspicious when these things don't happen. Mercy Chidi (Ripples), Kenya

I met a Canadian lady who was so nice and sent me so many letters. I didn't know what they said and sometimes it took time to find someone who could read me the letters. I lost my house and custody of all but one of my grandchildren. I was living in a tree and then in a small room given to me by the

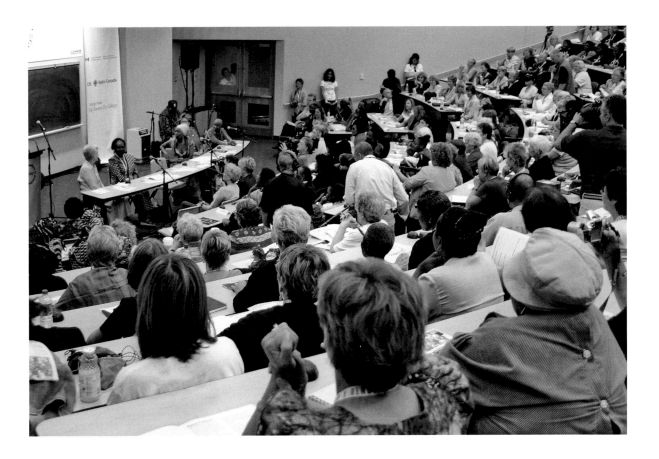

church. I didn't have an address so it took time for those letters to reach me. She sent me cards and pictures of her grandchildren and her home. She asked me for photos but I don't have any photos of my grandchildren and not even any small money for cards or postage, so I felt ashamed. She stopped writing me and I think she was angry. I always feel so bad when I think of her.

Isabella (Chiedza), Zimbabwe

Then came the very delicate topic of sponsorship or "adopting." The idea of "adopting" a granny, or one of her grandchildren, is widely popular among donors. In theory, donors feel they have ongoing access to an intimate and meaningful relationship and a sense of the direct impact of their support. The community organizations, however, offered another perspective to consider.

Participants of the Grandmothers' Gathering assemble for plenary meeting at George Brown College. *Toronto, ON*

Funding dollars and donor needs should not come before dignity. Often they do. Frankly speaking, the grandmothers don't want to be adopted. At this age in their lives, to be "adopted"—well, it is not dignified, and for some, feels a little like a return to colonialism or apartheid. Grannies want to feel autonomous, not adopted.

And when we talk of "adopting their grandchildren" this is something different as well. These grandmothers are the adopters, sacrificing their whole lives to keep these children alive. It can be painful for a donor to give some money and claim their grandchildren as "adopted." The grannies won't say no if this is the only way, but if we have a chance to make a different way, **let's try.** Regina Mokgokong, executive director, Tateni Community Care Service, South Africa

When the discussion turned to best practices in fundraising, the leaders of the African organizations offered insight on methods for ensuring fundraising dollars are as effective as possible: most notably, when funds are raised for general programming over earmarking and when decisions about how to spend the funds remain in the hands of the African organizations.

Workshops were run by and
for African grandmothers.

One of the important decisions to come from this session was the agreement that funds would be raised for general grandmother programming, not earmarked for specific groups or organizations. I think it was the right way to go, because if you mobilize resources for a specific group or organization you create limitations. But if funding is being mobilized for a general pool for everybody to access, then the initiative is upon the individual organization to determine what is the most effective type of programming for the grandmothers they are serving. This was a key decision. Cebile Dlamini (SWAPOL), Swaziland

We believe that we are accountable to each donor who gives, but we also need to be allowed to do our piece of work. Some funders expect us to tailor our programs to the interests of the donors, like water wells or goats. I think it comes down to trust. Deciding where one is going to entrust their donation requires discretion: "Do I trust this organization with my resources? Do I believe they can use these resources and make a difference?" When we are permitted to put our grandmothers' needs before our donors' needs, we know the answer is yes. Mercy Chidi (Ripples), Kenya

The guidance provided during this session was enthusiastically embraced by the Canadian grandmothers and became the bedrock of the Grandmothers to Grandmothers Campaign.

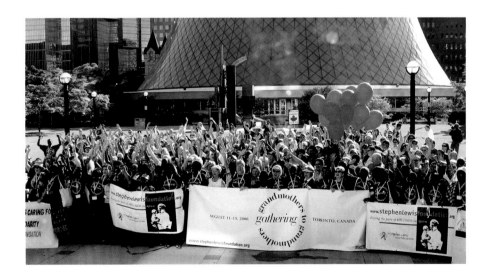

Grandmothers' Gathering march. *Toronto, ON*

Here we were, everything felt so urgent, we all felt this growing desperation to act, to do something now! And yet right in the middle of this, we all took some time to really hammer out the difficult things. In retrospect I can see how important this was to keep us all from rushing helter-skelter every which way, driven mad by good intent, which, as we all know, doesn't always translate to good impact. Jo-Anne (Toronto Grandmother's Embrace), Toronto, ON

We're bound together by a single commitment to the African grandmothers and their grandkids, but it flows out in all sorts of different ways. I think that's healthy. I also think it's healthy that the rules don't allow us to say that we want our money to go to that project. It's much better that it's done through the SLF so everyone is free to really focus their energy on what they are best at. Win (Quinte Grannies for Africa), Belleville, ON

The Power of Relationships

The relationships forged during those three days were among the most important accomplishments of the Grandmothers' Gathering. Both African and Canadian grandmothers often remark on an almost indescribable feeling of connection, to women from other countries and continents who spoke various languages and lived entirely different lives. It was a rare moment when the veil of all that separates people seemed to slip away. Many would later try to describe how, for an instant, in that almost sacred space, the women did not just meet, they encountered each other. And that instant would last a lifetime.

What I remember most is talking to a granny from Kenya. Someone was interpreting for us. She was telling me how she once had cows, but she sold everything she had trying to nurse her children thinking that they would get better. She lost all her children and lost everything she had. I still remember what she wore because she had just one T-shirt left. We ended up crying together, holding each other. She is always in my mind. She is ever with me. When I struggle, I remember my friend as if she is sitting there in a chair across from me. I love her so much. Nokuthula (HACT), South Africa

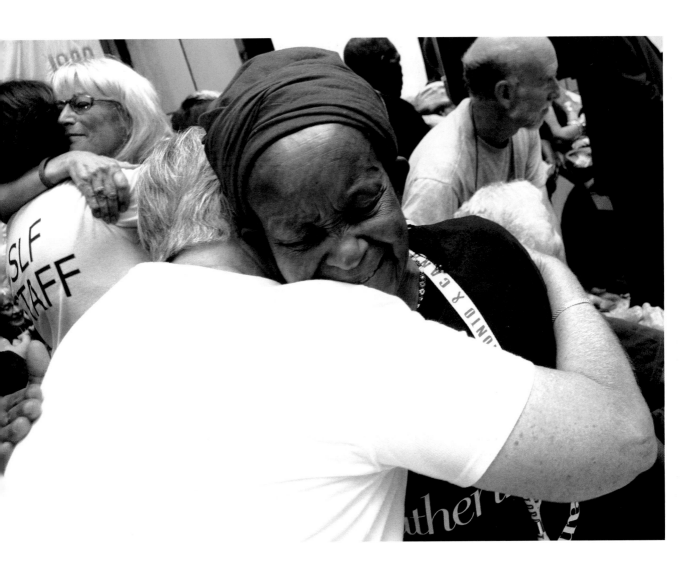

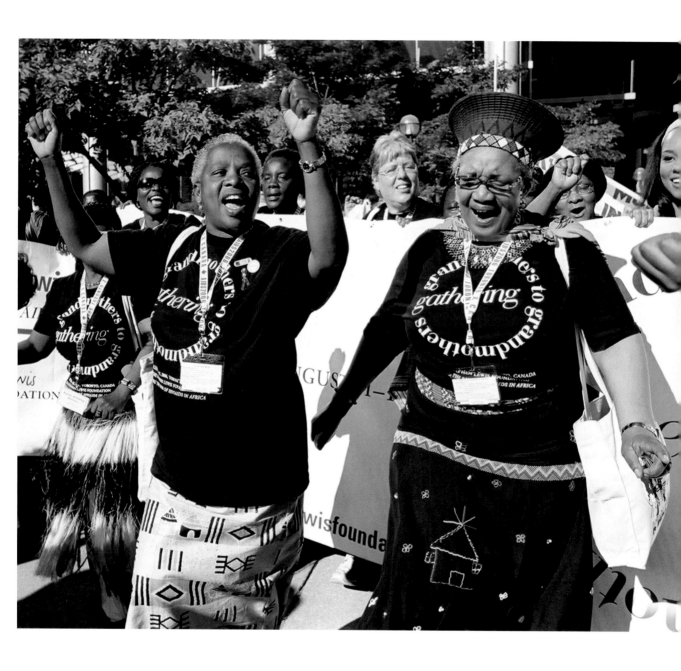

Grandmothers' Gathering
march. *Toronto, ON*

I was sitting beside this grandmother and at some point I said, "Is this how you cope? Singing and dancing, is this what gets you through?" And she looked at me, face to face, very present, and she said, "When we are alone there are only tears, so when we are together we sing and dance." I think it touched something really deep for me. I could see it as a purpose and a meaning, for me too. Donna (Nan Go Grannies), Nanaimo, BC

Even though they are in countries across Africa, they are here. They are with us. I still remember so clearly one grandmother who told her story—when her daughter died and then all of a sudden her grandson is living with her and he is mad. He's mad because she can't provide what he is used to having. And she is doing everything she can but she can't give to him. Now if that doesn't make you want to… I'm hearing her voice even now and I want to cry again.
Pat (G4G Shellbrook), Shellbrook, SK

What I remember most from the Canadian grannies, it's the love that they gave us. It was so warm. You know what I mean? I can't give you the right words, but I was changed by those grandmothers. I had a photo of them but I lost it. But it doesn't matter because that photo is printed on my heart. If I could open my chest, you would see them there. Isabella (Chiedza), Zimbabwe

Nothing could have driven and sustained the tremendous growth of the Grandmothers to Grandmothers Campaign like the relationships forged in that room. They would fuel a feminist social justice movement that would command the world's attention in less than a decade.

A United Statement to the World

At the close of the Gathering, the grandmothers—both African and Canadian—prepared for their march down the main streets of Toronto. They slipped on campaign T-shirts and armed themselves with signs and banners. They were also armed with their freshly written statement from the Grandmothers' Gathering, to be presented to UNAIDS and the International AIDS Conference. They would no longer be sidelined and silenced. It was the dawn of a new movement.

Toronto Statement

AS GRANDMOTHERS from Africa and Canada, we were drawn together in Toronto for three days in August 2006 by our similarities: our deep love and undying devotion to our children and grandchildren; our profound concern about the havoc that HIV & AIDS has inflicted on the continent of Africa, and in particular on its women and its children; and our understanding that we have within us everything needed to surmount seemingly insurmountable obstacles. We are strong, we are determined, we are resourceful, we are creative, we are resilient, and we have the wisdom that comes with age and experience.

From one side of the globe we are African grandmothers from Kenya, Malawi, and Mozambique; from Namibia, Rwanda, South Africa, and Swaziland; from Tanzania, Uganda, Zambia, and Zimbabwe, raising the children of our beloved late sons and daughters. We come to the end of this historic gathering filled with emotions: we are grateful for the chance we have been given—at long last—to make our voices heard. We are relieved to have had an opportunity to tell our stories, to share our experiences, to describe our hardships and our pain, to share the anxieties and express the sadness that descended on us late in our lives, and to receive respectful acknowledgement for the ongoing grief that scars our daily existence.

Each of our stories is different, each of our experiences is unique, and yet we are here as representatives of countless women who share in our tragedy: for every grandmother here today, there are fifty, sixty, seventy thousand at home. We have needs today, needs for the short-term and needs that will never go away. It is our solemn duty to the millions of grandmothers whose voices have never been heard that gives us the courage to raise those needs to demands—on their behalf, and on behalf of the children in their care.

Today, we demand the ear of the powerful: these words are for the conference organizers and the 25,000 delegates assembled at the 16th International AIDS Conference; for its host government, Canada; for the Global Fund to Fight AIDS, TB and Malaria; and for the United Nations. Grandmothers are worth listening to. We demand to be heard.

In the short-term, we do not need a great deal, but we do need enough: enough to safeguard the health of our grandchildren and of ourselves; enough to put food in their mouths, roofs over their heads, and clothes on their backs; enough to place them in school and keep them there long enough to secure their futures. For ourselves, we need training, because the skills we learned while raising our children did not prepare us for parenting grandchildren who are bereaved, impoverished,

confused, and extremely vulnerable. We need the assurance that when help is sent, it goes beyond the cities and reaches the villages where we live. In the long term, we need security. We need regular incomes and economic independence in order to erase forever our constant worry about how and whether our families will survive.

We grandmothers deserve hope. Our children, like all children, deserve a future. We will not raise children for the grave.

From another side of the globe, we are Canadian grandmothers, arriving at the end of our gathering enlightened, resolved, humbled, and united with our African sisters. We stand firm in our commitment to give of ourselves because we have so much to give—so many resources, such a relative abundance of time, so much access, so much influence, so much empathy and compassion. We recognize that our African friends are consumed each day with the business of surviving, and so we have offered—and they have accepted—the loan of our voices. We pledge to act as their ambassadors, raising the volume on their long-suppressed stories until they are heard, understood, and acted upon. We promise to apply pressure on governments, on religious leaders, and on the international community. We are committed to mobilizing funds and recruiting more ambassadors among our sisters in Canada. We are dedicated to finding ways to make it clear that Africa's grandmothers hold a place in our hearts and in our thoughts not just today, but each day. We are acutely conscious of the enormous debt owed to a generation of women who spent their youth freeing Africa, their middle age reviving it, and their older lives sustaining it. We will not rest until they can rest.

Africans and Canadians alike, we arrived at our grandmothers' gathering with high expectations, but also with nagging apprehensions. We worried that the grief—our own and our sisters'—would be overwhelming. We harboured fears that the language barriers would separate us. We Canadian grandmothers worried that our capacity to help might be reduced to fundraising alone; we African grandmothers worried that our dire straits might cast us as victims rather than heroes. But we were motivated to make the trip by the special love that every grandmother knows, and we were emboldened to face our fears by the wisdom of our years. Our courage paid off. The age-old African ways of speaking without words broke down our communications barriers. We gestured and nodded. And we sang. We danced. We drummed. We laughed and clapped and wept and hugged. Through our new discovery—grandmother to grandmother solidarity—we carried ourselves and one another through the grief to where we are this morning.

May this be the dawn of the grandmothers' movement.

Toronto, Canada
13 August 2006

I was at the very first meeting of the Greater Van group. Eight of us. May of '06. We met in a house in Vancouver. Barbara called together some friends and colleagues and I remember her saying, "This is gonna be big." But not one of us knew how big. Not one of us had any idea how big. Pat (South Fraser Gogos), Ladner/Delta, BC

4
Canadian Grandmothers Build a Campaign

FACING: Ann, Oomama.
Oakville, ON

One Size Does Not Fit All

After the whirlwind of the Grandmothers' Gathering
in Toronto, two hundred women returned to their homes
across Canada, impassioned, resolute, and armed with
the tools they developed over three life-changing days.
They and their grandmothers groups had their Toronto
Statement in hand and they had their goals: mobilize
funds, raise awareness, and build solidarity with the
African grandmothers.

As for *how* they would meet these goals, well, this was
deliberately absent. From the start, it was clear to all this
was a grassroots campaign and autonomy was key. The
way grandmothers groups would work would be shaped
by their communities and their members.

In Canada and Africa, it's bottom-up. What might work in downtown Toronto or Vancouver would not work in Tobermory, and nobody's telling us that it has to. And so, our sense of empowerment has come from a sense of freedom. Marg (Stonetown Grans), St. Marys, ON

There's no cookie cutter for a grandmothers group. There's no set of rules except the ones that Revenue Canada sets. Nobody tells you how often you have to meet, or for how long, or how much money you have to raise, or how many speeches you have to make. Hannah (Burnaby Gogos), Burnaby, BC

During the months following the Gathering, the number of grandmothers groups in Canada doubled, and then tripled. One grandmother in Vancouver described it as "heady and frenetic" as they spread the word. The result was an astonishing array of groups, no one exactly like the other.

The beauty of our group, I think, is that we decided right at the outset that we would set no agenda. We keep it simple. Unless the idea comes from within the group and there are people willing to do it, we don't do it. We are all women with children and grandchildren, we have been there, done that and have the T-shirts to prove it. We don't need more meetings. Agnes (Grateful Grannies), Camrose, AB

Very early on we decided to establish some structure. I remember we had a secretary, a treasurer, a president—and only two other members. As we grew in numbers we got ourselves more organized into craft groups and education groups, with regular meetings—that sort of thing. Lee (The GANG), Edmonton, AB

Many of our members come to our meeting, but we have an equal number of "satellite members" who rarely attend. They receive our notices, make donations, volunteer for specific events and often make craft items for our annual sale. When we have new members sign up, I'll send them an email saying, "Come out whenever you want to, and do what you are comfortable doing, there is no obligation, you can be anything you want, it can be anything that you want it to be." Ellen (Ujamaa Grandmas), Calgary, AB

Just as every group was encouraged to develop as they saw fit, every member was permitted to find her own way of belonging. There was a deep respect for the individual and there was room for everyone.

I know I have the freedom to step up and step back when I need to. Last year when I was struggling when my husband was passing away, everybody just stepped right up and so I didn't have any guilty feelings if I couldn't make it to a meeting. They knew. They understood. That's what sets us apart, I think. That's what's different when working with grandmothers. Brenda (Gogo Grannies of Cranbrook), Cranbrook, BC

What I really liked about it right away is that it's so inclusive: "Do what you can, be who you are." You know? It's nonpartisan, non-religious. It's connected; it's just people working alongside other people and that's it. Ime (SAGE), Mahone Bay, NS

Peggy, Marjorie, Pat, Janet, and Bonnie, One World Grannies. *Ottawa, ON*

Florence Lemmer and MaryBelle Thompson
Solidarity and Sisterhood
Rayanna's Hope for Africa, Stony Plain, Alberta

FLORENCE'S DRIVEWAY eats cars. In the dead of winter in Stony Plain, Alberta, her driveway—something of a local legend—has a prodigious appetite for vehicles. It looked innocent enough, but its snowy banks, we discovered, were angled just right for car-catching. Luckily, Florence's home is warm and inviting and provided a welcome retreat as we waited for Craig, the local tow operator.

"It happens all the time," Florence reassured us, as we stood on her doorstep with sheepish looks. She waved her hand unconcernedly at our car lodged in the thigh-deep snow and took us inside, hustling out the tea, coffee, and cookies.

An offhanded compliment about the cookie tin—Anzac biscuits from Stony Plain—made Florence catch her breath. She said quietly, as if to herself, "I bought that full of cookies for Rayanna and I remember she said to me 'Abuela, I'm keeping this box.'"

We had come to Florence's home to talk about her grandmothers group—Rayanna's Hope for Africa—formed in response to the loss of her five-year-old granddaughter, Rayanna, who was adopted from Malawi.

MaryBelle, her best friend and fellow granny group member, was also at the house. Florence explained that she was the emotional one of the pair, while MaryBelle was the communicator. "I'm Puerto Rican so English is my second language. I'm a little shy with public speaking."

MaryBelle piped in: "Whenever we go to speak, Florence always says to me, 'You talk.'"

Florence agreed with a laugh: "That's right, you talk, I'll just stand here and cry. You talk!"

But today it was Florence who started the conversation. She had difficulty addressing Rayanna's death directly and so she began with the founding of the group.

I remember I was telling MaryBelle a story about Rayanna and her connection to Africa and how she sometimes introduced herself: "I am Rayanna, I am from Africa." You know, she never felt adopted to me, she was my blood. After she was gone I was telling MaryBelle, "I have to find something that can honour her connection to Africa…"

Florence's voice began to waver and a few tears slipped down her cheeks.

It is still very emotional for me. I talk about Rayanna and I cry. I don't know when that will finish, I love her so much.

MaryBelle gently stepped in.

Florence had a very special relationship with Rayanna. For the majority of her life, Rayanna and her mother, Carla, lived here with Florence so they were very close.

In halting tones, taking turns, both women filled in the details around Rayanna's passing, beginning with MaryBelle.

It was in Phys Ed. class. She kinda fell down, she couldn't walk. And then the teacher called because that was just the time when the flu was going around, and so the teacher just thought she had the flu, didn't she, Florence?

Yeah, when Carla brought her home she just seemed tired. She opened her eyes, but she wouldn't talk. Then she tried to get up and she couldn't, so that was when we called the ambulance. At the hospital they found the tumour in her brain that had caused a vein to break and bleed. It was not cancer. They think she was born with the tumour. She was so healthy, she didn't even catch colds. If only they could have found it sooner before it started bleeding in her brain.

She was such a joyful and vibrant child. So full of life. It was almost impossible to believe.

That day she left very happy for school. Carla drove her to the end of the driveway to catch the bus and she said, "Mom, last night I dreamed I could fly."

The silence that followed was broken by MaryBelle's quiet reflection:

When we started the group, it was kind of like a twofold thing we wanted to do. We all were friends of Florence's, we loved her and we knew that she was just really, really going through a hard time and so we wanted to be able to fill in some of those gaps. We were also thinking, "How can we help her to honour Rayanna?" The connection with the grandmothers in Africa, well, it really was just such an awesome fit.

Of all their activities, the group is proudest of Rayanna's Country Fair. Florence explained the genesis of the idea:

Rayanna wanted to have a country fair for her fifth birthday party. She got the idea from her favourite Strawberry Shortcake DVD and she had it all planned out. She said, "Well, there has to be a petting zoo, the neighbour can bring the horses and we can have horse rides, and we can find somewhere to host this." And then she told me, "You can make pies and sell them." So she had in mind for this to be a fundraiser—at only five! But there were already plans for her birthday so we promised her the next birthday would be a country fair. And she died two months after her fifth birthday. You always think your child is going to have another birthday.

MaryBelle stepped in once more:

We decided to have our fair on Grandparents Day weekend in September, because it is around her birthday. We did all the things Rayanna wanted to do. We sold ice cream, cupcakes—three hundred cupcakes! Only two were left at the end of the day. There was a little petting zoo. I still remember that feeling, after it was all over. It was such a labour of love.

It is wonderful for our group to hear how the money we are raising is helping, but we also realize that we may never be able to see all the results. And we don't have to know the whole story. It is enough to know that there are these grandmothers across the African continent with these children and teens whose lives are made a little bit easier by something that we've done. That it is all somehow connected. That we are all somehow connected.

Florence nodded thoughtfully while listening to her friend and then added:

There's another thing that is very meaningful for me with this work. From Rayanna's adoption papers I learned that it was her grandma who took her to the orphanage in Malawi. She couldn't keep her, so the grandma walked miles and miles to take her to this orphanage. That must have been heartbreaking for her.

Once again Florence's cheeks were wet, but this time her voice did not falter:

I know that through this work with the Campaign we are helping grandmas to keep their grandchildren. I would love another little granddaughter and nobody will replace Rayanna—but as much as I can help other grandmas to keep their grandchildren, that's what I have to go for.

It was growing late. Craig had come and gone and our car was freed from the snowbank, but no one wanted to leave. We wanted to spend more time with these extraordinary women who reminded us of their African counterparts, with their ingenuity, courage, and steadfastness. It felt deeper than solidarity, it felt like sisterhood and it felt like hope—not just for Africa, but for all of us.

GRANDMOTHER and CHILD

Fundraising: Solidarity in Action

As groups across Canada began forging their identities, they also began raising funds. Most of the grandmothers groups chose fundraising dinners, craft sales, or collecting donations as their first activities. Few had any idea how it would all turn out; they simply rolled up their sleeves and got started, finding their way as they went.

We were kind of mulling over where to start and I said, "Well, it seems to me that an African luncheon would be great. We can sell tickets for $10 and talk to people about why we are doing this." We all made two pots of soup and Marilyn made all the buns and the next thing we had a sold-out crowd and made probably $2,000. That was the beginning of The Bay Grandmothers. We still do that luncheon every year but now we team with the local bank and we make about $11,000. Jane (The Bay Grandmothers), Upper Tantallon, NS

Back in the early days we did things like Gin with Grannies and no, I don't mean the card game. It started off as Tea with Grannies, but that sounded a bit tame, so we decided we'd have Gin with Grannies. Someone even had a recipe for gin slushies. Ellen (Ujamaa Grandmas), Calgary, AB

Very quickly, money began pouring in to the Grandmothers to Grandmothers Campaign, achieving what had once been unimaginable: steady, reliable funding for African grassroots programs targeting grandmothers. Support for this once-invisible group was finally coming together. Buoyed by success, Canadian grandmothers charged ahead.

I make ugly little Dammit Dolls—they are for stress. Attached to each one is a verse:

When you want to throw the phone or kick the chair and shout,
here's a little dammit doll you cannot do without.
Just grab it firmly by the legs and find a place to slam it,
and as you whack its stuffing out, yell dammit dammit dammit.

I sold 10 of them to my university professor. Barbara (Espanola and Walden Grannies), Espanola, ON

FACING: A selection of fundraising crafts: *(top right)* Linda *(Welisa Gogos, Vancouver, BC)* with baskets; *(bottom right)* Barbara *(Espanola and Walden Grannies, Espanola, ON)* with her Dammit Dolls

There were dances, concerts, and theatre performances. Down-east kitchen parties, yard sales, and antique sales sprang up in markets, malls, and community halls. Some grandmothers walked the Camino trail in Spain; others climbed Kilimanjaro for funds, producing a book about their adventure that raised even more. Cookbooks and calendars, fashion shows and a motorcycle rally, home and garden tours, a stargazing event: the sky truly was the limit.

We live out in the country on sort of a bald hilltop, and the view of the sky is just incredible. I invited an astronomy professor from the local university and he brought out telescopes and about 20 people came. It was a chilly October night, but it was wonderful as we stood out there and learned all about the different constellations. Then we went inside and had some apple crisp and sat by the fire. All I did to raise money was tell my guests in the invitation email that if they wanted to make a donation for their lesson there would be an envelope by the phone. So yeah, we dream up all kinds of ways to make money. Mardell (Grateful Grannies), Camrose, AB

Our group is called the GANG, so a motorcycle rally seemed like a good idea. There was a registration fee and we mapped out a route that was approximately two hundred kilometres long. At the four pit stops along the way there we were, passing out granny cookies to these big burly guys and they were so lovely. For our promo shot we all got into leathers and stood by a dumpster. We borrowed a motorcycle from one of our neighbours, because none of us actually rides a motorcycle. Grace, Louise, and Lauretta (The GANG), Edmonton, AB

Reaching into the Community

With evident delight, grandmothers played both to and against type. They harnessed the advantages of age ("The older you get, the bolder you get") while leveraging some of the stereotypes ("Who's going to say no to a sweet little old granny?").

The delight seemed mutual. Grandmothers were met with enthusiasm and partnerships were formed with businesses, non-profits, artists, unions, schools, religious groups, politicians, and media.

South on Highway 7, there's a store called Zak's and this woman brings in trendy clothes for older women. She approached us and said, "We'd like to do a fashion show; you can have all the profits, we'll do the publicity." So, of course we agreed! We held it at St. Andrew's church, right in front of God and the altar and everything. Bunty (North Bay Grandmothers for Africa), North Bay, ON

A nice thing about growing older is that you are not afraid to go out and talk to anyone. If you want something done, start at the top, go talk to the mayor. Why not? That's what I do. Also, we have a list of media contacts. We know we can pick up the phone and call Rob from CTV and he knows who we are. Also we did a really sneaky thing. After we got some good coverage we put a couple dozen home-baked cookies in the staff room to say "Thank you for putting us on TV"—so they don't forget us. They aren't likely to either because our cookies are delicious! Louise (The GANG), Edmonton, AB

Community partnerships could include donations of spaces for events, artistic talents, or items for auction. The scale and scope of events got bigger, bringing in more and more people, and engaging them in increasingly meaningful ways.

We had a big event here when the Stephen Lewis Foundation brought a grandmother and granddaughter from Malawi to visit and the whole community was involved. The unions helped and they were great. Rotary came out and sang in a choir. Two groups of kids from a local non-profit said, "We'll serve the food. We'll do the cleanup." The hotel gave us a cut rate for rooms for our visitors. It was a real community effort and such a success. People came from everywhere to hear them speak. They were lining the walls. Bunty (North Bay Grandmothers for Africa), North Bay, ON

Jackie, Cara, Sally, and Monika,
Merville Grand Mothers. *Merville, BC*

Multiple grandmothers groups sometimes collaborated to strengthen their networks, which resulted in a ripple effect bringing enormous benefit to their communities. The Merville Grand Mothers, on the West Coast, told us about a textile art project they undertook along with the Glacier Grannies and Victoria Grandmothers for Africa. The project, featuring stunning handmade art pieces by North Island Quilters for Community Awareness, grew into a travelling exhibition with gala events, auctions, and even an illustrated book. They shared a letter they received concerning one of the pieces that was up for auction:

> Regarding Bid #2. I am writing to you on behalf of my mother, Virginia Lee Crocker. I took her to see the textile art exhibit Saturday afternoon. She's 92 years old, manoeuvres with a walker, and is 97 percent blind. She looks upon a world of grey to black shadows. During her lifetime she has been an artist, creating artworks through needlepoint, hard edge acrylics, copper, enamel, and knitting. She can now only knit through feel.
>
> As we wandered through the gallery I described the pieces to her as best I could, the colours, materials used, and the meanings behind each piece. She was particularly taken with one entitled "Who Will Grind the Maize." Days later... she called asking if she could purchase that piece. She has been moved so much by it, and the greater project itself, that she is willing to use her entire life savings of $555 in support of the project... So if there is any way to secure this artwork for her, it would be like a dream and prayer answered for her involvement in assisting the bigger global picture of humanity... Yours sincerely, Caroline

This letter was read aloud at the end of the auction after Virginia had won the bid, but she didn't have to give up her life savings—three people came forward to pay for her. In turn, Virginia knit gifts for each of them. As the Merville Grand Mothers explained:

There is this incredible aspect of community building and bonding that happens through our work as well. There are just so many layers of connecting and healing to this.

"The World Is Our Community"

By making inroads outside their own circles, grandmothers reached new donors, and made possible new ways of giving. When people offered to send clothing or items directly to Africa, the Canadian grandmothers offered an alternative—organizing local clothing drives for items to be repurposed and sold in Canada and the profits sent abroad instead. In this way, the African grandmothers had access to funds for their highest-priority needs. Further, the pitfalls of sending second-hand goods to Africa could be avoided, like when donated items cost money to ship but are not always usable, or when they destabilize a struggling local economy by flooding the market with cheap goods that undercut local manufacturing and small businesses.

The money that we raise, we know it goes to the grassroots organizations, and it's them making the decisions about what is needed in their communities. And we try to emphasize that because it really goes against the usual charity model—it busts it into a million pieces. Canadian grandmother (G4G Saskatoon), Saskatoon, SK

It may have been their charm offensive (and creativity and energy) that got grandmothers in the door with new supporters, but they kept it open with conversations that were challenging and changing public perceptions about AIDS in Africa. This is why awareness raising was built into the mandate of their campaign alongside fundraising. This wasn't about charity, it was about justice and taking an approach to development that actually worked.

We are doing things differently in this movement. We are really supporting the African grandmothers to make the decisions they need to make. And to me that really makes me feel... how shall I describe it? Pride is one word, but it's a stronger emotion than pride. We're women of a certain age and we have strength and power and we can lead the world in saying, "It can be done differently." Lee (The GANG), Edmonton, AB

I've had people say to me, "Why are you raising money for outside of our community?" Well, we believe the world is our community. As human beings

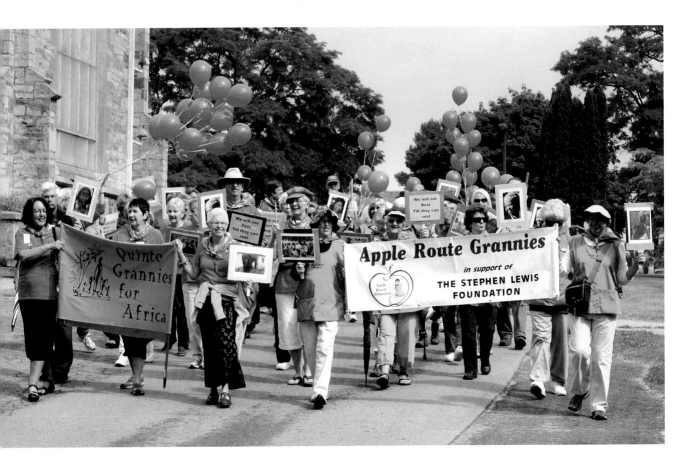

we need to get past the point where compassion and the worth of another person is based on "proximity to me." Alison (G4G Saskatoon), Saskatoon, SK

There's no Lady Bountiful in any of this; you know, "Good people doing good works because we're so much better than everybody else." This is about really respectful, responsible partnership. It's about stepping back and trusting those who are living the experience to take the lead. This is social justice work at its core. Janine (Royal City Gogos), New Westminster, BC

We are fundraisers, but part of our mandate as a group is we are always thinking in terms of building community, elevating the conversation. We fundraise with the long view in mind which means we are also always raising awareness. Sally and Tina (Merville Grand Mothers), Merville, BC

Canadian grandmothers' annual walk—Stride to Turn the Tide. Quinte Grannies for Africa, *Belleville, Ontario* and Apple Route Grannies, *Brighton, ON*

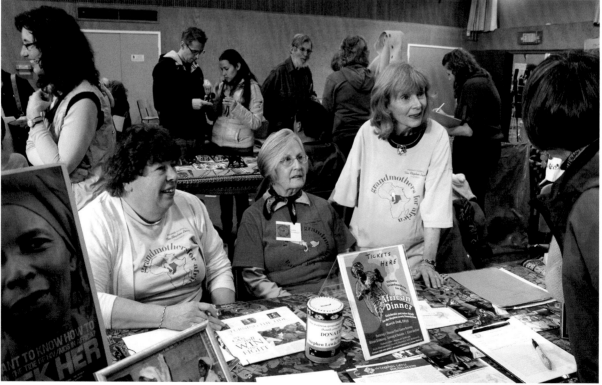

This is not the traditional charity model where it's "We are here to help you." How we raise the funds is as important as the funds themselves. This isn't charity, it's sisterhood. Canadian grandmother (G4G Regina), Regina, SK

With each successful event, outside perceptions of the Canadian grandmothers also shifted. Media stories covering their activities went from sweet and slightly patronizing to downright political. The Canadian grandmothers received even more partnership requests once people began to recognize their reach and reputation.

It took a little time for us to get noticed in our community. The newspaper was the first, and then we got a little more publicity for our first national walk. Before, people didn't know who we were, but now this whole town knows, for sure. Carol Anne (G'Ma Circle of Summerside), Summerside, PE

We hardly need to advertise our various fundraising events anymore. The people just come. People in the community recognize that we are a serious group and the cause is really important and the money is going to the right place. Canadian grandmother (Grandmothers Embrace South Simcoe), Alliston, ON

The other day a senior came up to me in the grocery store and asked, "How are the grandmothers doing?" She had met us at a craft sale that we held at the seniors' complex. She is not saying, "How much money did you make this month?" She is saying, "How are the African grandmothers?" Canadian grandmother (Grandmothers Helping Grandmothers), Fredericton, NB

The Campaign was full of life and expanding quickly. Grandmothers continued taking on events of every ilk—big to small, individual to deeply collaborative—the hallmark of the Campaign was that there was no one way of working and if they could imagine it, they could do it. The connections they were making along the way seemed a natural outcome of a campaign rooted from the beginning in relationship. This was fundraising and awareness raising "granny-style," and it was working.

FACING TOP: "Good Words for Africa" Scrabble fundraiser. *Left to right:* Gladys, Carol, Colleen, and Wendy, Eastside Grannies. *Sherwood Park, AB*

FACING BOTTOM: *Left to right:* Audrey, Joan, and Grandmothers Campaign supporter, Victoria Grandmothers for Africa. *Victoria, BC*

A One-Woman Fundraiser

Margo, Espanola and Walden Grannies, Espanola, ON

My husband, Phil, is the reason I got involved with the Grandmothers Campaign. I was an artist but I started to lose my eyesight and I thought, "What am I going to do?" I was almost 90 and I suddenly had all this time, but I knew it had to be purposeful. Phil found an article in the *Globe and Mail* about the Stephen Lewis Foundation and he read that to me. Phil does all my reading for me now.

I was moved by those African grandmothers but I didn't know what I could do. Having bad eyesight, I couldn't get into anything that was very creative like sewing. Knitting drove me crazy, I dropped so many stitches. Don't ask me where the idea for fudge came from, but I thought, "I could do that." And well, it caught on.

I have my own table at the mall and Phil helps me set up. At the end of the day we usually come away with $85 to $90. Now, I probably could get more people involved but, being my age, I don't want organizational problems. If you join me, you have to do your own thing. And it's working. Different group members make cards, knit, or bake cookies and I'll sell their stuff at my table but I don't want to have meetings and have big plans because that would worry me to death.

I'll tell you a secret: there's a big fudge factory up the road but my fudge is better— it's pure luxury. Vanilla, chocolate, white chocolate, and maple are the big sellers. I don't put anything in it that's bad, just sugar, butter, and flavour—like maple or blueberries. Oh, and yes, the secret ingredient—██████— but you mustn't tell anybody.

The way I look on life is that we're all here for a reason. I'm in my nineties, so I think if I'm going to use up this very valuable time I've been given through my genetic line, I suppose, I should put it to good use.

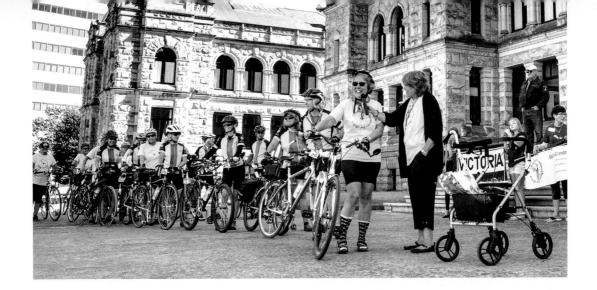

Annual Cycling Tour

Jocelyn, Janet, and Carol, Victoria
Grandmothers for Africa, Victoria, BC

I was new to Victoria and had just joined the Cross Canada Cycle Tour Society as a way to get to know people. I was cycling along, and Carol's beside me just chatting and she mentioned something about the Victoria Grandmothers for Africa, and I said, "I'd like to become involved in that." And then I suddenly said, "We should do a cycling fundraiser!"

So we organized one. It's not just a bike ride, it's 275 kilometres over three days, so it really is an opportunity to get to know people and share a bond and do something really special. There's this incredible scenery when we cycle, and we can swim in the ocean when we stop at night.

As the ride has developed we have been very careful to make sure that it's possible for everyone to do it. Obviously you have to have a bike, you have to have some biking experience, but by organizing training rides

we've enabled some people to join us who would never have imagined they could ride for three days.

The range that individuals raise is huge—$300 or $6,000—but we don't make a big issue about that; it's not competitive. We don't give more pats on the back to those who have raised the most money—there are no prizes for that. It's really about collaboration.

Other grandmothers groups on the Island are joining us and the idea is spreading. There's a ride in Ottawa, too. I've heard there's been an inquiry out of Calgary.

We raise funds for our African sisters—that obviously is the motivation to be out there. But we also have people do something that they had never imagined that they could do in their sixties or seventies. It's like a bucket list experience. And then there is the camaraderie that's built between us.

Forget a "win-win situation," we grannies go for "win-win-win." We wouldn't settle for less.

Stirring Memories:
A Food and Family Memoir

Louise, Lauretta, and Grace, The GANG, Edmonton, AB

Our group sells lots of homemade goodies and so we discussed putting together a cookbook for a fundraiser, but we thought, "Oh well, cookbooks have been done and everyone gets all their recipes online these days." So the idea sat on the back burner for a couple of years.

But then I [Grace] lost my mother and I found myself going through her cookbooks and recipes and started to remember the foods I enjoyed in my childhood, and I said, "Let's get that idea back on the table." This could be a food memoir—a means of honouring our own mothers and grandmothers. So that's what we did. Along with recipes we included little stories connected to these food memories and we left room at the back so that anyone buying the book could write their own stories and favourite recipes. We saw this as a way of connecting to our past and also creating something our own children and grandchildren could cherish in the future.

And it's been so successful—far more successful than we ever imagined. Our paper, the *Edmonton Journal*, was asking people to send in their pick for the best book in 2012, and we thought, "Well, our book is best," so we nominated *Stirring Memories*, and then it appeared on the list!

We invited the premier, who contributed a recipe and story, to our book launch. She couldn't make it but we were invited to the legislative assembly. So of course we went. There we were, in our granny T-shirts and scarves, standing up there in the gallery as she introduced us and our book. Sometimes you start a thing and you never know what road it will take you down!

Gogo Tote Bags

Pat, Jesse, and Joy, South Fraser Gogos, Ladner/Delta, BC

I remember when I knew we had hit upon something big. We were at a speaking engagement in North Delta and we had set up the tote bags at the back of the room. When I finished speaking I said, "One of the ways that you can help is to buy some of our products." Boom! We were knocked over! The people rushed past us for the bags. It was pandemonium!

The bags are bright and fun and useful. The beads are fun and funky. Very often, when I'm out someone will say, "I want your bag!" So I put my stuff in a plastic bag and sell it right there and then and walk away carrying my things in a grocery bag. We've all sold our bags that way multiple times.

Other groups started to make them and are teaching each other how. This has gone far and wide.

Grannies-in-the-Buff Calendar

Sue Walker and Claire Vilela, Quinte Grannies for Africa, Belleville, ON

CLAIRE: I've always danced around naked. I'm not bothered at all by bodies—not mine or yours or anybody else's. How I came up with the idea for a grannies-in-the-buff calendar, I don't know, but people were quite enthusiastic. It did have challenges, but we got through them all and, $57,000 later, I would say it was worth it.

We managed to get so much of the cost donated—for example, the photographer. He was brilliant. It was just fascinating watching him work and the way he operated with each person. He was very good at sensing a person's needs, who was upset or nervous, and who wasn't. He would take a bunch of photos and then come and show them to you so you could see how it looked. Then he would just get on the computer and say, "Don't like the look of your bum? Don't worry." Whoosh, whoosh, whoosh on the computer and lumps were smoothed, you know? It just made us feel good.

SUE: I went on probably eight of the shoots and Claire was truly the only one not bothered at all. Claire wanted her photo to be in the daffodils. She was lying there, starkers, swatting down all the flowers, saying to the photographer, "Am I all in? Am I all in?" And we're saying, "Yes, you're all in. In fact, we have to get a bit less of you in."

CLAIRE: It never occurred to me to worry about it and it turned out to be a very nice picture. There's a few squashed old daffs down there.

SUE: Personally, I wasn't overly enthusiastic to be photographed nude. But I found out that I have a talent for going after money and I really enjoyed that aspect of the project. I got a lot of sponsors. I'd say, "I'm part of Grannies for Africa and we're producing a grannies-in-the-buff calendar. I know you're dying to see us with our clothes off." I'd just keep talking and they'd usually go for it. I actually found most people's responses heartwarming. We got support from the most unexpected places. I would say to any other group, if they wanted to do it, contact us, because I do have a time-line. I can save them a lot of hassle!

I only knew one grandmother when I went into my group and now I consider them the dearest people. And I feel I've grown as a person since I joined the group. From Claire, I've learned to take off your clothes and to lie in a daffodil field from time to time.

You can forget the idea that we are little grey-haired grannies, in our little aprons, at home in our rocking chairs—that's not happening. We're on the move. We're changing. We're developing. It's not stagnant and it's not just a campaign. This is a movement. It's an international movement.

Linda (The Bay Grandmothers), St. Margarets Bay, NS

5
A Movement Emerges

FACING: Heather (Bay Grandmothers, St. Margarets Bay, NS) at the Atlantic Regional Gathering. Halifax, NS

| 113

Gathering Steam

Never before had older women in Canada seen themselves as a collective force, a separate current of the mainstream with an identity and velocity of its own in quite this way. Like all movements that flash into existence seemingly all at once, the grandmothers' movement had been gathering strength, just below the surface, for some time.

The first Grandmothers' Gathering in Toronto was the flashpoint. In a remarkably short time what had started as a campaign was now a movement of grandmothers springing up all over Canada as the women in dozens of communities coast to coast stepped up into

the role of global citizens. With the financial support coming from the Canadians, African grandmothers were beginning to move their families and communities forward from sheer subsistence to a wider activism. But the Canadian women were also creating their own narrative as agents of change in their communities, savvy fundraisers, and activists who could influence public attitudes in the struggle against the world's most devastating plague.

As organically as the grandmothers' movement had grown, a more sophisticated level of organization swiftly evolved. This new movement was bound to channel itself into several different streams—and there were predictably rocky passages along the way as a national identity as a movement began to emerge.

The Building Blocks of a Movement

Regional bodies served to fuel the creative expansion of the grandmothers' movement. Provinces with higher concentrations of groups were among the first to develop them: ORRG, the Ontario Regional Resource Group, and Greater Van Gogos (from the Greater Vancouver region) brought local groups together to develop resources and offer support for the grandmothers groups working in their regions.

Groups were springing up so fast, and we knew it would be difficult for the Foundation to support them all. The grandmothers groups that were already established had the most to offer these new groups. This was the impetus to create ORRG and from the start we had a strategic plan for what we would do to help the groups evolve and connect. We knew that this was more than a campaign, it was a movement, and that groups had to stay connected to it for 15, maybe 20 years. It wasn't a fast fix.

Then other regional networks began to spring up across Ontario and in other provinces. It's exactly what you want to happen spontaneously.

Penny (Toronto Grannies in Spirit), Toronto, ON

FACING TOP: Grandmothers from Saskatchewan and Manitoba at the Prairie Regional Gathering. *Winnipeg, MB*

FACING BOTTOM: Alberta Regional Gathering. *Edmonton, AB*

Regional gatherings followed shortly after. At these daylong meetings, groups from a particular region come together to exchange ideas, develop relationships, and further their education. As gatherings proliferated, the enthusiastic collaboration and fusion of ideas sparked ever more creative expansion of regional resources.

The first regional gathering I ever went to, part of it was all sorts of groups getting up and saying how they'd raised money. It was brilliant; I couldn't write fast enough to get it all down. There were workshops on how to use Facebook

British Columbia Regional
Gathering. *Vancouver, BC*

and Twitter, and that sharing of expertise was really important. And then the connection, the companionship, meeting grannies from other groups, meeting and hearing from folks from the Stephen Lewis Foundation—all of it helps us to realize that we're part of something much bigger, something extraordinary. Judy (Abbotsford Area Gogos), Abbotsford, BC

I had been hearing about the regional gatherings in other places so I said, "Well, I think we need to get something going here in Alberta." So we connected with Vancouver, and they sent out documents explaining how they had set things up. The group in Red Deer, Alberta, agreed to host because it was central. Our first provincial gathering was a bit rough and ready, but it was a coming together of everybody with the same purpose, that same philosophy and sense of commitment. It was so energizing. We had a discussion at the end saying, "Is this valuable? Should we continue this?" And the resounding response was "Yes!" Vicki (The GANG), Edmonton, AB

Hannah and I created a speaker-training package. We summarized the context of the pandemic with key talking points, and we wrote potential speeches for people—like templates—where they could insert their own stories, or a video from the Foundation. We made PowerPoints, and now I've made a movie. Then Hannah and I applied for a government grant—and wouldn't you know—we got it! So we bought a laptop and projectors that grandmothers could use when they go out and give talks. Janine (Royal City Gogos), New Westminster, BC

In this region, there's a group that Carolyn started for retired teachers who meet specifically about education. There's a fantastic speakers' bureau and there are so many avenues for people to find a place for themselves. If you can dream it, you can do it—and you will find other grandmothers who will do it with you. It feels like magic sometimes. Canadian grandmother (Greater Van Gogos), Vancouver, BC

"It feels like magic sometimes." When women come together with a collective purpose in mind, and step outside their accustomed roles as wives, daughters, mothers, or even, yes, grandmothers, that magic is what happens. It's liberation: an unaccustomed freeing of energies and a lightning connection with comrades-in-arms.

Terra Nova Grannies and Sister Lois Greene
Community Connections

St. John's, NL

Poised on the tip of the island of Newfoundland, the city of St. John's has the distinction of being Canada's most easterly city—any further and the next stop is Ireland. St. John's also has the distinction of being home to the one and only grandmothers group from the province of Newfoundland and Labrador: the Terra Nova Grannies.

We met with members Kay, Sharon, Jennifer, Gwyn, Frankie, Doreen, and Elke and they shared over tea and coffee how they have adapted to work within a campaign that draws its strength from connection despite their relative geographic isolation.

For example, every year the Terra Nova Grannies participate in the Stride to Turn the Tide—a national fundraising event organized by the Canadian grandmothers where groups across the country hold walks in their communities on the same day. Several members of the Terra Nova group also made the trek to their closest regional gathering—for Atlantic provinces—requiring a flight and small time-zone hop.

You know, it's hard for us to feel connected so we've done our own thing in our own way. We participate in national events taking place across the country with other granny groups but we're also connecting with like-minded women's groups in our community.

Terra Nova Grannies (left to right) Doreen, Kay, Gwyn, Jill, and Frankie. *St. John's, NL*

The group spoke in particular about their partnership with the indefatigable Sister Lois Greene from Presentation Convent who ran an annual fundraising dinner for the Terra Nova Grannies. They took us out to meet with her and she spoke about her connection to the Grandmothers Campaign and her experience as an "adopted" granny.

I am very involved in international justice work, and our convent is twinned with Zimbabwe so when I heard about how the grandmothers in Canada were supporting the grandmothers in Africa, it was a good fit for me. I thought, "Well, if they can do something, I can do something." This is my something.

Besides, I'm a grandmother by adoption. My sister died when she was 56 and left two grandchildren. Jake was one of them and he was only two at the time. He pulled me off in a corner and he says, "Lois, I want you to come with me up to my special place." And we went upstairs and he had all of his fire trucks around in a circle on the floor. And he said, "We have to go in there." So he and I go onto the floor in the middle of the fire trucks and he says, "Lois, you know my nanny died but something else happened. I got another one and that was you." And I started to cry, is what I did.

I got to know the Terra Nova Grannies through an event that they were holding at The Lantern [Presentation Convent's Centre for Social Justice and Ecology]. At the end of the evening the grandmothers challenged the crowd to raise funds. I thought, "A fundraising dinner is something we can take on!"

The convent staff came on board and they did a fabulous job! A woman named Loidetta came and practically lived in our kitchen for two or three nights while she taught our cooks how to make her African recipes: black-eyed peas, chicken, rice, and spice cake. And I got the notion that if this is about grand-mothers and grandchildren then this should involve grandchildren, too. So I went to Claire, another one of my adopted grand-children, and asked if she and her friends from the school band would be the entertain-ment. Claire was only 12 but she's good on the saxophone!

This is now an annual event! As soon as it is over people start asking when the next one will be. I really believe this is all about connec-tions, about relationships. There are many problems in life, in the world, and I think you just get on with it and you try to help where it fits. That's how grandmothers work—African, Canadian, and adopted ones like me!

Sister Lois Greene, Presentation Convent. *St. John's, NL*

An Older Women's Movement: Strength in Experience

It must be acknowledged that, first and foremost, the newly emerging grandmothers' movement is a women's movement—addressing the systemic barriers to gender equality with a deep sense of shared sisterhood.

There is something about women mobilizing that has an incredible energy to it—we are not alone. That is what the African grandmothers have been saying, but it's also true for us. We are not alone. Jean (Richmond Gogos), Richmond, BC

I love that grandmothers across Canada, as well as Africa, are being empowered. Having grandmothers groups across Canada is a great way of reminding people that we are not invisible, and it is women that really change the world. Catherine (Grandmothers and Grandothers), Barrie, ON

I think both in Africa and in Canada, sometimes older women have been written off as not important, having no power, and really not being that skilled. Talk about stereotypes! And we are turning that on its head. This is a journey from powerlessness to taking power—for us and the African grandmothers. Canadian grandmother (G4G Regina), Regina, SK

What drives this movement? Love, and a sense of injustice about what is happening—those two things together are very powerful. Marjorie (One World Grannies), Ottawa, ON

Embracing the principles of dignity and respect for women who were marginalized, the unsung heroes of the AIDS pandemic in Africa, was a powerful equalizer, especially among women with their own experience of growing older and being seen less and less as actors in their own right.

The fact that African grandmothers had to hold their families together and then contend with being invisible resonated with Canadian grandmothers, as different as their respective worlds were. It was as if hearing about this injustice gave the Canadian women a kind of permission to express the anger that some already felt about marginalization.

We share the experience of being "one down." We're not in the power position in this world. Having worked in women's health for eons, as a nurse, you do

see the difference in the power structures in our cultures no matter where we live. I think our hearts go out to the African grandmothers because we identify with them. Kathy (Oceanside Grandmothers to Grandmothers), Parksville, BC

The women in this movement have a certain degree of wisdom: we've got experience, we've got skills. But, in so many instances, many of the attempts to exercise personal power have been squelched. In our younger years this tended to happen in our professions. Part of that is the nature of organizations but let's face it, part of that is also the nature of being female. As older women we're fed up with it all. That's why being part of this group is so empowering. For the first time in our lives nobody's told us what to do. Marg (Stonetown Grans), St. Marys, ON

Carole and JoAnne, Grandmothers and Grandothers. *Barrie, ON*

My mother got angrier as she got older, which had to do with how women were treated, and I now find myself getting very angry. But this is not blind rage. This is compassion and anger operating together. Penny (Grannies in Spirit), Toronto, ON

Canadian grandmothers are quick to revel in the fact that the strength of their movement is informed by their age as much as it is their gender. Some identify strongly as lifelong, experienced feminists; others talk about the liberation of being older and no longer needing approval or having to apologize for the depth of their emotional engagement. Many spoke of aging as a time in their life when they felt they were truly coming into their own. Indeed, the wild success of this movement serves as evidence of the collective skill, energy, and vision inherent in this group of women, not despite their age, but because of it.

Some of us were involved in the feminist movement, the civil rights movement, the environmental movement—so many of us from this generation have been learning how do to this type of engagement for 45 years. Jean (Richmond Gogos), Richmond, BC

Because of our age and our experience, we know what we can take on and what we can't take on. We know what our strengths are, and we also know the things that we would rather stick needles in our eyes than do. We know the power of no. That is the beauty of older women organizing. Canadian grandmother (G4G Regina), Regina, SK

There is something about being older and wiser—it's not that we're older and wiser than other people, but we're older and wiser than we were when we were younger. We are not striving anymore and we've learned about what's important and what's not important, so I think there's strength in that and I think it's one that a lot of us share. Marjorie (One World Grannies), Ottawa, ON

I worked in big oil for years. It was such a male-driven atmosphere of performance appraisals and reviews and there was all this fear and tension. Just before retirement it dawned on me: "My God, is this the only way I can measure myself?" Being part of the Campaign gave me a reality check about how worthwhile my time really was and I had the freedom to choose how I would spend it. Gerry (Brookbanks for African Grannies), Toronto, ON

For a number of women in the Campaign, it was not necessary to be a grandmother or relate to "grandmotherhood" in order to feel deeply aligned with this movement.

I'm always telling people that I'm too young to be a grandmother—I'm a "grandother"! But it is deeply meaningful to me to be involved in a movement that is led by older women. It feels like such an honour to be surrounded by such experience, wisdom, and strength. Catherine (Grandmothers and Grandothers), Barrie, ON

For some reason, the term "grandmother" really sort of turned me off. You know, I'm not really there yet and I resisted being put into the stereotype. But while some of us struggle with the term "grandmother," it also feels good because it means that this is our movement. I'm not a granny in my head but I embrace the role of an elder, a feminist. An activist. Penny (Grannies in Spirit), Toronto, ON

Left to right: Ellen (Ujamma Grandmas, *Calgary, AB*), Jean (Abbotsford Area Gogos, *Abbotsford, BC*), and Hannah (Burnaby Gogos, *Burnaby, BC*)

Donna Anthony Fairness and Feminism

Nan Go Grannies, Nanaimo, BC

"SOME OF US are born with a kind of predisposition to be political, I think."

Donna Anthony reflected on her personal connection with the Grandmothers Campaign as we sat enjoying a cup of tea at her dining room table.

I can remember getting into an argument with my father when I was seven. He made a racist comment. He was in the war, right? He fought against the Italians. So he was saying that Italians are dirty people because they kept their pigs in the house. And I was outraged. I remember standing there with my hands on my hips and challenging him: "If you had a war around your house and had to keep your pigs safe you would put them in the house too! You wouldn't want your family to starve!" I was so angry that he was criticizing what people did when they were trying to survive. It just wasn't fair.

So, I think I've always had a big mouth. I've always been political and I've always been a scrapper.

Donna dropped out of high school, married young, had four children, and was divorced by her late twenties, so she knew what it was like to carry a worldly weight from a young age. There were some difficult personal times.

Over the years I've had various jobs, working my way up to supposedly better positions, but the jobs always involved inadequate pay, sexist and often racist attitudes, and no real future. But these were issues many women were experiencing at that time. Finally, dealing with a very aggressively bigoted employer forced me to seek help and I found a therapist who helped me gain the courage to quit, and to go to university where I obtained a master's in historical sociology and later a master's in counselling psychology. That led to a fulfilling career as a feminist counsellor until I retired.

My motto always has been, "Women do what they have to do." I learned that from my adopted mother, who was very strong and very tough.

Donna's fighting spirit, in no small part, helped her find her way forward, but it also caused a few problems—largely because Donna was never content to fight solely for herself.

Once I was disciplined by my union for insubordination when I campaigned for a woman president. Another time I got a write-up on my record for refusing to write a trumped-up complaint about a 23-year-old female colleague because it simply wasn't fair.

It can be seen as a childish term, "fair," but that's why I like it—because it's the term we have before we are schooled, before we have an analysis. That's the word we have when we see inequality, when we see people suffering.

I went on to get a good socialist education, and since the late '70s I have understood myself as a feminist. A feminist analysis looks at how the system works, who it works for, and who it works against. Fairness ultimately drives a lot of feminism as well.

I came from a real working-class environment. I had been a union member, so that sense of working with people instead of doing it for them is just part of my psyche. I resist anything that feels like, "We will save you"— in my bones. I know nobody saves anybody, you only stand with them.

I think that's why the Grandmothers Campaign had me leaping out of my chair,

Donna at the BC Regional
Gathering. *Vancouver, BC*

right from the start. Well, even before the start. I always say I was part of the Campaign before there was a Campaign. I think it was in 2004 when I heard Stephen Lewis speaking when he was UN Special Envoy and I literally was up and pacing: "I have to do something, I have to go to Africa." And you know, you think about that for two seconds and you realize "I'm not that useful in Africa—so what next?"

That was how it all started for me. I contacted the Foundation and I said, "I've got a crazy idea," and the woman I was talking to said, "Oh, we like crazy ideas here." And I told her about my idea for groups of Canadian grandmothers and she said, "We'd like you to call Sandra in Kamloops who has started a group. You're not the first person with this idea." I was shocked.

That's how I knew right away that it was a social movement. It just started springing up—and there was such enthusiasm and energy. Really, I think the movement came before the Campaign—if not a movement then at least a groundswell. A groundswell of older women who saw terrific injustice and said, "We can't stand by and watch this happen. We have to wade in there and see what is really needed and connect with people who are already doing it."

Donna and Jane.
Nanaimo, BC

I went to the Toronto Gathering in 2006 and I saw that the solutions were coming from a collaboration. I have seen with my own eyes that the African grandmothers and African community-based organizations know what needs to be done. They know how to do it and they need some resources and that's where the Grandmothers Campaign can meet them. And then we really started to get going. I started profoundly feeling like, "This is the best thing I've ever done. This is the best thing I've ever tried to do."

I am still excited about it. I haven't lost a bit of that. And it's never just about what you do, it's how you do it. It matters that we are not participating in language or practices that were forged from a history of conversions, colonialism, and capitalism that has pulverized the continent of Africa decade after decade after decade, and that was so clear, that was so immediate.

During the course of our conversation, Jane—Donna's partner for more than three decades and a grandmothers group member herself—had returned home from walking the dog. She joined us at the table, pouring herself a cup of tea. We asked Jane if she had anything to add. After a moment of reflection she answered:

Right from the beginning, Donna saw what this was. Early on she saw the implications, the possibilities. And she helped our own little group when we were coming together in the early days. In many ways, we were all over the charitable giving map and Donna just pulled the line, she made it clear what we were doing and why. She's a modest gal, but she's a visionary. Anyway, she inspired me 30 years ago and she continues to inspire me every day.

Donna indeed channels an electric energy. When she talked about her feminist principles, her hand slapped the tabletop; when she touched on the deeply personal, it often rested on her heart. Now her voice grew soft.

Maybe that's the heart of it for me—the solidarity that says, "If you can actually survive the loss of your child, or children, if you can pull yourself up, take on those grandchildren, if you can somehow go on, if you can do that—well, is there anything I can do so you can go on just a little bit further?"

It's not highfalutin—it's really, really basic.

As we said our goodbyes and got ready to leave we asked Donna if she had any advice for new members when they joined the Campaign. She smiled broadly.

That's easy. Just keep coming back to why you're doing it. It can get exciting, it can get discouraging, but it's not about us. Remember why you are doing this: it's for the African grandmothers and those kids. As they say in unions, "Hold the line."

Just hold the line.

Barb and the "Grand" Kids
of Nelson. *Nelson, BC*

The Evolution of Awareness Raising

As the grandmothers' movement expanded so did the range and scope of their activities. For some, their awareness raising—which was already woven into all of their fundraising events—began to evolve and branch out as part of their larger effort to raise Canadian consciousness about global developments.

Along the way, the grandmothers discovered a new community that was magnetically drawn to the stories of the African grandmothers: children. Children responded with urgency and open hearts.

Work with youngsters rang a bell for grandmothers. It was a natural step to take the awareness raising right into the schools.

Yes, this is about grandmothers to grandmothers, but it's also about a responsibility to children. There is a generation of children that the world is responsible for. How could you not be? That is why you see a growing interest in working with the schools. Hannah (Burnaby Gogos), Burnaby, BC

The AIDS pandemic in Africa has been going on for three decades now, and yet nowhere in the curriculum is it really covered. If a child somehow gets all the way through elementary and high school and into university and nowhere has anyone properly addressed this horrendous thing happening to millions of people, what kind of message does that give? Either that it's not important or we are powerless to do anything, and we don't want our grandchildren's generation to get that message!

Our group has developed a puppet show for children and PowerPoint presentations for older children and youth. We go into a classroom and when we walk out we don't have money in our hands. We hope they might do a class fundraiser, and sometimes they do, but maybe they won't. But we know that we're making a difference to future citizens. It boils down to a kind of faith, that if you do something that is really important and really worthwhile and really comes from the heart, that somewhere, somehow, there will be a little movement towards more dignity, more equality, more justice.
Alison (G4G Saskatoon), Saskatoon, SK

The "Grand" Kids of Nelson

Sharon Henderson, Nelson Grans to Grans, Nelson, BC

I FIRST GOT the idea of including "grand" kids in the Grans to Grans activities when the AfriGrand Caravan passed through Nelson in 2010.* We gathered in a community theatre to hear Gogo Nde and Thandeka share their stories. The presentation was so incredibly moving that most of us were left speechless. But there was a group of young girls in the audience and they were full of questions. One of them became so emotional that she couldn't get her question out through her tears. So when Gogo Nde (who was sitting on the stage) put out her arms, the little girl ran up the stairs and onto her lap. She just cried while Gogo rocked her, rubbed her back and sang. There wasn't a dry eye in the theatre! In fact, I get teary every time I remember that moment and I'm not known for tears.

I came away from the theatre thinking that there were probably lots of kids who would like to help out in whatever way they could. I think they understand the plight of those orphaned children on a deeper and more personal level than we do.

Our first project was to make cookies for our local Christmas craft fair. My nine-year-old grandson was a tireless salesman. He soon had a few other enthusiastic children helping and I suppose that is where it all started.

A number of other eager "grand" kids have joined in. The local nursery donated some trees and we planted and sold them; we've made some mason bee houses, painted some rocks for decorating, created planting boxes for Mother's Day—the kids are getting so confident. They get to run power tools. They learned how to mix concrete. They *love* joining the grandmother events. They served tea at our last event and everyone was thrilled.

Many of these kids don't have their grandparents nearby, they may be hundreds or thousands of miles away. Their parents keep telling me I am the closest thing they have to a grandmother, so I guess I am taking on that role. It is just so rewarding to work with these children and it feels like such an important extension of our work as grandmothers.

* A nine-week long road trip organized by the Stephen Lewis Foundation in 2010. African grandmothers and granddaughters from South Africa, Malawi, and Swaziland travelled the length of Canada beginning in St. John's, Newfoundland and Labrador, and ending in Victoria, British Columbia, visiting 42 communities along the way.

From Awareness to Advocacy

As grandmothers continued to raise funds in innovative ways, always linking their monetary goals with awareness raising, another current bubbled up. Among the women participating in the Grandmothers to Grandmothers Campaign, many were seasoned activists—often veterans of political action or the feminist movement—who found deep alignment there with its grassroots model and social justice foundation. Before long, a number of these women from different groups across the country found they had a common interest in advocacy and began to work together. They called themselves the National Advocacy Committee (NAC), and theirs was a vision of the power of older women, united across Canada, stepping into their rightful leadership roles as political activists and change agents.

The beauty of our groups is they can do any part of what they're comfortable doing and what they have the skills to do. So if you got a whole bunch of retired teachers and principals, you're gonna be doing a lot of education outreach, great. Our particular group has a lot of people with advocacy experience. Peggy (One World Grannies), Ottawa, ON

They researched the issues and identified several areas ripe for national advocacy in Canada on behalf of the African grandmothers, including education and access to medication. NAC kept Canadian grandmothers groups informed about the various opportunities for activities and actions and even developed educational material and resources for the grandmothers to use, such as information on how bills are passed into law or templates for petitions.

Grandmothers across the Campaign, many of whom had never before participated in advocacy, rallied together under NAC's banner, signing petitions, writing letters, meeting with their local MPs, attending parliamentary sessions—in short, applying enormous pressure on policymakers and earning respect as intrepid advocates in the process.

When we first showed up as a presence on Parliament Hill the MPs used to laugh and say, "Oh, the grannies are coming." It was kinda nasty. They don't laugh anymore. They say, "Holy s***, the grannies are coming!" This is a really wonderful part of our advocacy story. Peggy (One World Grannies), Ottawa, ON

For many, this was deeply empowering work. As they lobbied for the passing of the Canada's Access to Medicines Regime (CAMR), a bill to enable the sale of generic AIDS drugs to Africa, they were a formidable team. Their most ferocious opponent was MP Tony Clement, whose Conservative government unfortunately prevailed in stalling the bill to oblivion.

There were highs and lows for grandmothers involved with advocacy, but these extremes served to strengthen the identity of a national movement that was emerging from the Grandmothers to Grandmothers Campaign, along with their growing sense of the much-needed place of the elder stateswoman.

The various successes of our work on CAMR, the different moments when it got through another layer of government were such a high for all of us. But the ultimate defeat of the bill knocked all of us sideways. I was choked up—I thought, "This is another example of why women should be leading the world." Most of us were new to advocacy, but I could see the possibility now of the power of older women as leaders. Claire (Quinte Grannies for Africa), Belleville, ON

The powerful presence of NAC expanded and rippled throughout the Grandmothers Campaign, and for some this was unifying, while for others it was destabilizing. They worried about mission drift: NAC's own campaigns were often time-sensitive and urgent, and they required energy, resources, and funds. The overwhelming aim of the Canadian grandmothers had to that point been to support the African grandmothers: to enable the women directly affected by the issues to identify those most urgent for them, to speak for themselves, and to advocate in their own communities.

A division was undeniable: some felt that advocacy was complementary to the fundraising—not only could they could do both, but also, activism desperately needed the presence of older, informed women. Others felt that advocacy was, at best, threatening to eclipse the work of fundraising and at worst, siphoning off Campaign resources, diverting energy from raising funds desperately needed by African grandmothers. More difficult to articulate was the fact that not every woman wanted to participate in advocacy and yet some found it exceedingly difficult to say no to another impassioned grandmother. As one grandmother, who wished to remain anonymous, put it:

The very spirit of this movement is that all grandmothers are equal and have a right to choose our avenue of participation and we really do respect each other. So what do you do when you are at an impasse? When there is this fierce, well-intentioned energy, but you feel more like you are being intensely pressured or "less than" if you don't get on board? We didn't have the energy for in-fighting. It was discouraging. The power of "no" as a collective is so life-giving, but the power of "no" among the collective can really be life-draining. It was a difficult moment for our movement.

Ultimately, the role and place of NAC within the Grandmothers Campaign was decided not by the grandmothers, but by the strict government controls placed on Canadian foundations around political advocacy. Under the government of the day, foundations that dabbled in political advocacy were on shaky ground. Even though NAC's advocacy actions were not part of the Campaign per se, the grandmothers groups undertaking the actions were part of the Campaign—and that was a threat to the Stephen Lewis Foundation's charitable status.

To safeguard the Foundation and to give full rein to those grand-mothers whose passion tilted toward greater and greater advocacy, NAC was lifted up and out of the Grandmothers to Grandmothers Campaign. In 2011, the Grandmothers Advocacy Network (GRAN) was born out of NAC as an autonomous organization. While GRAN operates as a completely separate group, with its own mission and mandate, many of its members remain active in the Grandmothers Campaign to this day, and grandmothers groups, in turn, decide their level of participation and affiliation with GRAN.

In our group, it's a synergy. We're the Capital Grannies and we do fundraising for the African grandmothers through the SLF and we do petitions for the African grandmothers through GRAN, and that's who we are. And I think for me, my fundraising capacity has actually been enhanced by the advocacy, which has really sort of nurtured my particular interest. Pat (Capital Grannies), Ottawa, ON

For many of us, we're still the same people. Sometimes we have the advocacy hat on with GRAN, other times the Grandmothers Campaign hat is on. The way I see it, we are separate but we are together on the issues. At first, I was very worried about the separation but it's been good for us [GRAN]. We've gotten bigger and bigger since that day, and you know, we're doing pretty good at figuring out what we need to do, and we can stand on our own. Linda (Grands 'n' More Winnipeg), Winnipeg, MB

As the birthing pangs of this new movement abated, the grandmothers emerged as a collective that was stronger, more confident, and more focused than ever. These were, after all, women with the long view firmly in their sights.

This can be a messy business sometimes. You have this group of really smart, capable women who want to hit the ground running. That's the good news, but that can also be the bad news sometimes. There are no shrinking violets: everybody's got ideas, and everybody can do things, and everybody can organize, and everybody can keep it all rolling in a lot of different ways. And the more we collaborate the more opinions we have. We care about getting it right, though. It's worth the struggle. We always come through it stronger and more aligned. Judy (Abbotsford Area Gogos), Abbotsford, BC

I often think of it as building an airplane in mid-flight. We're making it up as we go along. We try and we experiment and we take risks. We're often more successful than we could have dreamed, and when we are not… we learn from it. Janine (Royal City Gogos), New Westminster, BC

We change, grow, try new things, and evolve as we need but we always keep our end goal in sight: to educate ourselves and others around us and to raise as much money as we possibly can to support the grandmothers on the ground in Africa. Well that, and to change the world. Canadian grandmother (G4G Regina), Regina, SK

International Women's Day March. *Holeta, Ethiopia (with Kulich Youth Reproductive Health & Development Org, KYRHDO)*

The great thing about the Grandmothers Campaign
is that when things get difficult or when people get
upset with each other, you know, we can say to each
other, "Look, remember, it's not about us. This is about
the African grandmothers," and this is what keeps us
centered. Hannah (Burnaby Gogos), Burnaby, BC

6
The Centrality of Relationship

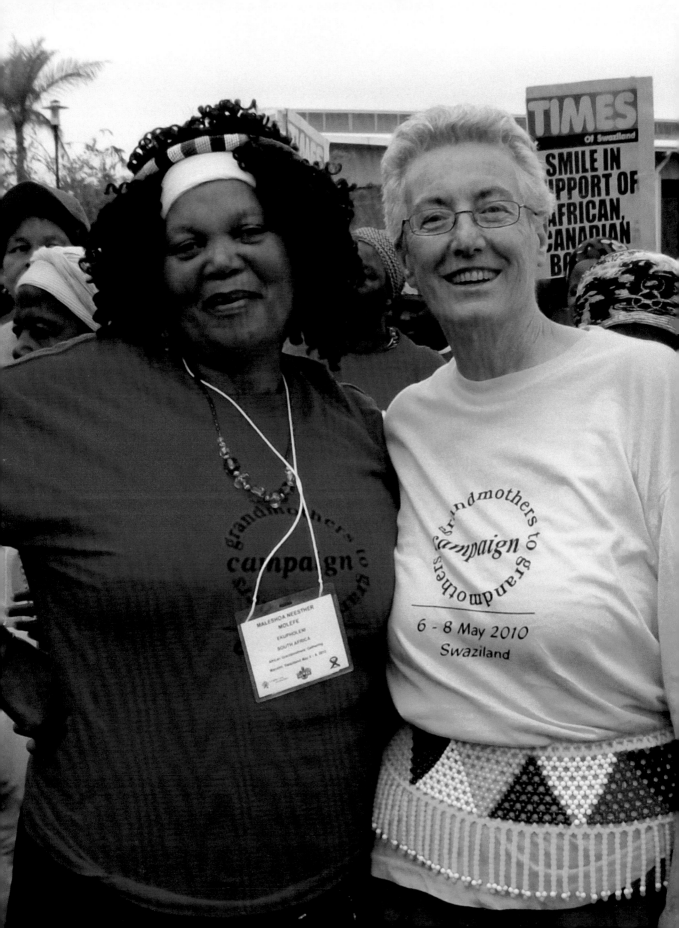

A Grandmothers' Movement: Powered by Love

At the centre of the grandmothers' movement is the identity of "grandmother" and what that means. Being a grandmother means more than just being a woman, or a woman of a certain age—it is an identity that is created by relationship, an identity that places love at the centre of its being.

Grandmothers were not reticent to talk about love: for their grandchildren, for each other and of course, for the African grandmothers. These interwoven layers of relationships provided the passion, fuel and direction that drives their movement ever forward.

Grandchildren: The Spark of Connection

For many Canadian grandmothers, their own grandchildren were a source of deep connection to the Campaign. They are deeply committed to investing in their grandchildren and in the future world they will inherit.

When my first grandchild was born I thought, "I am going to make this a better world for her." And I have had that thought with all my grandchildren. I want them to inherit a better and different world. And my grandchildren are young but they know about the grandmothers in Africa. They know why we do it. Actually, that is a huge part of the motivation for me too. I want my grandchildren to know that they are citizens of the world and have a responsibility to make it a more just world for everybody. Linda (Grands 'n' More Winnipeg), Winnipeg, MB

When I became a grandmother I tapped into this well of joy, but there was also this new anger. I feel no small amount of rage at the injustice that some children should have so much and others so little. So that also drives me forward. Janine (Royal City Gogos), New Westminster, BC

My grandkids keep me really focused on this because I want my grandkids to grow up in a world of balance. We do that the same way the African grandmothers do—we contribute to building the world we want. We don't stop, because the stakes are too high. Judy (Abbotsford Area Gogos), Abbotsford, BC

For the women of the Grandmothers Campaign the shared love of their grandchildren was their place of most immediate and intimate connection with the African grandmothers. Many spoke about trying to imagine what it would be like to lose all of their adult children to AIDS, and then pick up the next day and care for grandchildren. And they expressed a visceral understanding that the African women were drawing their almost supernatural strength from the reservoir of love that grandmotherhood inspires and evokes.

You want so desperately for your grandchildren to have a good life and grow up happy and well. The African grandmothers spoke of the same desire for their grandchildren. You feel that with your kids of course, but you've got it even

more with your grandchildren because you see it going off in the distance and you know you won't be around to help them. Gillian (Glacier Grannies), Comox, BC

Being a grandmother is not about how we can have fun with our grandchildren and get to send them home when they start being trouble. It's that you are in a unique time of life when you know what's important and you have the time to actually just be with these children, and see them evolve, learn from them, and teach them things. And some day I won't be around for them anymore, but we will have this. And this is not something many of our African sisters get to have. Linda (Grands 'n' More Winnipeg), Winnipeg, MB

I met a South African grandmother who said to me, "I'd like to be a grandmother, not a parent. But I don't have the option." That will stay with me forever. Pat (G4G Shellbrook), Shellbrook, SK

We are not claiming to understand what the African grandmothers must feel like—we can't. Of course we can't fully experience what it means. But I think it is that concept of the power and strength of grandmothers—this resonates. Vicki (The GANG), Edmonton, AB

Maureen with grandchild, Omas
Siskona of KW, *Kitchener-Waterloo, ON*

Canadian Grandmothers:
An Unexpected Network of Support

When we asked Canadian grandmothers what drew them to the work of the Campaign, their response was always the same: the African grand-mothers and the children in their care. But something else was happening. They were becoming a support system to each other as well.

Grandmothers groups in Canada, like the ones in Africa, offered not only the resources of a group when it came to problem solving but also a space for discussing the challenges of life—especially those affecting older women, which seemed somehow missing from public consciousness. As they extended their networks wider, their astonishing relationships with one another flourished.

Jean and Marion, Omas Siskona
of KW. *Kitchener-Waterloo,* ON

I may not know every member of our group inside and out, but I am sure of what I know of them: I know they are trustworthy, I know they are fantastic people. And if I needed help, if the chips were down, where else would I go but to a grandmother? Carol Anne (G'Ma Circle of Summerside), Summerside, PE

We can pick up the phone, we can talk, we can go visit each other. I can travel across this country and I never have to stay in a hotel, I just stay with women involved in the movement. You know, it's such an amazing feeling, when I meet a grandmother, it's instantaneous, we're kindred spirits, because we want to make a difference and we believe that social justice is the way to achieve that. We're all interwoven across the country and across the ocean. Linda (The Bay Grandmothers), St. Margarets Bay, NS

I'm inspired by the presence of the Canadian women and the feeling of being part of a community that stretches across the country. And now there are groups in other parts of the world and that network of women is deeply meaningful to me, it strengthens me, it propels me forward in this work. Joanne (Grannies for Good), Montreal, QC

I've learned so much and I love it, but the best thing is the other women. The research is really clear—when you get older, you lose friends. People die, you leave the workplace, you know, your network shrinks. My network has grown five times, 10 times, because of the Grandmothers Campaign, and that's very special at our age. Peggy (One World Grannies), Ottawa, ON

When Sally's brother died we had to go to the other side of the country, to Halifax, Nova Scotia. The grandmothers groups were holding their Stride to Turn the Tide national walks across the country that weekend so we said, "Let's see if there's a walk," and sure enough, there was, so we joined the Halifax walk.

When the grandmothers found out why we were there, they just took care of us. They gave us a spare room and took us out to Peggy's Cove for sightseeing. We were there for two weeks, right in the middle of a crisis, in the middle of a place where we don't know anybody, and suddenly, we have this whole network. That is incredibly powerful. There are women across this country and we're all doing the same thing, we're all focused on the same thing. And to me that's just been one of the most meaningful things. Sally and Tina (Merville Grand Mothers), Merville, BC

"Moyo" Means Togetherness

Penny, Grannies in Spirit, Toronto, ON

I WAS SUPPOSED to go on the SLF trip to Swaziland with other Canadian grandmothers but then I found out from my oncologist that I was no longer in remission so I couldn't go. I was really sad. I gave Helen, another grandmother who was going, a little rock that had "moyo" written on it, which means "togetherness" in Swahili.

About a month after the trip I received a book from the grandmothers who went. They had taken pictures of themselves with the rock every place they went and they wrote in the book. Grandmothers from across Canada—even those who didn't know me—wrote beautiful things about me. So that's the sweetness of a granny movement. And I don't mean cute, I mean preciousness, I mean tenderness. It's a tenderness that women have between each other and among each other. No granny left behind!

So in a way, I did go to Swaziland— I was a little rock. I still have the rock and the book. They are among my most treasured possessions.

Penny, Grannies in Spirit.
Toronto Island, ON

"She Would Be Proud": In Memoriam

Canadian grandmothers were invited to nominate anyone they felt should be included in this book. Beautiful letters flowed into the Stephen Lewis Foundation and perhaps the most touching nominations were those for group members who had passed. Here was a poignant reminder of how deeply intertwined the lives of the Canadian grandmothers had become, how much they now carried one another within themselves.

Eleanor Wright
Supporting African Grandmothers Efforts (SAGE), Mahone Bay, NS

Eleanor was one of the founding members of our group. She died in 2011 from cancer.

I remember the first time she talked to me about her illness. We used to go together to the regional meetings in Halifax and on one of these trips she told me that she had to go to the hospital, where they were going to take a little piece out of her lung. But she said it was nothing. Then, instead of just a little piece, they took out one lung. And she went through chemo. But she kept working and came to the meetings and was involved right up to the very, very end. Even when I visited her in the hospital in Bridgewater, she still wanted to know about the group and what we were doing.

Without Eleanor, the group would not have started and after she died I wondered how we'd keep this going. Jane, from The Bay Grandmothers, came out to that first meeting after we lost Eleanor. She told us we'll be OK—and we are. You lose somebody and think you won't be able to manage, and suddenly others jump in and we can go on. It's a good group. Eleanor would be proud.

Ime, Angela and Margie, Supporting African Grandmothers Efforts (SAGE), Mahone Bay, NS

Janet Stuart
Oceanside Grandmothers to Grandmothers, Parksville, BC

Jan is our heroine in the group. She was our poster girl.

I can still remember her at one of the first fundraisers right at the very beginning. She could barely walk, her back was so bad, but she was there.

She was determined. This was the woman who went to the general manager at Walmart, or Thrifty Foods, or Safeway down in Duncan, and who would go up to them and say, "I have a product that I would like to sell. Would you put my card table up outside your store?" They never denied her once. Jan was not to be denied, let me tell you. She charmed them. It wasn't just the angels she made and was selling, it was the idea that she's out there working on behalf of the African grandmothers and their grandchildren and, by gosh, you've got to listen.

She was an inspiration and guiding presence to the women in our group. We might be having all sorts of discussions—should we go this or that way?—and then all of a sudden she would stand up. And she'd have to move to the front because you couldn't see her otherwise and she would tell us a story that would remind us in a very sensible, very honourable way, of what this was all about and the kind of difference that we could make.

And the thing that I'm dying to say here is that she mothered us. I can still see her at my front door, and she'd come in and say, "Hi, dearie!" Or on the phone, "Hi, dearie!" And I knew immediately it was Jan. You know what I mean? She nurtured us, she mothered us.

She didn't have much in the way of family support when she was sick so we kind of became family for her. I remember dashing her a few times to Vancouver because she needed help. We shared her pain, we did. It felt good to be family for her, to be able to mother her back when it really mattered.

Kathy and Carol, Oceanside Grandmothers to Grandmothers, Parksville, BC

Kate Bryant
Capital Grannies, Ottawa, ON

Kate attended the Toronto Gathering in 2006 and came back to Ottawa inspired and determined to make a difference in the lives of the African grandmothers. She was instrumental in starting the Capital Grannies and then

steering it as co-chair. Kate's commitment was tireless and she was wonderful at forging relationships with people. Her energy, inspiration, and enthusiasm were essential in defining the group.

Kate was always so full of life, sparkling blue eyes and a big smile, and it was such shocking news to learn that she was sick. We heard she had a brain tumour and they were going to operate. It was so sudden. Throughout all of it, Kate was remarkable. As she did chemotherapy and radiation she just coped with it. She had only one daughter in town so our group stepped in to help. We had a roster going with Kate's appointments on the calendar, and we drove her to appointments so that one of us would always be with her. Group members made things like soup or cookies, and still others stayed overnight with her when she came out of the hospital because she was really sick. As a group, we really came together in a way we had not before. We recently came across an old email from Kate to Jenny that said, "Chemo was much more fun with you. 'Cause we bought trashy magazines and we laughed a lot."

When Kate passed, we drummed for her funeral. It was Kate's idea, of course. Our group is known for drumming, and it was Kate who originally got us involved in that. It feels awesome when we drum; we feel more connected to each other and Kate was always keeping us connected. So we drummed. We were there, with Kate's family, children running around—it was a celebration.

It is difficult to put into words how much Kate meant to all of us. We loved her for herself, for her concern for others, for her passion for social justice, and for her generosity of spirit. We admired her for her directness and impatience with pretence and red tape, for her ability to build community, and for the courage and grace with which she faced her illness. We will always remember her vitality—she was our "ball of fire." The loss of Kate has been immense, but it is her spirit that has carried us forward. Jennie and Joyce, Capital Grannies, Ottawa, ON

Kate drumming with her group
The Capital Grannies. *Ottawa, ON*

African Grandmothers: The Centre That Holds

The deepening relationships that the Canadian grandmothers were experiencing with each other as their Campaign expanded into a movement could have eclipsed the more distant and slightly more intangible nature of their relationship with the African grandmothers, but the Canadian grandmothers seemed to know intuitively how to keep their focus and purpose clear. Their relationships with their African sisters were the beating heart of their movement and guided the trajectory of the Campaign in all its forward momentum.

But how to reinforce this deep and foundational relationship? Because the grandmothers were not pen-palling, sponsoring groups or visiting projects on their own as donors or volunteers, they would have to find another way.

Around 2008, the Stephen Lewis Foundation began working with community-based organizations to plan visits that would bring Canadian and African grandmothers together. Once again, African organizations took the lead on decisions around when, where, and how the visits would take place with a special emphasis on how they could compliment and not tax the ongoing work in the community. These trips continue today.

Over the years, Canadian grandmothers travelled to Ethiopia, Rwanda, Uganda, South Africa, Swaziland, and Zambia to visit community-based organizations that are implementing grandmother programs and to hear directly from the African grandmothers about their evolving needs and the realities of their lives.

What they saw was invigorating. Through the sustained funding provided by the Grandmothers Campaign, African grandmothers were extraordinarily busy—their work in their groups was as frenetic, evolving, and increasingly sophisticated as that of their Canadian sisters. The gogos were moving from securing their most basic needs to educating themselves, taking on leadership roles in the community, and starting their own programs for orphan care. The trips provided powerful insights into the work being undertaken with African grandmothers, into what holistic programming actually entailed, and the challenges the women still faced.

Raswork (with NLK) and Marg (with
Grandmothers and Friends for Africa,
Guelph, ON) in Addis Ababa, Ethiopia

Most importantly, it allowed the grandmothers from Africa and Canada (and eventually the UK and Australia) time enough to build and strengthen their relationships with each other.

We were in Johannesburg and one of the projects I visited was Tateni Community Care Service. They showed us the gardens where they grow vegetables and offer grandmothers a course in how to make nutritious food. Then we went to the church hall and there was a whole group of grandmothers gathered there to meet us. We had lunch and I visited with a grandmother who was the leader of her grandmothers group. She had been a teacher. She'd lost

Jill (Terra Nova Grannies, *St. John's, NL*) and Irene (with Nyaka AIDS Foundation) at the Ugandan Grandmothers' Gathering. *Entebbe, Uganda*

children and was taking care of her granddaughter. It felt like a nice, normal talk until it was one o'clock and they had to leave because their grandchildren were coming home. For some reason, that's when it all hit home for me. We were surrounded by the women I had always known as the unsung heroes of Africa. These women didn't have all the time in the world; they had to go home for their grandchildren. It made me think, "This is why we are here, why we were listening to what they have to tell us." Ime (SAGE), Mahone Bay, NS

I went to one of the projects outside Johannesburg. One of the grandmothers who took me aside had a little piece of paper that she showed me and she told me that her home had been broken into two days before, that she had gone to the police and this was the policeman's writing on the piece of paper and he was coming to her house to check up on it. I was saying, "That's really good, I'm glad they're following up." I didn't realize the significance of what she was telling me until we got back to the group and the other grandmothers said, "This is amazing progress! In the past they couldn't report it because they were further traumatized by the police or they're brutalized." There were many moments like that where I realized there were so many more layers of understanding, so much more to learn. Linda (The Bay Grandmothers), St. Margarets Bay, NS

The grassroots project that I visited was ROCS, which was in Sophiatown. We came away from there and could hardly talk. It was a crisis-counselling centre for women who were victims of war, rape, and violence, and these grandmothers, they weren't singing and dancing. It was a serious place. It was a real eye-opener for me—this really was the front lines. Louise (The GANG), Edmonton, AB

More commonly, the Stephen Lewis Foundation organizes opportunities for the African grandmothers to meet with Canadian grandmothers in Canada. Over the years, African grandmothers have attended group meetings and regional gatherings, marched in national walks, and travelled on the AfriGrand Caravan. They have returned to their own groups with stories of connection and support. They, too, feel like they are a part of a larger movement and connected in palpable and ongoing ways to the Canadian grandmothers.

I never imagined that there were all these homes of love waiting for me. We had heard of the Canadian grandmothers but we didn't understand that these are not just donors—these are grandmothers coming together in groups, like us. They are working so hard and raising money, doing all sorts of crazy things. I never heard of a grandmother cycling before and I said, "Oh! My grannies at home are going to be surprised." So I heard of the Canadian grannies before, but now I can say I understand them. Or, it's better to say now I love them. And I know that they love me. Rosemary (Counsel Homes), Malawi

I travelled on the [AfriGrand] Caravan and visited all these communities across Canada. I learned so many things, but what has stayed with me over these years is the hope. When you meet the likes of people I met, who were so welcoming, so loving, so accommodating, willing to really listen to us and raise funds for our work, well, that brings me hope.

It gave me hope for humankind, if I could say that. Regina Mokgokong (Tateni), South Africa

Never in my wildest dreams could I have imagined how many grandmothers groups there are—all with different names, doing all sorts of different projects—it was just amazing! When I get home I will give a big presentation about my trip to Canada. I will tell them about all the thousands of grandmothers and you know, there were even some grandpas who were helping out. I will tell the grandfathers in our community, "You need to be a part of what we are doing!" I feel inspired, energized, and I know this news will unite our community. Eunice Mangwane, Manager, Keiskamma Trust, South Africa

The Canadian grandmothers, too, insist that the encounters that have allowed for the greatest kindling of intimacy took place during these visits to Canada.

I think it is important that we have opportunities for some to go to Africa, but it is so much better when the African grandmothers come here. It is so nice to be able to welcome them as our guests and have time together. There are opportunities for us to really learn from them and get to know one another. Penny (Grannies in Spirit), Toronto, ON

Rosemary was the grandmother from Malawi on the AfriGrand Caravan. And I was lucky enough that she stayed with us. It was October and it was so busy in the house that we snuck outside and sat in the garden with blankets so we could visit. We chatted for maybe two hours, and we had so many things in common. It was like talking to my next-door neighbour. She said something to me that I will never forget. She said, "We do not waste time asking, 'Why did this happen to us?' There is no point. 'Why' only keeps you standing still. But we need to say, 'What next?' That will help us to take the next step." I've used that advice many times in my life. Jenny (G4G Saskatoon,) Saskatoon, SK

Ellen from Ujamaa Grandmas (*Calgary, AB*)
and Mariam from PEFO (*Jinja, Uganda*) at
Alberta Regional Gathering

Reciprocity, Solidarity, and Transformation

Canadian grandmothers share an intense desire for the African grand-mothers to understand how they truly feel about them, to know that these are not one-sided relationships between donors and beneficiaries but relationships based on reciprocity and mutual accountability, and how their lives have been forever shaped by these relationships.

It's been such a symbiotic situation, you know? I always think for every little thing I do, I get back tenfold. Linda (The Bay Grandmothers), St. Margarets Bay, NS

Meeting Regina and Nukuli on the AfriGrand Caravan, that affected me. I'm reminded that there are really terrible things in this world, but there are some fantastic people who are actually doing something, and thankfully I can be a part of supporting their work. I find that I am not as negative, not as quick to complain. You know when you recover from an illness and then you are not the same person again? Well, it's like that. They are healing something for me. Carol Anne (G'Ma Circle of Summerside), Summerside, PE

I met Esther and Alena in Swaziland. And I tell people that, everywhere I go now, those two ladies are beside me. And I see things through their eyes so I see things very differently than I used to. It just brought into clearer focus the things that really matter. Suzanne (North Bay Grandmothers for Africa), North Bay, ON

I'll always remember the grandmother who hugged me when I left Swaziland, tears streaming down her face. She thanked me so much for coming and asked me not to forget her. I'll never forget her face. You know, we may not be paid a salary and we may not have a performance appraisal at the end of the year, but the grannies give us one, right? That's our performance appraisal. Adele (Grandmothers by the Lake), Verona, ON

Jean Way "This Will Not Be in Vain"

Richmond Gogos, Richmond, BC

OVER THE course of almost a decade with the Grandmothers Campaign, Jean has been a passionate member and leader, filling such roles as group founder, group chair, Swaziland Grandmother Delegate, and regional co-chair for the Greater Van Gogos to name a few. We visited Jean at her home in Richmond, BC, to learn how her journey had changed over the years.

Throughout most of the interview, Jean sat curled up on her sofa studying a large table which stood at end of the room, clearly the heart of the house, covered as it was in framed family photos of her three children, eight grandchildren, and sixteen great-grandchildren.

When Jean reflected on what led her to the Campaign, she turned first to her son Ted.

When I found out I was going to be interviewed, the first thing that I started thinking about was Ted. I thought about him for days. Ted died of AIDS. He was my stepson but through his struggle with AIDS, I became his mom. He's been gone for almost 25 years now, but I think that is the root for me.

His diagnosis was in the late '80s. It was 15 months from his diagnosis to his death. Ted's prognosis was severe, prolonged wasting. It was so hard. For the last six months I stopped working. I just couldn't cope with work, and I wanted just some time to be with him and to help out. I got so close to him, closer than I ever was, and then he died. I remember thinking, "This will not be in vain."

Almost immediately following Ted's death, Jean would suffer another blow: the death of Ted's beloved partner, Don.

Reeling from these losses and driven by an almost defiant desire to fashion something meaningful from them, Jean became involved in a number of volunteer activities. She provided hospice care to sick children and supported bereaved parents—she employed her hands, her heart, and her ability to listen. But privately she experienced acute anguish over what seemed to be the loss of her voice.

I remember being at a party and there was a school principal there who made just a horrible comment about homosexuals. And Ted had just died and I couldn't speak. And it happened again in several different instances and I can't really describe how awful it felt to be silent and not be able to defend him.

When I heard of how the African grandmothers watched their kids die of AIDS, I thought, "I know what that's like." And I know what stigma feels like. My son was a gay man who died of AIDS; there were not many safe spaces where I could talk about that. I could understand why there was such a powerful need for support groups for these grandmothers, a place to break the silence.

After a long moment of reflection, Jean described the strength she would discover for herself in communion with the African grandmothers.

That is one of the things that the Foundation has done, to create times where we can meet each other—and the impact of these connections: it's huge. These visits are really essential.

I had the chance to go to the Swaziland Gathering and I attended a workshop about women and violence. I couldn't believe how bravely these women got up to tell their stories, many for the first time. I always remember a woman named Della. She had suffered an awful lot of abuse and she just stood up and told the women, "Cough it out, just cough it out!" Those words have really stuck with me.

They guided me through my own grief, but there was something larger there, too, just something so important about all women being able to tell their truth. That's what Della was saying to me: "Tell your stories, what has happened to you, cough it out, do not hold on to it."

Along the way, Jean has also reclaimed her own voice.

I was never comfortable with public speaking but now it has changed. When I give presentations and I talk about the African grandmothers, they are not a continent away, they are right here with me. I can even speak about AIDS as a parent who has lost a child. It's easy to talk now—it comes from a different place. Ted is still there in the centre of it all, but the work I am doing is not about death. It's bigger than that now.

At the time of our visit, Jean was grappling with the recent and devastating loss of her husband, Ron.

With Ron's death, the grief has been so intense and physical, it is like a monster. To lose someone that you've been with for 45 years—well, I've discovered that there is such a thing as broken heart syndrome.

I realized that right now I needed to step back from all my activities and take a bit more solitude. I needed more quiet time and maybe that is part of what the Campaign provides as well. It gives us that wonderful energy, that passion, but there is room for stepping back when needed.

Even in this moment of solitude, though, it was clear that Jean was not alone. She spoke of the African grandmothers returning as guides through the darkest paths of this new grief. She spoke of her deepening and precious relationships with the Canadian grandmothers.

I don't feel like one person anymore, I feel like part of a movement. I have a voice, we have a voice together. I feel like my heart is connected to women—across this country, across Africa.

I'm in a new phase of life now. I am not sure what that means for me exactly but I know I want to stay involved with the Campaign. After 10 years I still feel so much passion for this—for our purpose, for our voice, for our work. I don't know what the future will hold, but I know I am going to be a part of it.

Susan and Jean at the African Grandmothers' Gathering. *Manzini, Swaziland*

We don't have to go and ask from other people—
we do things for ourselves. We can produce food
for ourselves, we can sew clothes for ourselves.
We are very proud of being grannies. When a
person says that gogos are too old to learn new
things we say, "You are behind the times."

South African grandmother (HACT), South Africa

7
African Grandmothers on the Move

FACING: Philister. *Kogelo, Kenya (with PENAF)*

Grandmothers at Work

As the Canadian grandmothers were branching out and growing the movement, the African gogos across the ocean were flourishing in unexpected and variegated ways and transforming their communities in the process. Their support groups continued to provide a space where women could find their voices and share their grief, challenges, and joys, but they were also figuring out how to address the most urgent needs of the children in their care: for food, housing, and income security; for access to school, health care, and protection from violence. The grandmothers' programs quickly became multi-dimensional, with tendrils growing into every corner of their lives.

The idea of bringing grannies together in support groups—that came from our organization in 2006—but they decide what they want to do. Very quickly it came from the grannies that they also wanted to do income-generation projects, because they need money to help their grandchildren. They mentioned gardens, they mentioned sewing and tailoring, beadwork, things like that. Then, from there, I realized that it was going to be a huge project. Staff Member, HACT, South Africa

Robina Ssentongo, executive director,
Kitovu Mobile, with Afisa. *Masaka, Uganda*

Gogo Irene First, Off To School
Mavambo Trust, Zimbabwe

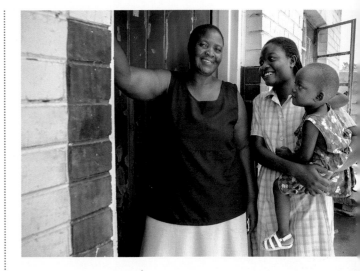

MY GRANDDAUGHTER Francesca was eight and she wanted to go to school, but I didn't have her birth certificate or legal papers and without them I could not enroll her in public school. It was paining me so much to see this child growing up so smart but not in school. Then I went to Mavambo because I heard they started a school for orphans who did not have birth certificates. They told me, "Francesca can start tomorrow." I was so excited I ran home and started shouting to Francesca, "Go scrub yourself—you are a school girl now!" And we were dancing in the house.

At Mavambo they were also starting a group for grandmothers so that we could come together and discuss our problems and get support and training for our grandchildren. So Francesca started at Mavambo's school, the young one went to their daycare, and I now had the time to attend this group.

We learned how to get birth certificates so all my grandchildren could attend public school. I learned how to garden. I didn't have space to plant, so they taught me about sack gardens. I used buckets and sacks and planted so many things. The first day the vegetables were ready, I cooked so much, we ate and ate and it was the first time the grandchildren said, "Gogo, I can't finish." That day I knew my life was transforming. The grandchildren started growing and I started to gain weight and look beautiful again.

I started selling extra vegetables at a table outside my house and could afford to buy clothes for the children and all of the other things they need. We grannies learned dressmaking for income, and patchworking, so even scraps of clothing would not go to waste—they can become blankets for the children. Now we grandmothers have started saving together and using the revolving loans for bigger projects. With my loans I go to second-hand markets and buy clothes that I sell here or trade for maize in the rural areas.

Irene with granddaughters Francesca (16) and Ropofadzo (3). *Harare, Zimbabwe (with Mavambo Trust)*

165

The early grandmother support programs evolved rapidly, becoming ever more sophisticated and integrated. The momentum came from the grandmothers themselves. Never content with handouts, they wanted sustainability and control. The idea that so many other grandmothers were still on their own and suffering was intolerable, so they wanted to extend their reach. Lack of information around HIV & AIDS was killing their families, so they wanted training. The moment an immediate need was met, the grandmothers were figuring how they could improve what they were doing—they kept pushing at the boundaries of what was possible.

In one of the support groups, the grannies realized that three of their members were staying in mud houses that they had to rebuild every year because they fell down when the rains came. So the grannies started saving some money and they built three houses for those grannies—on top of all their other activities. This is development for the whole community, really. Cwengi Myeni, granny groups manager, RN (HACT), South Africa

Kitovu Mobile helped us get health care for us and our grandchildren but also we have learned about sanitation, farming, poultry, and animals. I took first aid training and now I can give others first aid in my community and help with home visits to the sick. We grannies can help others and we know we are important in this world. Now we are alive. Now we are alive. Ugandan grandmother (Kitovu Mobile), Uganda

Over time, the experience and focus of the grandmothers groups was shifting, from healing to expansion—the expansion of activities and programs and, ultimately, of identity.

We share the work; when everything is done, we sing, we pray, then we have our food from our garden, and then we do our income-generation activities— sewing uniforms and sanitary napkins for the girls, making cleaning products and jewellery. We have started doing all of these things, but at the same time we share our problems. Sometimes we discuss difficult problems we are having with the orphans and we come up with solutions, or sometimes we talk about our health. Sometimes I go to group, you know, nearly in tears. But when we share and talk, I come home relieved. It makes me feel … big. Isabella (Chiedza), Zimbabwe

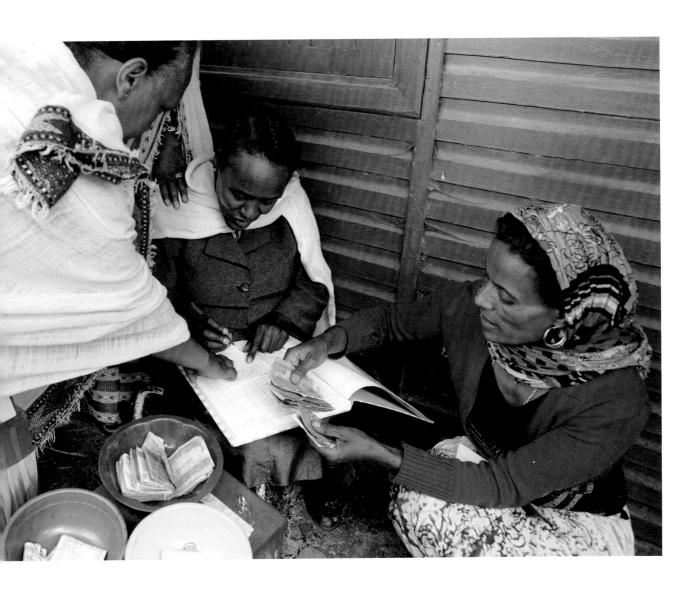

Makidas participates in her grandmothers'
revolving loan program. *Addis Ababa,
Ethiopia, (with NLK)*

Gogo Siphalele
Swaziland's Oldest Carpentry Graduate

Swaziland Positive Living (SWAPOL) · Mahlangathsha, Swaziland

WE VISITED Siphalele at her home in Mahlangathsha, Swaziland, an hour and a half from the bustling city of Manzini. At 68, she had just become the oldest woman carpenter in the country. About a year earlier, she and several other grandmothers approached SWAPOL and expressed their interest in learning the carpentry trade. The idea was preposterous in an area where it was almost unheard of for women to be carpenters, but it was also ambitious and groundbreaking and *the grandmothers'* idea—the perfect combination for SWAPOL to take it seriously.

Siphalele gave the interview in her blue carpentry coveralls, hard hat, and steel-toe boots. One of her fellow graduates, Winnie, was also there but hesitant to don her uniform; she said it was challenging for her husband to see her in trousers, so she only wore it when she actually worked. They brought their certificates from the college, which listed their training along the bottom: "Courses in woodworking: basic principles, introduction to wood-work, timber technology, health and safety, woodwork tools, basic woodwork joints, basic drawings."

Siphalele began by explaining her appearance:

You see me standing here today wearing this protective clothing. It is not clothing for going to cook, or going to take care of children, it is the uniform for a carpenter.

The carpentry course is something that we thought of as grandmothers and then we discussed it with Siphiwe, the executive director of SWAPOL. We said to her, "We are happy with the income-generating projects we are doing through SWAPOL, like making peanut butter and skin cream, but we are ready to do more and we want a trade that fills the gap for our community. We have a shortage of coffins here, especially children's coffins. We have so many kids filling the schools but no benches for them to sit on in the classroom. So we thought of carpentry." But Siphiwe asked, "Carpentry? Can you operate a machine? Will you be able to leave your homes and live on campus because the school is far?" But she trusted us and helped us to get this training by partnering with Swaziland Skills Centre.

When we arrived at the college, we are seeing young kids there and here we are, grandmothers, and we thought, "How are

we going to manage?" It was worse when I was in the classroom seeing the big machines! But through the support of the instructors, we were able to operate them in three days. My favourite is the giant skill saw.

There were 10 of us grandmothers from SWAPOL. After our sessions we would go back to our guest house, where we stayed during the week. We would come together with our exercise books and start to review together. If anyone was expected not to complete the course, it was me. I'm 68. As an old lady I needed to be studying harder than the others, so my mind was the one that was actually working more than anyone else's. And at the end of the day we have all graduated.

My husband was so supportive. At first he also said to me, "Carpentry? How are you going to operate this big machine?" But he was seeing my progress and he was very happy. I never, never in my life imagined myself being a carpenter. My husband used to build houses, so I would just assist him by getting the bricks, or he would say, "Pass me that wood," and I would give it to him. But now things have turned around. I am teaching him how to do a bench, because I can do a bench; I can do a coffin; I can do a beehive; I can do a wardrobe. Wardrobes are popular here.

To my surprise eight more women from our groups want to learn. They are already saying, "You better teach me how to do it." So we have started. There are ways to

make certain products without using the big machines, like benches, so we will start with them.

As the interview wound to a close, Winnie stepped forward to join Siphalele, now dressed in her uniform as well. She perched on the arm of Siphalele's chair; she had something she wanted to add.

With grandmothers, the training doesn't stop at our front door. We teach each other in the groups. Maybe in a few years' time in this community people will not be seeing this as male-dominated work only. They will see this can be gogo-dominated work. For me, it feels so great. It is like we are showing them that we are capable of doing anything. As long as we are empowered we can do it. There is nothing we can't do.

Siphalele. *Mahlangathsha, Swaziland (with SWAPOL)*

The Unique Contribution of Community-Based Organizations

No one knew the grandmothers or their communities better than these grassroots organizations, and they knew how to access the full range of supports and resources available locally and nationally. They had a penchant for bold and innovative ideas, which they channelled into their grandmothers' programs, and which pushed the grandmothers to broaden their expectations of themselves and even make room for a little fun.

Chiedza Child Care Centre started a granny netball team. At first we grandmothers were amazed—who could come up with such a scheme? But now we play netball at our centre and we dance with whistles and drums. Netball makes us stress-free. When we come home we are tired and just go to sleep. We don't even wake up at night and think, "What am I doing? What is going on tomorrow?" We just go to sleep. And you know, when we play together as grandmothers, it makes us stronger. I'm 72 and I play the position of defender. When we fall we get up and start playing again, so that's it. Isabella (Chiedza), Zimbabwe

The Gogolympics started in 2010 and is very popular with the grandmothers. It has motivated them to be physically active and to stay healthy and we wanted to help our grandmothers to have a mind shift, because so much more is possible. Now the grandmothers are saying that they feel very fit. They never imagined they would be playing on teams and competing like this. This year we are inviting the Canadian grandmothers to join the competition. We want to see if they can keep up with us. Cwengi Myeni (HACT), South Africa

If the grandmothers championed an idea, however unexpected, and it was at all possible, these stalwart organizations got to work turning it into reality. As they did, they began to amass an expertise of their own.

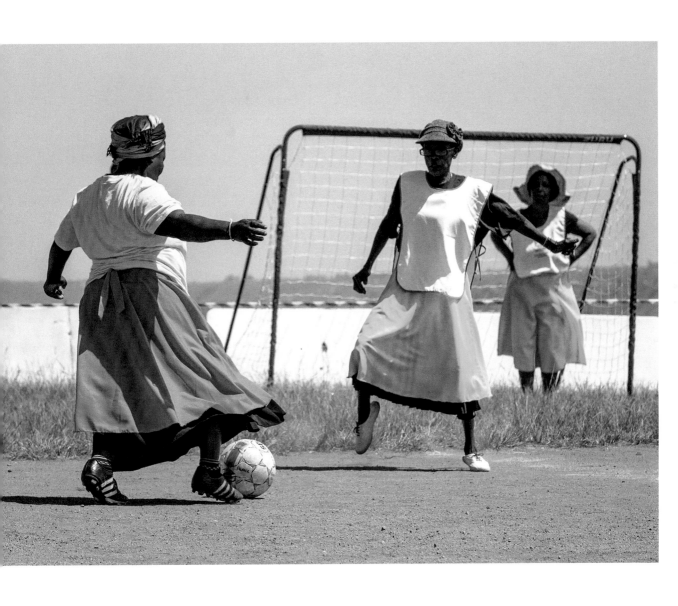

Gogolympics. *Hillcrest,*
South Africa (with HACT*)*

Jjaja Margaret Waziko The Making of Miss Granny

Phoebe Education Fund for Orphans and Vulnerable Children (PEFO), Uganda

WHEN ENTERING PEFO's head office, on the outskirts of Jinja, one immediately encounters the media wall, covered with clippings from the extensive coverage this community-based organization's work has garnered over the years. A quick perusal reveals that PEFO has a remarkable range of activities in support of grandmothers, including housing, agricultural, income-generation, and training programs. But there is one grandmother initiative, in particular, that dominates the media wall: the Miss Granny Pageant.

There are news reports, editorials, and opinion pieces on the annual event. There are full-page colour photos and even front-page stories with headlines that include, "I'm Having Fun at 76," "Here Comes the New Miss Granny," and "Oldies Beauty Contest Sex-cites the Region."

The light-hearted nature of the headlines belies the more serious content of the articles, where journalists discuss the role of grandmothers as heads of households and spokeswomen for better HIV & AIDS supports in the community. For PEFO, this is exactly as intended.

Miss Granny was the brainchild of Justine Ojambo, the co-founder and national director of the organization. He explained the origins of this event as we climbed into his truck and began to bounce along the red mud roads of Jinja, on the way to meet Waziko, Miss Granny 2012.

We have struggled to get media attention and community support around issues of the grandmothers. They are invisible in society. There is this idea that grannies don't have long to live. People say, "Why are we focusing on them? Let's focus on the next generation." But if we want the public to come away with one message it is this: You can't talk about solutions for HIV & AIDS and not talk about grandmothers. They are the ones who are left and who care for the orphans. They are the guardians of the future and also the ones doing the work right now.

For Justine, the beauty contest was serious business masquerading as fun.

People were surprised and curious when they heard of a grandmothers' beauty contest. We were pushing the boundaries of societal norms around grandmothers, who they are and what they can do. Once the media flocked to cover this event, the grandmothers had the platform they needed to promote other, more serious areas, around the value

and worth of the grandmothers and the important role they are playing in society.

The grandmothers prepare for so many months. PEFO gives them training in communication and helps them develop their personal story. We also bring in someone to train them on how to deal with national and international media and how to perform in front of a large crowd. A tailor comes from town to take their measurements and sew their dresses for them.

Waziko was waiting outside as we pulled up to her home. We were quickly ushered inside, where she delighted us by donning her pageant dress and sash and striking a few poses before settling in to share her perspective.

I was so happy to win Miss Granny. From the first I heard of it I wanted to take part.

I was inviting everyone to attend the beauty contest and create awareness that older persons are able and they are still very useful. I was very happy to be able to promote the event. Just imagine, after the deaths of all my sons I was a woman who couldn't even talk, but there I was now talking on the radio two times.

When I came back in the village, everyone was saying, "I heard you on the radio, I heard you on the radio." Everyone was saying how much I had changed since joining my PEFO granny group.

The day of the competition, I remember, I prayed. Then I went on the stage, and I started walking how they had taught us.

I was nervous but when I was waving to the crowds, when I was waving to people, I wasn't shy. I looked up and smiled and looked right at everyone. People were making noise, clapping and encouraging and I was cheering up. I felt I was the one. I felt so good and confident.

As Miss Granny you have responsibilities. During my reign I was very disciplined. My role was around mobilizing and training people for farming and on food security, to make sure that all of the grannies have enough food. I used to tell them about what to grow and how to apportion their harvest for eating, selling, and planting. Now you can say that everyone knows me in this community. No longer they are thinking of me as the lady who buried all her sons, but as Miss Granny.

Waziko wins the Miss Granny crown. *Jinja, Uganda*

Yamrot. *Addis Ababa,*
Ethiopia (with NLK)

Training Tailored for Grandmothers

Training is an essential part of grandmother support programs. Vocational and financial skills training enables grandmothers to establish greater financial security. New skills in gardening bolster health and nutrition for the entire family and, in many cases, excess produce can be sold, bringing in much-needed cash for other household expenses. Training around the prevention and treatment of HIV & AIDS enables grandmothers to protect themselves and their families, and support others in the community. Finally, the acquisition of new skills and knowledge contributes enormously to their emerging self-determination and expanding identity.

We grannies are from rural communities, and because of that we have been undermining ourselves. Most of us are uneducated but now through Hillcrest AIDS Centre we look like educated people. We have been trained in bookkeeping. We have been trained in how to take care of people that are sick. Old as we are, people see us differently now. Even we see ourselves differently. South African grandmother (HACT), South Africa

I am proud of Mama Zodwa for starting Siyaphambili and I have learned many things at this organization. I think I have got about four different certificates from here. From my training, I got a job working with street kids. By the end of the first week my employers were amazed at the difference with the kids and they said, "Tell us again, what qualifications do you have?" When I showed them my certificates they were impressed. They said, "You know exactly what to do."

I am getting a lot of opportunities now. The training that she gave me means my grandchildren can eat and I can also help other children in the community who are suffering. Kholiwe Manzama, home-based care worker, Siyaphambili, South Africa

When working with the grandmothers, community-based organizations paid particular attention to ensuring the grandmothers obtained tangible verification of their continuing education in the form of certificates of completion for all workshops and in-house courses. Whenever possible, they forged partnerships with local training centres or educational institutions where grandmothers could earn accredited diplomas and certificates.

Now that I have graduated as a tailor, people come to me to do things like mending or sewing clothes. The skills we get from the support group help us a lot because we are able to sell our products and get money to support the grandchildren. You know, in the past I was so hopeless that I wished I could die. Now I am a qualified tailor. I have a diploma on the wall. I have an education and I make myself an example to others. I don't say anymore, "Look what has happened to me," but now I say, "Look what I am doing for myself."
South African grandmother (HACT), South Africa

Before Mavambo [Trust] I was just alone. I had nine children. Five have died. My eldest son is emotionally disturbed. I care for 10 grandchildren. I couldn't get my grandchildren into school, I couldn't provide anything for them and I wanted to die. But with my granny group I have learned so many things. My grandchildren are now getting an education and so am I. I am a seamstress and I made the dress I am wearing. My garden is now a community display garden and I have branched into mushrooms, which is very profitable. I have so many certificates—Business Management, Counselling, Child Protection, and Paralegal Services. I have all this education.

There are so many children in this community who are abused and have nowhere to turn, so I allow them to grow close to me so they can feel free to tell me all their problems. My heart is strong to bear it. I am a paralegal now so I know what to say and where to send them for help, or how to send someone from child protection to their place. Everywhere I go all the children say, "Gogo, Gogo." They know me. Before, I could not even manage to be a grandmother to my own grandchildren. Now I am Gogo to the whole community. Ronica, Mavambo Trust, Zimbabwe

For women who had been denied education their entire lives and treated as both invisible and powerless, the opportunity for formalized education proved revolutionary. Suddenly the grandmothers could imagine themselves living more expansive lives with entirely new possibilities. This was more than breaking new ground—this was stepping into a whole new world.

I am unlettered—I have no formal education at all. I got married at age 12. I was a shepherd, married off, and at age 15 I gave birth. So I have been trying to have my children learn, my daughters and granddaughters especially. And now as an old woman I am learning new skills, going for trainings, attending international workshops. I was there in 2006, in Toronto. Imagine! Me! Etabezahu (DFT), Ethiopia

Nya Nya Lucia Nyangoso
The Transformative Power of Education
Young Women Campaign Against AIDS (YWCAA) · Nairobi, Kenya

AT 36, LUCIA was the youngest grandmother interviewed for the book. When asked if she identified as a grandmother, or nya nya, she laughed:

Sometimes I can feel surprised that I am a nya nya, but I can take care of family, I can advise someone in trouble, I can bring people together. It's not determined by age, it's all about being selfless. And I can say that I have wisdom, even though I am not educated. So, yes I am a nya nya.

Lucia is the secretary of Bar Waitresses (BAWA), a group founded by the Young Women Campaign Against AIDS (YWCAA) to support women—most of them grandmothers—living in the informal settlement of Kibagare in Nairobi, who were engaged in the dangerous and illegal business of making and selling alcohol from their homes. After years of YWCAA's support, all of the group members are now earning their income through secure and diverse activities. As we walked through the slums toward her home, Lucia pointed out the businesses she had started using her group's revolving loan program: her water vending and public bathroom

stations, her food stand and, finally, her fully licensed bar.

Lucia's home was built on the roof of the bar. We squeezed down a narrow alley to a set of rickety and dark stairs that lead to her house. It was a patchwork quilt

Lucia with grandson Lewis (2).
Kibagare, Nairobi, Kenya

of sundry building supplies—a piece of corrugated tin here, a sheet of pressboard there. This was her third rebuilding at least, her home having suffered through a fire and a razing during elections. One cannot own land in an informal settlement so Lucia is considered a squatter, even though she has never lived anywhere else. But while she may be landless she is not homeless. Her defiant little home radiated warmth and was bursting at the seams with family. There were babies, children, teens, and adults, all treating Lucia as their mother. Some were siblings she had raised since she was a child herself, some were her biological children, and some were adopted children. And there was the apple of her eye—her first grandchild, two-year-old Lewis.

She received an effusive welcome. There was kissing and cuddling, laughing and playing. Then the room went almost instantly from chaotic to quiet. Children who were racing about suddenly sat contentedly on the floor playing together with smallest ones scooped onto the laps of older children. Lucia gave a half smile in response to our looks of incredulous admiration:

I'm not just a leader in my community, I'm the leader in my home.

Lucia picked up Lewis, settled into a comfy, well-worn chair and shared her story.

My mom had to raise us on her own and she used to sell liquor illegally from home. That is what she brought us up with, but there is danger in this business. The clients are men, drinking in your home where the children are staying. These men, even the old ones, make passes at you. So you have to be keen, you have to brush them off. In poorer houses where there is no food, the men may offer to sleep with the mother for 3 shillings [4 cents] or 5 shillings [6 cents] if he can also sleep with her child. And they can become violent if you refuse.

We didn't learn from our parents about how to protect ourselves, so I got pregnant when I was 14. Eventually I had to leave school. My child was born crying and I was also crying because I didn't know what to do. I had five younger sisters and my mother told them that they should now call me "Mom" so I went from being a small girl to an adult overnight.

Then my mother got sick, so she went to her brother's and I was left to manage the home. I continued selling the illicit brew but the burden was heavy. I was so worried about how I could get enough money for us to eat, and about the safety of my young sisters in the home. At night I could never sleep, I would just lie in my bed, building castles in the air—imagining the things that a young girl imagines, but which, for me, were never going to materialize. Sometimes I would take a bit of the drink just to help me forget those dreams of mine.

Left to right: Lucia, Trina (Zebia's daughter), Stephen, and Zebia

It pained me that I could not go to school myself. Even at 14 I understood that education is the key to life. So that's why I promised myself that my siblings will be able to do their studies—and my child, too. I didn't want them to be like me.

Along the way we took in other children who didn't have a home. My son met Stephen when they were both young boys. He told me Stephen was sleeping on the streets in doorways and asked if we could bring him in. He was only eight years old at the time but he has lived with us since then. He is 19 now.

Zebia is my adopted daughter. She joined us when she was 16. She was staying in a home for orphans but at 16, the girls are discharged onto the street. She was worried that she had no choice but sex work, so I took her in. When she came, I told her that we were poor but we would share what we had with her.

I worried constantly about the future of all these children. I continued the illicit brewing until we met up with YWCAA. They helped the women brewers form the BAWA group and we were taught how to keep our children safe from clients, how to work together to save our money and how to stop drinking. Yeah, that was the first step. After that, they gave us a loan. So I started changing.

Now I have these three businesses, but even more, I found myself becoming an educated woman! I learned how to write and take minutes. I have taken trainings and earned certificates. I was chosen as the chair of my group and I had that position for five years. I didn't know I could get to that point!

I was taught how to be open about HIV with the children and now I teach my own children and all the children of my community, especially the girls.

I can do this because of what I have gone through, but also what Young Women [YWCAA] have taught me. If it were not for them, I don't think I could have ever reached this place in my life. I have gone from no education to being a teacher in my home, in society, and the whole community.

Parenting 2.0

Next the grandmothers began to request training of a completely different nature: they wanted parenting classes.

Cwengi, a nurse and the granny groups manager with HACT in South Africa explained:

As we started working closely with the grandmothers we noticed something. In past days grannies could take care of their children, but now it is much more difficult—even just considering the age gap between the gogo and the child. In our area, something that was coming up a lot was that the grannies were being abused by their grandchildren. During a workshop it came up strongly that we also need to provide some workshops on parenting skills for them. And so we listened!

In Zimbabwe, at Mavambo Trust, a new workshop was created called "How to Love an Orphan." Irene, a graduate of this workshop, explained its rather surprising name.

When my children died, it was such a difficult feeling because I had to face the challenges of looking after the grandchildren; at the same time, I was in pain of losing my own children. I was so depressed. It was so difficult to express love to the children because in reality I knew I had nothing to give to them. The sad part was that the grandchildren themselves, they were so much in love with me.

I only came to understand this when I went through the training with Mavambo. They taught us how to love our orphaned grandchildren no matter what the circumstances were like. We learned how their needs and challenges were different from others who had not lost their parents. We learned how to have a relationship with these children. I learned that, as an individual, I need somebody who listens to me, because in turn I need to listen to the child. Despite the fact that they are young, they need to be listened to. Mavambo taught us to understand how some of our struggles were the same: the child did not ask for their parents to die, like I never asked for God to kill my own children. We were in the same boat really, and I felt better when I really looked at it like that.

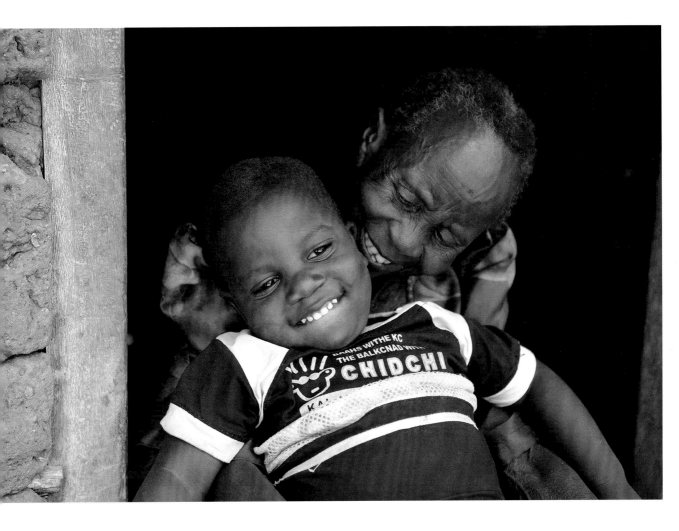

At these workshops, we were also taught to explain to them how their parents died. At least if they know when they are young, it is not going to be difficult to break the news to them. If they learn when they are older it could affect them more seriously. They can be destabilized.

My life changed completely after this training. These children who were my burden, they became my friends. I realised that although I lost my children, I still had family who could support me and comfort me: my grandchildren.

One family at a time, homes that were rent asunder by HIV & AIDS were being stitched back together.

Paulina with grandson. *Masaka, Uganda (with Kitovu Mobile)*

Through GAPA I received training on how to care for my grandson and also they provided counselling sessions for the children. My grandson went to help him deal with the loss of his mother. They told him, "Write everything about your mum, how you feel," and at the end of the session he was asked to place a picture of his mum on that letter. And he chose a picture of me and his mum to place on it. That touched my heart so deep, I can't really explain. I guess on that day I felt like my grief was also coming to an end. South African grandmother (GAPA), South Africa

But What Will the Community Think?

As the grandmothers began to breach the boundaries of societal norms and expectations, it was no surprise that they began to experience resistance. Here again, community-based organizations proved invaluable.

These communities are poor and vulnerable and AIDS has pushed them to the brink. There are cases when providing a new home for a grandmother has resulted in problems for her in the community because of jealousy. People can say, "A school principal can work his whole life and can't afford to build a home and now an old woman gets one?" Or her relatives may have been waiting for her to die to take her land because they are desperate for her resources. Suddenly she has a house, suddenly her health is better, so this becomes a threat to them in a way. So you see the problems? She and her grandchildren were in danger living in an old house that was about to fall in on them. They get a new house and now they are in danger of the community and her family turning on them.

So this is something we are thinking about as an organization. We are thinking of a project called Light up a Village. The idea is this: we build a house for a granny and we make microcredit for solar power available to her whole village. Solar power can be very difficult to access so we can broker all those arrangements and make it very easy. In this way people will want the granny housing projects in their village because it brings benefit to them, too. That granny and her kids will belong to everyone again. Justine Ojambo, co-founder and national director, PEFO, Uganda

A New Public Image

As grandmothers became more active and visible in their communities, emerging with new skills and roles, their communities began to view them differently. Rather than dismissing grandmothers as a drain or individuals in need, they started to see them as a group of well-connected women with resources and knowledge, who could provide much-needed assistance to others.

People here know there is communication between me and Hillcrest AIDS Centre. So people that are sick in this area will come to me and ask me to book them a bed at the Hillcrest hospice. They say, "Gogo, please phone for us. You know what to say, we know we will get a bed." And I know the questions to ask them when this happens. I will check if that person has been tested for HIV and if they are on treatment, have they been tested for TB, and things like that. Now people in this community call me Nurse Gogo. Somebody was just talking to me this morning, saying, "Gogo, what I am now is thanks to you. I am healthy because you helped me." Nokuthula (HACT), South Africa

Before Young Women [YWCAA] came here, all of us in this group were just taken for the lowest of the low, but we have learned so many things. Many of us are now community health workers and we work with the Kangemi Health Facility which is nearby. They have issued us triage books. In these books we record whatever is ailing the person so when they go to the clinic they have this information ready. If we refer a patient to the clinic, they will not have to wait in the queue. We have reduced the backlog at the health facility. Now the whole village refers to us as doctors. We are proud because our community loves us. And we will continue helping them. Olivia (YWCAA), Kenya

A New Personal Identity

Grandmothers were acutely aware of this elevation of their social status. A similar turnaround was occurring internally as well.

In the past we were always being told, "You are living on borrowed time." I used to feel bad about it, but nowadays I know I am playing a very big role taking care of my grandchildren, and words alone cannot make me feel useless. The baby that was left for me, he is now a strong child. That is because of my role. Setoloza (PEFO), Uganda

Collectively, the grandmothers were relishing breaking new ground and challenging stereotypes around gender and age, channelling a spirit strikingly similar to their Western counterparts' half a world away. African grandmothers began to question the limitations that had been thrust upon them their whole lives—everything was open for reinterpretation. They were on the cutting edge—first by necessity, now by choice.

Nowadays, it is very different from what it used to be in our parents' time. The women were not allowed to do so many things. It was only the men that were working. It was only the men that could be on a committee or be a chairperson of the community. Even playing soccer—that was for men. But now it is us doing it. I mean, anything that can be done by a man, as grannies we can still do it and that is the thing that is making us proud. South African grandmother (HACT), South Africa

We are different from the older generation because even when we were children growing up, we were looking at our mothers and knew something was wrong—we realized that a woman can still do more, but it was cultural. And then we were forced to do the same as our mothers. We had to submit to our husbands when we got married. But through all of this we have learned—husbands won't be there forever, and we have to be able do things for ourselves. This world doesn't belong only to men. Kenyan grandmother (PENAF), Kenya

FACING, CLOCKWISE FROM TOP LEFT: Name Withheld. *Debre Sina, Ethiopia (with DFT)* · Narikungera. *Arusha, Tanzania (with Maasai Women Development Organization MWEDO)* · Evelyne. *Kabale, Uganda (with ROTOM)* · Regina. *Harare, Zimbabwe (with Mavambo Trust)*

Tackling the Taboos

As the African grandmothers began to apply pressure to societal constraints they pushed hardest against traditional gender roles. This should come as no surprise, given that gender inequality and a cultural refusal to address sex were among the primary drivers of the AIDS pandemic.

I have a man in my life and we have stayed together eight years, but we don't sleep as lovers, more like companions. Because when I advised him to use a condom, he said, "I'm too old." So we just cuddle and stay together and keep each other company. I would not have been able to do that in that past. I would not have wanted to part with him, because I would have wanted a sense of belonging, and him first, him first. So I would have stopped insisting on using condoms. But now I know I come first.

It helps a great deal to have those other grandmothers to talk to. That is where I found my strength. Without other grandmothers to talk to and share life with, then you feel vulnerable. You feel you are obligated to do whatever men want from you. Olga (GAPA), South Africa

In our community it is a shame to talk frankly about sexual intercourse and sexual transmission. But since no one is talking frankly, our children became infected. We are very old, too old to talk about this, but who else will do it? So we teach our grandchildren about condoms. We will educate them, we will tell them everything frankly. We will not hold back and they will not be victims again like their mothers and fathers. Ethiopian grandmother (NLK), Ethiopia

It is not easy for grandmothers to speak with the children about sex. There is that boundary. Even a mother doesn't speak to her children about sex—that is the role of the uncles or the aunties. But with AIDS we have lost so many of the adults. I'm telling you, silence is going to kill these grandchildren. If grannies must be mother and father to their grandchildren, why not uncle and auntie, too? No more living in the past. South African grandmother (GAPA), South Africa

Grandmothers across Africa were emerging as community leaders, pragmatic, no-nonsense agents of change. But their work could not simply be

that of recovery; they had to address the eradication of the virus that was still in their midst. The grandmothers knew, from their years of experience, that HIV is not only a medical issue, it is a social disease—planted and nourished in environments of inequality and injustice. And they were going for the roots.

Isabella. *Harare, Zimbabwe*
(with Chiedza)

People here, they know me and trust me. I am very open about being HIV positive and so they come to me if they are sick. The first thing I do is to encourage them to know their status first and foremost. They ask me, "How did you do it?" I tell them, "You can walk into many types of hospitals or clinics. Don't be afraid. Go and know your status."

Sometimes they come back to me and tell me they have tested positive. And I don't cry for them, I say, "Welcome to my church." I shake their hands and congratulate them because now they will live! Philister (PENAF), Kenya

8

Grandmothers at the Heart of the AIDS Response

FACING: Ugandan grandmother group members. *Jinja, Uganda (with PEFO)*

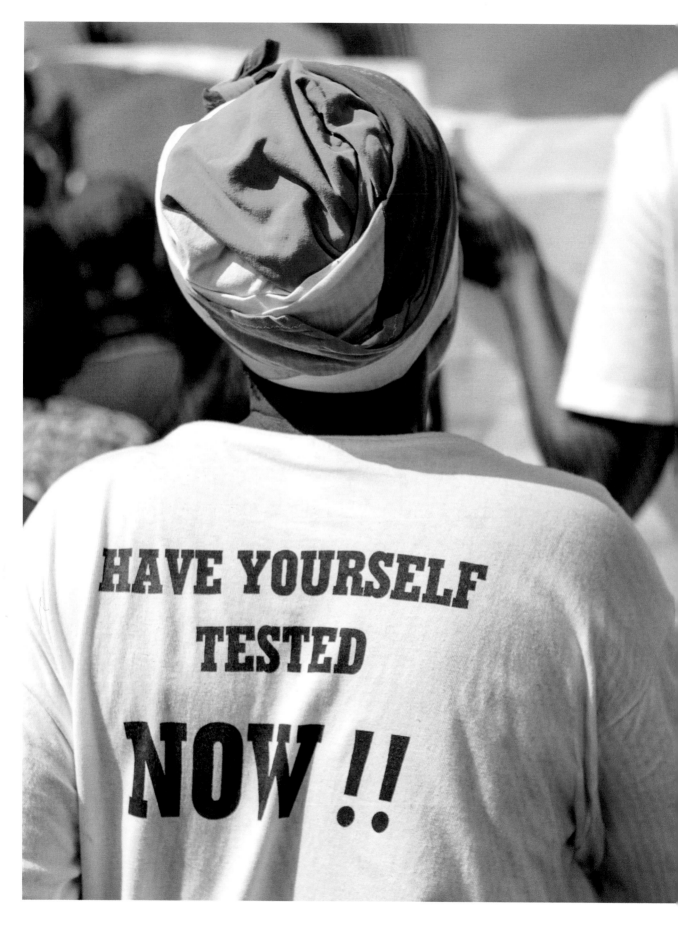

Grandmothers in the Era of HIV Treatment

During the years the African grandmothers were undergoing their personal transformations, medical advances in the field of HIV & AIDS were radically changing the landscape of this disease. Improvements to antiretroviral (ARV) medication transformed HIV, if managed correctly, from a death sentence to a chronic condition. Evidence began emerging that HIV patients on uninterrupted treatment were no longer infectious. If ever there was a medical miracle, this was it.

As treatment finally began trickling down to African communities, it did not bring an end to the

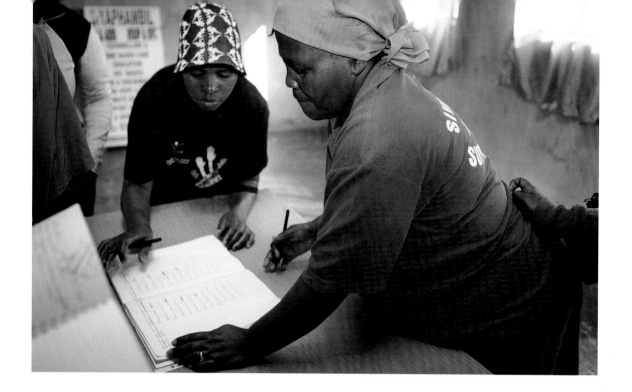

grandmothers' participation in the AIDS response. Their responsibilities shifted, and in many cases, increased. Now, instead of palliative care, the grandmothers expanded their work to include home-based care. Instead of helping their children die with dignity and support, they were working hard to ensure they would live. While doing so they were developing a unique expertise around addressing the many barriers to accessing and staying on treatment.

However, now that ARVs were readily available, the global winds were shifting away from community-based programming and toward a more singular medicalized approach to HIV prevention and treatment. At the level of international funding, ARVs were on everyone's minds. ARVs were an excellent and long-awaited development, but the supports and resources for ensuring that communities actually benefited from this treatment, such as the provision of home-based care, were being ignored at best and scaled back at worst.

As the impact of these decisions rumbled through communities in the midst of precarious recovery, it was the grandmothers who found themselves once again at the heart of the response, stepping up to fill in the gaps and hold the line.

Home-based care volunteers. *Umlazi, South Africa (with Siyaphambili)*

Elizabeth and Grace Home-Based Care Heroes

Catholic AIDS Action (CAA) · Bukalo, Namibia

WE HAD travelled to the Zambezi Region of Namibia to meet Elizabeth and Grace, two home-based care workers who had been trained by Catholic AIDS Action (CAA), a community-based organization that was one of the first responders to the AIDS crisis in the country and had grown to be one of the largest, with offices and programs throughout Namibia. After almost 20 years, their home-based care workers had become an invaluable resource to their communities.

CAA, like so many African community-based organizations, was experiencing funding cutbacks for their home-based care (HBC) programs* and they were valiantly trying to stretch these remaining dollars, but struggling. The impact in the community was palpable, and they wanted us to witness this. And so we found ourselves in Bukalo, a small community about 20 kilometres outside of Caprivi town where Elizabeth and Grace lived. They were home-based care volunteers for CAA and had been for years. Both had celebrated their 60th birthdays recently and both were grandmothers with

demanding home lives. Each had come to this work differently.

Elizabeth explained that she felt compelled to join CAA with the intention of making a difference in her community. The first person she ended up helping, it turned out, was her own granddaughter.

That young granddaughter of mine, she could have died of HIV. I didn't know she was infected, but because of that training I received, I noticed her symptoms and I could help.

* At the time of our visit, the Stephen Lewis Foundation was CAA's only partner that had not cut funds to HBC.

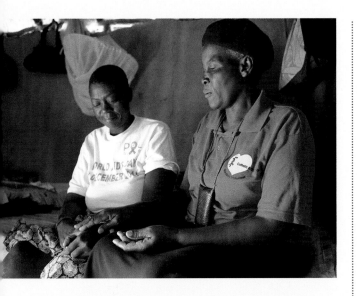

For Grace, the life saved through her training was her own:

When I joined as a volunteer, I begin to understand about HIV and that motivated me to go and get tested. I learned I was positive. And this woman, Elizabeth, who is here next to me, she cared for me. I felt comfort because of her. I had someone by my side. And now over all these years, I have helped neighbours, and my family—I have changed the community and myself.

Elizabeth and Grace were on their way to a home visit, and as we walked with them they explained that about 75 percent of a home-based care worker's day consisted of walking. The distance between homes in the rural areas is great, and there is no money for transportation. Grace had a slight limp and it actually looked painful for her to walk. Elizabeth hooked arms with her and steadied her as they marched along together under the white-hot sun.

We arrived at the home of Veronica, a mother of two who is HIV positive and had a severe stroke the past year, leaving her unable to talk and paralyzed on the right half of her body. Her aged parents took her in, and her mother, Namasiku, became her primary caregiver. Both of Veronica's children were now living with their uncle a long distance away.

Inside, most of this one-room house was taken up by the large bed upon which Veronica was resting. There was a child's chalk drawing on the wall—a stick figure of sorts, done by Veronica's younger son, who was 10 (see frontispiece, p. 2). Namusiku explained to us: "That's a picture he drew of himself so his mother doesn't forget him." This was accompanied by a small laugh, to try and lighten the weight of her words. But a chalk drawing is no substitute for a son, and Veronica was noticeably not laughing.

Grace and Elizabeth helped her sit up and began their regimen. Meanwhile, Namasiku spoke with us about her daughter's progress.

Before, she couldn't even talk; now she is talking. Now she can take that walking stick, and she can go outside and come back with their help. When they visit, they also go and fetch water, which is very far, and wash her. This helps me so much because I am the one

Grace applies lotion to Veronica's weak hand during home-based care visit. *Bukalo, Namibia*

normally who must do this. They give us counselling about life and staying healthy.

The challenge for me is finding enough food. You can see the way I am, I am very old, but she has pills to take [ARVs] and she has to eat. This is very, very important.

I had eight children; now I am remaining with only two. All the others, they died of this HIV. I was the one who took care of them but I didn't understand this disease at all. Grace and Elizabeth have been teaching me. Now I understand that this is HIV so I am free to talk about it.

After providing some personal and therapeutic care, Elizabeth and Grace managed to get Veronica up for a short walk. She was tired after that, and it was time to go.

Some distance away from the home, we paused under a large tree while Grace and Elizabeth updated their records with details of this visit, Grace writing in small neat script in an exercise book, while Elizabeth checked off charts in binders. It was clear they had done this countless times. Asked about Namasiku's openness around HIV, Elizabeth shared the backstory.

At first Veronica's mother wasn't keen on the HIV drugs because of their side effects. She said to her daughter, "Throw them away, they are making you vomit." She wanted us to treat the stroke—she wasn't interested in HIV. She would chase us out of the home when we brought up the issue of HIV. Many people used to do that.

So we decided, on our visits, to ask the mother to go and fetch water, far, far away. We would begin talking to Veronica about HIV and counselling her without her mother around. After a few visits she was willing to take the drugs. Then we started to teach the mother. Now the mother is the one who is giving the drugs. She has learned a lot.

Elizabeth shared another success story from her HBC work:

I worked with a young HIV-positive woman who wanted a child. For her, she didn't want to fight for her future if she could never be a mother. I knew how to counsel her, what doctors and clinics to refer her to, what social workers. So now this woman has her dream. She has three kids. She is taking ARVs faithfully and her children are negative, all three.

The issue of adherence to HIV medications was of particular importance to Grace and Elizabeth. They stressed to us, again and again, how challenging it was to stay on ARVs and that getting people tested and on medication was only half of the task.

There is all this work getting them on the drugs, but what people fail to appreciate is the part of our work that ensures that when they are on ARVs, it is for life. Because, for our client, HIV is something that will never end, until death. We know the challenges people face and what causes them to stop taking their pills.

even afford to stock the medical kits that Elizabeth and Grace used for their home visits.

We are losing ground with our patients. In the past we used to be able to come with soap to wash the clients, basic food to make porridge so they could take medication. But now, we don't even have painkillers. They still let us into their homes, but they are growing frustrated. Each time they question, "Why should we share our problems with you if you can do nothing?" They are right, of course. CAA is doing everything they can, but we see they are struggling and we wonder what will happen next. How can the donors think we can stop here? We have come so far.

Without home care, we know what will happen. There will be defaulting of medication, very widespread. The HIV will be back. Those horrors that we experienced in our communities will come back. But it will be worse because we will also be defaulting on hope. You know?

For example, food security is a big issue. These pills have to be taken on a full stomach. There are also the challenges of travel to and from the clinics, which can be quite far away. Sometimes the clinics are in short supply of the drugs so they can only give enough for one week, and so the patient herself has to come up with the time and money for this extra travel. Many are hiding their drugs from their family because the HIV is a secret, so that makes it hard for people to stay on them. That's why we work with the whole family.

Elizabeth and Grace had numerous other examples and stories, each illustrating the importance of counselling and support for people to adhere to the treatment. But now there were fewer home-based care workers due to the cuts in funding and fewer resources. CAA could no longer

We asked them what they would do. They were among a handful of remaining HBC volunteers in the area. Elizabeth shrugged.

I have done this for 13 years but I can't get tired. You remember how they use to chase us? We didn't get tired. We will keep going because for us, this is for life.

And so they continued walking, with a hitch in their step, arms locked together, and grey heads held high.

Elizabeth and Grace walk many kilometres between clients' homes.

The Fight Against Stigma

Even in an era of treatment, the scourge of stigma continues. Medicine can halt the virus in its tracks but is powerless to stop the spread of stigma, and so this remains at the fore of the grandmothers' response to HIV & AIDS.

HIV does not have to be a death sentence any longer, but people don't want to be seen taking drugs; the issue of disclosure is still a challenge. To put it simply: as long as there is stigma, there is death. We must still continue to address this first if any of the other advances are to help our community. Thulisile (SWAPOL), Swaziland

I have lost four children and six grandchildren. They died in silence, but I'm telling you—this is enough! I have four more grandchildren who are positive. I have taught them, if you don't disclose you cut yourself off from all the help that is available. These clinics are here. These medicines are here, but people are still dying. In my family we are living healthy and well, we say it straight. We talk about this. South African grandmother (HACT), South Africa

African grandmothers possessed uncanny insight into the various barriers created by stigma, especially for the most vulnerable groups in their communities.

HIV is always blamed on the woman; that is problem number one around testing. But I want to talk about the challenges for younger women especially. These girls will be judged harshly for even wanting to learn about how to protect themselves because this is the issue of sex. If you test positive and are unmarried, no one will have you—you will remain alone and without children. For married women, of course we know the husband will always accuse her of being unfaithful and she can lose everything. It is still like that. Zimbabwean grandmother (Mavambo Trust), Zimbabwe

There are a lot of seniors who have hidden their status and died in silence because it was difficult for them to come out with this disease as elders. Because there is shame—they are supposed to have good morals. When you are older, you have respect, or you are a leader. You have worked your whole life to gain these things. If you lose that respect or admiration this means you really will remain with nothing. Olga (GAPA), South Africa

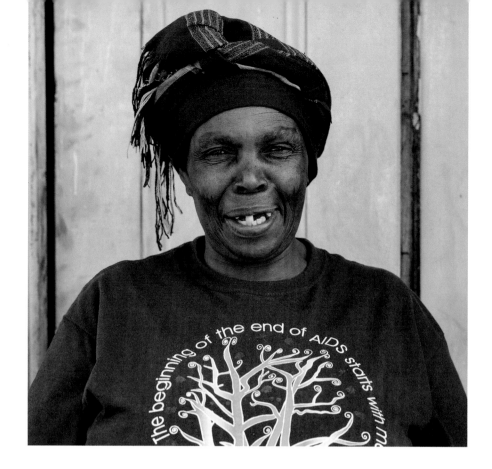

At times children don't disclose because the parents become very aggressive. The children are scared that the parent will disown them. It breaks my heart. I have lost many children to this disease; if I see anybody that is sick, it's like it is my own child. So I try by every means to help my neighbours and counsel them—teach them that what their child needs is love and acceptance. Because it is not the disease these days that will kill their children, it is their own judgment and anger. South African grandmother (HACT), South Africa

Scapegoating and blaming the victim, phenomena that accompany HIV & AIDS the world over, persisted, and grandmothers addressed this challenge head-on—starting with their own lives.

When HIV hit my home, when I found out my children were positive, I could not come to terms with it. How could it be in my home? I had raised my children with the Christian life, so how? After coming to GAPA I found my peace because I realized this disease belongs to all of us. I became a counsellor at home. I became the one who comforted my children. I am accepting them

Nokuthula. *Hillcrest, South Africa (with HACT)*

and it helps them, in turn, to accept it. They have started taking treatment. **They will live.** South African grandmother (GAPA), South Africa

I remember one of my neighbours came to me and was taunting me, saying that I was an important nurse and she only a kitchen maid but all my children were dead of HIV so she was better than me. I replied and said, "I am a nurse but it does not mean anything. I am also a human being. To be a kitchen maid does not mean anything. You are a human being."

Then it happened to her, her daughter became sick. And everyone told her to come to me for help but she said, "No, I cannot face Mama Zodwa because of what I have said." So I went to her. I was the one who brought her daughter to the hospital, who sent caregivers to her house. I was the one who was providing counselling. I knew that mother's pain and I wasn't going to **let stigma divide our community more.** Zodwa Ndlovu, founder and executive director, Siyaphambili, South Africa

Grandmothers also stepped up the promotion of HIV testing within their communities. They faced their own fears and began to test themselves in larger and larger numbers.

We have been brave to counsel our communities to know their status, but we are also realizing that we must hold ourselves as examples, because this is a very frightening thing. Now you see grandmothers, for the first time in their lives getting tested in large numbers. It doesn't necessarily mean they have tested positive, but they have done it and gotten tested. And with persistence even some of our husbands are getting tested for the first time in their **lives.** Olga (GAPA), South Africa

At first we grannies resisted because we were very afraid, but PEFO took time with us, so you see this change in us. Now we test, just to make sure. There is medication now, so we want to ensure we're strong and healthy to look after the grandkids.

When I went for the test and they started to take the blood, oh, my heart was pumping. And the doctor said, "Why is your heart pumping fast, are you scared?" And I said, "Yeah, I feel a bit sickly, I'm a bit worried." And then the doctors asked me, "If you are found to be HIV positive, what will you do?" And then I responded, "I'll start treatment and I will tell people that I'm positive. **I will not hide it!"** Waziko (PEFO), Uganda

Asnakech Mekbib "My Heart, My Courage"

Negem Lela Ken New HIV Positive Women Support Organization (NLK) · Addis Ababa, Ethiopia

ASNAKECH LIVES with her 12-year-old grandson in Ethiopia's capital, Addis Ababa. We located her small home in a maze of a compound, with ramshackle cul-de-sacs and tiny houses cobbled together with a variety of building materials and livened with bright splashes of orange, green, and blue paint. Her home is made up of two rooms. The front room—small, narrow, and dark—is where she cooks and sells her injera (Ethiopian flatbread). The larger back room makes up the living and sleeping quarters. Both Asnakech and her grandson are HIV positive. They're on treatment but still struggling a bit with their health, she told us, in part due to the toll exacted by their previous days of extreme poverty.

We are both doing better now that I have my injera business, thanks to NLK. Before that time we had to beg on the street for money just to get some small things for food. We always take turns caring for each other but you know how it can be with HIV, you can be fine one day and sick the next. I worry so much for my grandson; he is small for his age. He also had TB so it has been difficult for him. Even yesterday he was home sick. I wanted to keep him here another day but he was desperate to go to school so I sent him.

After coffee we settled down together to begin the interview. Before the first question could be asked Asnakech began to talk—her words pouring out of her like a river, without pause or breath. She spoke of the loss of her children, of nursing her daughter as she died from AIDS—loss upon loss, followed by the news that she and her remaining grandson were HIV positive. While those days were in the past, death was still a spectre in her home.

I really have come back from so many things, I have held on from so many losses. But if I lose my grandson… that will be really all I can take. I need him. And he needs me, too. I am the only one remaining now. I only hope I make it until he is at least 15. Then maybe he will be OK.

Asnakech spoke about the stigma surrounding HIV.

When I learned I was HIV positive I just hid from everyone. I locked myself inside the house and when I had to go out I would cover myself with a blanket.

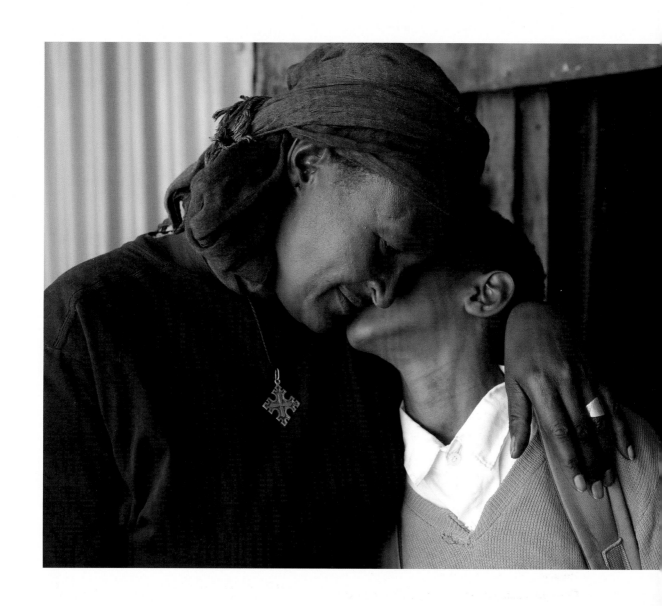

Asnakech with grandson.
Addis Ababa, Ethiopia

She talked of the terrible inner conflict she felt trying to decide whether or not to go to the health clinic for treatment for her grandson and herself.

Here, if you want to get on treatment you must register at the clinic, but then everyone knows, it becomes like public knowledge. I was worried more for my grandson than myself. I knew without treatment he would die, but I was so afraid of what kind of life he would have once everyone knows.

She got involved in NLK and, with support from the organization's staff and her newly found grandmothers group, she decided to risk exposure for the sake of her grandson, choosing their social death as the lesser of the two evils, but the cost was high.

My family disowned me when my status became public, but I am not so much worried about me. My grandson cannot play outside the house—the neighbourhood children will taunt him and torment him. When he does go outside to play he runs far away. I had to enrol him in a school that is far from here because the teachers and kids should not know his status. I don't know what we will do if they find out, because there isn't another school. As it is, this one is too far for him to come home for lunch. He must buy his lunch, which is costly. It is far for him to travel back and forth; he leaves so early and comes back late.

In response, she is doing the only thing she can—becoming a voice in her community to end stigma. A woman who once could not go outside without cover of a blanket, she now goes door to door and talks to people about HIV. It is a radical move in a community locked in silence. Most listen politely because she is an elder and that gives her a certain authority to speak. Other times she is scolded and driven away. A number of women have responded by going for testing and getting on medication, others by joining NLK; still others have joined her to become community advocates for positive living.

For Asnakech, every household that became a bit more open to understanding HIV, every person who would listen to her, was one step closer to building a community that would be safe for her grandson in the future. Everything she did was clearly for him. Here was love both terrifying and tenacious. A double-edged sword of strength and vulnerability that pressed against her heart at all times.

As we left the house she grabbed my hand, whispering now because her grandson was home from school and she didn't want him to know what we were discussing:

Love is stronger than HIV. That's why God gave me my grandson. He's my heart. He's my courage. He's my reason to live.

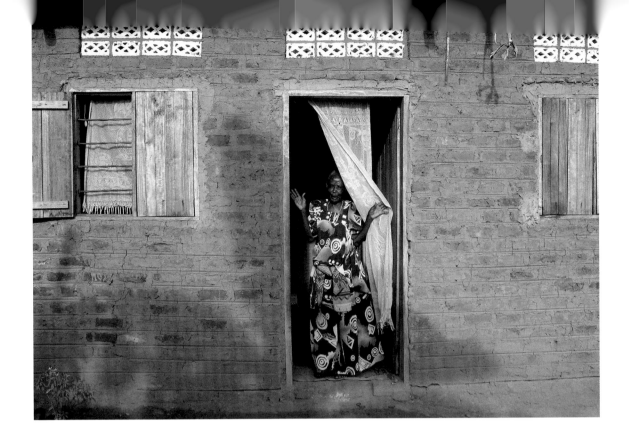

Community Counsellors

When grandmothers tested positive they continued to offer themselves as public models of how one could live openly and well with HIV. This was radical behaviour that required exceptional courage and leadership. As a result, a new type of trust was being built between grandmothers and their communities. They offered a safe space and the first point of counselling for many. Their homes, which had started as havens for their children and grandchildren, became destinations for others with nowhere else to turn.

I find that people are coming here for counselling and support and to ask me about private matters. Some come here and present some rashes or other symptoms and they will ask me what I think it is. I know they are too afraid or ashamed to talk to anyone else. That is when I get an opportunity to talk to them about HIV, about knowing their status and the best way to approach it. Thulisile (SWAPOL), Swaziland

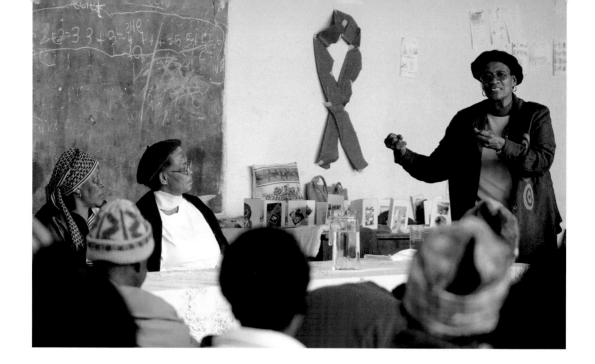

Personally, I am on ARVS. So, people who need help will come to my house and ask me, "We saw you when you were very, very sick. What is it that you did that has really changed your life?" I usually tell them, "If you go and get tested and you are found with HIV, you will be put on medication, you will be given counselling and there is also a support group for people living with HIV & AIDS." So that is how it is. People are getting tested, finding comfort, and getting training on when they are supposed to take their medication and the issue of disclosure. So we are hoping to continue doing this for as long as it is needed. Kenyan grandmother (PENAF), Kenya

The grandmothers had a particularly deft touch with young people. Teens could ask questions without judgment or fear of gossip. Gogos, in turn, knew a lot about disease prevention, treatment, and community services.

It's a big problem that many young people don't know their status and spread HIV far and wide. We grandmothers have targeted working with them. But we don't just lecture them—we talk to them in a kind way. Often we find they have more serious problems on their mind, like they can tell us that they don't have anything to eat. And we tell them, "I have flour, come, let us share this." And then we become friends, they can listen to us. They understand what we are saying and they go for the test. Life continues. That is what it takes to connect to these kids. Lucia (YWCAA), Kenya

Regina Mokgokong, executive director,
Tateni. *Mamelodi, South Africa*

When teens come to me asking me to take them to the clinic, I take the time to counsel and educate them beforehand. I explain to them how the virus transmits more easily to women and how to protect themselves. I ask them, "What will you do if you find you are positive? Will you tell your girlfriend or boyfriend?" And they always say they won't tell. That's when I tell them, "Do you realize that you are killing each other?" I advise youngsters to go with their partners to the clinic to be tested. Or I will go along with them.
Nokuthula (HACT), South Africa

Holistic Treatment: It Takes More Than Medicine

As the years progressed the grandmothers were becoming the growing voice of experience and authority on how community programs in tandem with medication were the only solution for successful treatment. Funding for medication was essential but could not come at the expense of supporting the community-based organizations that were key to ensuring people could access treatment and stay on treatment.

Now there is medication for HIV and with it you won't even get to the stage of being sick. So you might ask, "What's the problem with these people who are not getting treatment—are they ignorant?" No, but there is a problem around not being educated. Many just don't understand the disease, especially in the rural areas where so many didn't get a chance for school. What causes people to choose traditional medicine over the clinic? What causes people to go to miracle churches? There is even a myth that persists that if you sleep with a virgin it will go away. So if you look at that, all of that is caused by what? It is fear and not knowing—so that is where we must start. Just telling people to take pills, that is ignorant. Olga (GAPA), South Africa

You know, our grannies have changed so much. When we first started to work with them it was because they were the ones in our communities that were the most desperate and needed the most help. For those who have been in groups all these years, they are now the people we work with who are the most advanced, who have the most to offer their communities. Cebile Dlamini, program coordinator, SWAPOL, Swaziland

Mama Zodwa Ndlovu
"Don't Sweat the Small Stuff, Baby"

Co-founder and executive director, Siyaphambili
Umalazi, South Africa

THERE IS a phrase that is often repeated in South Africa: "If you strike a woman, you strike a rock." This line is almost always delivered by an older woman with a defiantly tilted chin and eyes that betray how hard won this truism is. It takes a lot of striking, perhaps, to realize you are that strong, that unshakable.

From the moment you meet Mama Zodwa, it is impossible not to sense that strength. Physically, Zodwa is of medium build; her smile is easy and she has a penchant for affectionately calling people "Baby." But she just feels like a woman in charge.

This was only reinforced throughout our afternoon visit to her organization Siyaphambili, in Umlazi, outside of Durban, South Africa. In 2001, Zodwa, along with four other HIV-positive women started Siyaphambili in order to provide home-based care and HIV education and counselling to her community. The other four founders have since succumbed to AIDS, but she is not doing this work alone. Zodwa has a small army of workers—all volunteers, many of them HIV positive themselves.

Inside the centre, about 20 volunteer HBC workers were milling about, signing in and preparing for their home visits. They spent three days a week performing house visits and the other two at the centre receiving ongoing training or working on Siyaphambili's new garden, which supplies their feeding program for vulnerable children.

Flip charts taped to the wall were covered in writing from a recent workshop for the caregivers on HIV counselling. In the middle of the room was a large pillar that seemed to hold up the entire building. Prominently pinned to this central structure was a rather well-worn piece of paper. It looked as if it had been handled many times, and it was clearly a working document, not framed or ironed onto a plaque. It was the Toronto Statement from the 2006 Grandmothers' Gathering in Toronto.

By the time we sat down with Zodwa in her home for a personal interview, we had more than a clear picture of her: a consummate professional, a galvanizer of people, and a respected leader. This was a hard-earned status, so it was all the more courageous that Zodwa was willing to step

away from the safety of these roles and speak from her most personal and vulnerable place, that of an HIV-positive woman and a mother who had lost her children.

She chose a bedroom in her home as the location for the interview. We had to lift the swollen painted door up an inch to get it open where it brushed against the small chair pressed between the bed and the dresser. Zodwa took her seat in this small cramped space and began.

My daughter got sick in 1999, early. Before that time, I was still working as a nurse on the infection control ward. In those days we didn't know it was HIV, just that it was big and it was a killer.

The hospital demanded secrecy around dealing with this disease. Understand, this was part of our working policy, total secrecy or you risk termination. From the earliest days, that stigma around HIV was built right into the health system.

My daughter was admitted to a hospital in Eastern Cape, which is far from here. So I retired from nursing and travelled there to be with her. I was staying at the home of a friend who was a nurse at the hospital where my daughter was. Every night I begged my friend to tell me what was wrong with my daughter, but she wouldn't. From April to July, I begged her. And then on the night of July 27th, she told me. And then I finally knew: HIV. No cure, no treatment. I knew the best I could hope for my daughter was that she would die a dignified death.

So my daughter did die. And the entire time she never told me she had HIV. In the last days, I had time with her to talk from my heart. I think she died a dignified death because I was around. She died with dignity and she died loved.

After this time, I continued my work with HIV, but not as a nurse. I volunteered for Treatment Action Campaign (TAC), talking to mothers and people at the clinic. I started to work with four women, visiting the homes of women with sick children and providing care—this was the beginning of Siyaphambili.

One morning in June I came home after a home visit and saw my house burning. This used to be my son's room and he was inside here. He had taken petrol and thrown it on himself and burned himself to death. He was 21. I didn't cry. I only said, "God what

*Zodwa. Umlazi, South Africa
(Siyaphambili)*

is happening? What have I done to you? Why is this child killing himself?" I buried my daughter in January, now in June my son is burning himself.

A month later when I was cleaning the room, taking all the mattresses out, I saw a letter. He wrote, "Mama, I could not stand that I am HIV positive, and we have buried my sister and now you are going to bury me." That is when I cried. I said, "Why should this child do this? Because now I have got the knowledge of how to live with HIV." I cried, and I was angry—doing all this volunteer work, I am helping other people with their children who were HIV positive, but I could not help my own child! He thought he was saving me from the pain of a killer disease, but this was much worse.

Now I was left with no children.

You know what I said to myself? "No, I don't want other people's children to die like my own children." This is what I told myself. "I am going to work with this animal of HIV. I want to fight it. And I also want to help people. I also want to educate people about this disease. I want everybody to know what HIV really is."

Then, in 2002, I tested positive for HIV myself. I went for testing as part of my work at the clinics. I said to everyone, "We must get tested. We must know our status." So I went for testing. I'm telling you, this time in my life was so dark. I didn't stop my work in the community, but the stigma and discrimination was almost more than I could take.

We just kept moving forward. I kept on with the work I started with those four other women in 2001. You know, the name Siyaphambili means "We are growing up." And we have been growing up!

Now that the work with Siyaphambili is going so well, last year I also started volunteering in the prison, counselling the prisoners who are HIV positive. I don't know what led me to start this on top of all my other work, but I had in mind that there must be people who are HIV positive in prison and who are suffering.

It was difficult to get in because prisons are very closed places, but I didn't stop. I just kept pushing and talking and eventually I got through those doors. And what I found was worse than I imagined. The discrimination in prisons towards HIV-positive people is very heightened. They get harsh treatment from all over—from the hospital, from the guards, from their peers, and even, I'm sorry to say this, the nurses. Everyone treats them like dirt, and they have no one to talk to. When I first came I would hear people saying, "I can't get my medication refilled. The last time I had my ARVS was two months ago." So I fought with the managers at the hospital and now I think it's a little bit better because I'm there.

I have been doing this for a year now and it's going very well. And I am getting used to it. The prisoners are, too, and they are coming and talking to me. It's easy now to get treatment. If someone is HIV positive, they will say, "Wait for the Mama. Wait for the Mama." When I get into the prison, in the first gate, I will see the list of the people who want to see me. I go and see them. It's easy now.

When I sit and think about all the work that is going on, I'm thankful for all these volunteers here. And I am also thankful for those grandmothers from the Campaign. You know why I put the Toronto Statement up in my office for all to see? Well, it inspires me. It is always on the wall. People come into our building and say, "What is this for?" I explain that there are grandmothers in other countries who are joining hands with us as African grandmothers to fight HIV. It also reminds me daily that they are with us. And it reminds me of all we heard in 2006. It is calling all the grandmothers to action. So I thought to myself, let me put it here, because everyone will see that we are not alone in the battle against HIV & AIDS.

I am 62 years old now and have so many years living with the virus, and I am not shy to say it. I will work myself out until I reach my goal. But you need community. This isn't a goal I can reach alone. Because even if today I am alive and kicking, I know that I have got this virus in my veins that is running through me, and I know one day, one day, it will get me. It will hunt me, it will catch me. But today I am still alright, I am alive. I'm well and good. I have learned something about not taking the difficulties to heart.

Don't sweat the small stuff, baby. There is too much to do.

Becoming Experts on Child Treatment

As the guardians of the children orphaned by HIV & AIDS, African grandmothers accumulated more experience than anyone in treating children: getting them tested, accessing counselling and medication, helping them disclose and dealing with pressures from peers and siblings.

I am the one who gives the orphans the medication. They cannot take medication when they are very young, and even when they are a bit older, they won't remember to take it every day even if they try. ARVs are very strong drugs, and even more so for children. They must always be taken with adequate food. I must always be sure there is plenty of food.
Zimbabwean grandmother (MASO), Zimbabwe

When you have a child in the home who is positive, you have to talk to the other children in the home, too, saying that the drugs are only for this child, so they don't touch, they don't tamper with the drugs—because children are curious and wonder why only one of them is getting something.
Kenyan grandmother (PENAF), Kenya

It can be difficult when it reaches the time for telling the child the reason why they are taking the drugs. When it came time to tell my own grandson, it was at the point that he was refusing to take the drugs saying, "Jjaja, why must I take them? I am tired of them." When I told the child why, he understood. Nowadays, the child takes the drugs and even reminds me, "Jjaja, isn't it time for me to take the drugs?" Glades (PEFO), Uganda

Children feel the stigma. If they go to school with rashes everyone will stay away from them. It is painful for them. The teachers are not trained properly on how to deal with these children. There is a school where we were having difficulty with the head teacher and how he was dealing with children who are positive. The medicine must be administered during the time the child is at school. They told us to do it from home, which is impossible. I explained and said, "At break time, please give the child some small thing to eat and administer the medicine." But they said this is not when the school serves food, that is only at lunch and they do not allow any food to be brought from home.

I reacted roughly because they are putting children at very great risk. Very great risk. Mariam (PEFO), Uganda

We grandmothers are becoming spokespersons in our communities for breaking the silence around HIV status, but it is another thing entirely when it comes to having to tell your own grandchildren that they are positive. This is something that is more difficult than I can ever explain. Grandmothers want to tell their grandchildren but something raises from deep within, chokes us and takes our voice away. There is no way we can do it without counselling, education, and, most importantly, support from each other. We motivate and inspire each other. It is the other grandmothers who put wheels under my feet so I can move forward down the most difficult path. Eunice (Keiskamma Trust), South Africa

Nya Nya Philister Ondiege "We Have Chosen Life"

Pendeza Africa (PENAF), Kogelo, Kenya

WE VISITED Philister at her home outside of Kisumu in Western Kenya. Her compound was spacious and rolling, dotted with mature trees. She had a large garden where corn, cassava, beans, and sweet potatoes were growing. We would learn later that since she began receiving support from PENAF, the produce from her garden has fed all of her grandchildren, with enough left over to trade for flour at the community grain bank run by her granny group.

At the foot of the largest tree in Philister's yard an outdoor fire was crackling with a giant pot resting atop the flame. Children buzzed around, too many to count. There was a clothesline strung between two trees that looked long enough to service several families, no doubt the intended purpose, as this was a family compound. Five homes were scattered across the property. All had firm roofs and strong brick walls. They were sturdy but strangely silent. Upon second glance, the windows were boarded and the doors were padlocked. All of the homes, save the one Philister stayed in, were abandoned, if you didn't count the house serving as a chicken coop.

It felt like a ghost town. Scattered among the trees, low to the ground, were the final pieces of the puzzle—there were graves everywhere.

Philister was the only remaining adult in her family. Everyone had died: husband, in-laws, uncles, aunts, sisters, brothers—gone. All lost to AIDS. Philister was literally the last woman standing. And she, too, was HIV positive.

Philister shooed the grandchildren out of earshot, then pointed out each grave on her property, sharing who was buried there.

My sister-in-law passed in March of 2005, my husband in April. My brother and sister-in-law are there, they passed in 2006…

It was a long list and it soon became evident that not only had she lost every adult member of her family, she had nursed each one up until their death. She reflected on those early days when everyone had died and she was left alone with seven grandchildren under her care.

It was painful. I cried and I mourned. I remained alone. People all kept away from me. I struggled to provide for my

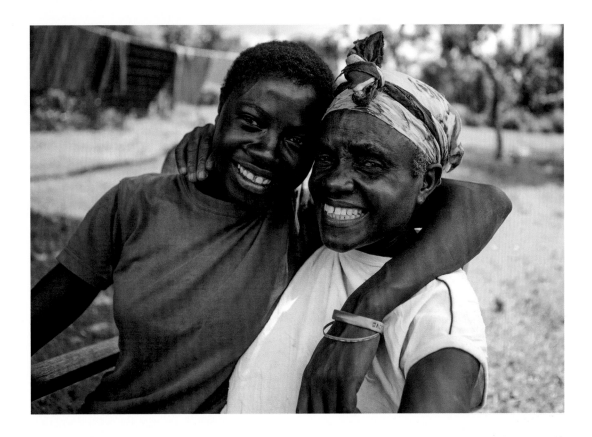

grandchildren, because this was before PENAF was there, before my granny group. I was left to provide everything they needed for school and food and housing, but also I had to be their mother and their father when they were scared or upset. And I was so weak, because of my own health. I also tested positive for HIV. Those days were very dark and difficult.

Asked how she had managed to stand again after falling so low, Philister underwent an instant transformation. It was as if a light had snapped on behind her eyes.

She smiled a half smile and gestured with her head toward the cooking pot, where all the grandchildren had clustered and she uttered one word: "Beatrice."

For a moment that was all she said. Then she went on.

When Beatrice's parents died, she was three years old. From such a young age she loved me so much and she took special care of me. I could be sleeping here on the ground because I wasn't feeling well and Beatrice could come and sit next to me. When I was weak Beatrice would make me porridge and

Philister and granddaughter
Beatrice. *Kogelo, Kenya*

I could eat that even when I didn't have an appetite. That child has made me so happy. I was left with seven grandchildren; I love them all so much, but Beatrice is the one that helped me to get back on my feet.

After some time, I took my grandchildren to the clinic for testing because all of their parents had died of AIDS. Six were negative and only one positive—Beatrice.

Beatrice was not told about her diagnosis; she was far too young at the time. Philister agonized about what would be the right moment to tell Beatrice and wondered if she would have the strength to do so.

I waited until she was 10 and then I brought her to the clinic so that the doctor could explain that she is HIV positive. She cried and cried.

On the walk home she was still crying, so I took her hands and I told her, "Beatrice, you see the drugs I take every day? Those are the same drugs as yours, for HIV. Nya nya is the same as you. You see how I am strong? You see that I will live long? If you take the drugs you will also live for long. I want you to be strong. So I'm asking you, at the time when you are taking your drugs you should also give me mine. You take and I take, we can help each other."

She didn't know that I was HIV positive; she learned on that day. She's 15 now and has been taking the drugs for five years.

As if on cue, Beatrice came over and wiggled in beside her nya nya. Beatrice shared a bit about PENAF's Kids' Club that she attends for HIV-positive youth. She told us that the club helped her accept her HIV status and that she was especially pleased to get a school uniform through them. She said she wanted to become a doctor someday so she could give back and help others.

As Beatrice spoke, pride, love, worry, and no small measure of sorrow danced across Philister's face. When Beatrice made her way back to the circle of children, Philister spoke.

I do still worry about the future for Beatrice. As we walk through this life we are different from people. Some wake up in the morning and they can just do their activities; Beatrice has to take drugs. Before she sleeps she must take drugs. If Beatrice refuses to take drugs, she'll die.

When I was first diagnosed with HIV I wanted to die. But now I can say that I am grateful, because this is something that I can share with my Beatrice. I can understand her and she doesn't have to be alone in this. We help each other. She is strong because of me; I am strong because of her. You know, all these graves are here and I walk past them every day but I don't even see them anymore. I am focused on life. For me and for Beatrice, I have chosen to be alive. I cultivate my vegetables. I go to my group. Beatrice goes to school. We take our drugs together, morning and evening. We have chosen life.

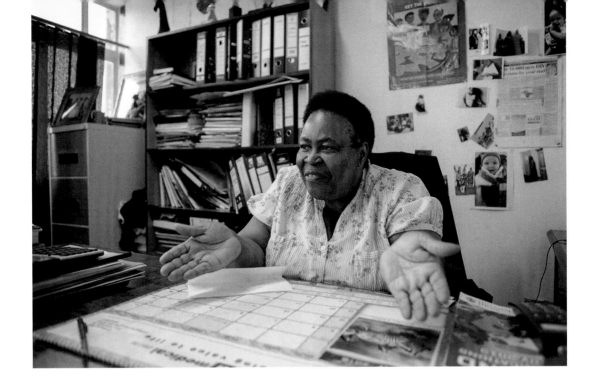

But Where Are the Grandmothers?

The African grandmothers were developing a respected voice and becoming visible in their communities, but despite all of their progress they were still relatively invisible in the forum of the international AIDS response. Take the issue of pediatric treatment. Here was urgent new territory for everyone involved in the AIDS response—from the drug researchers and the medical personnel administering the medication to international policy-makers and national governments developing health care priorities. But where were the ones who actually ensured hundreds of thousands of children got their medication and took it, who brought the kids to the clinics for checkups and monitoring, who dealt with disclosure and HIV prevention education for children and teens?

Grandmothers were transforming the situation on the ground and creating new, essential knowledge, but the wider world had yet to observe and absorb what they had to teach. It was time, once again, to bring the international world up to speed on the changes that were taking place at the hands of the African grandmothers. It was time for another grandmothers' gathering.

Siphiwe Hlophe, co-founder and executive director, SWAPOL. *Manzini, Swaziland*

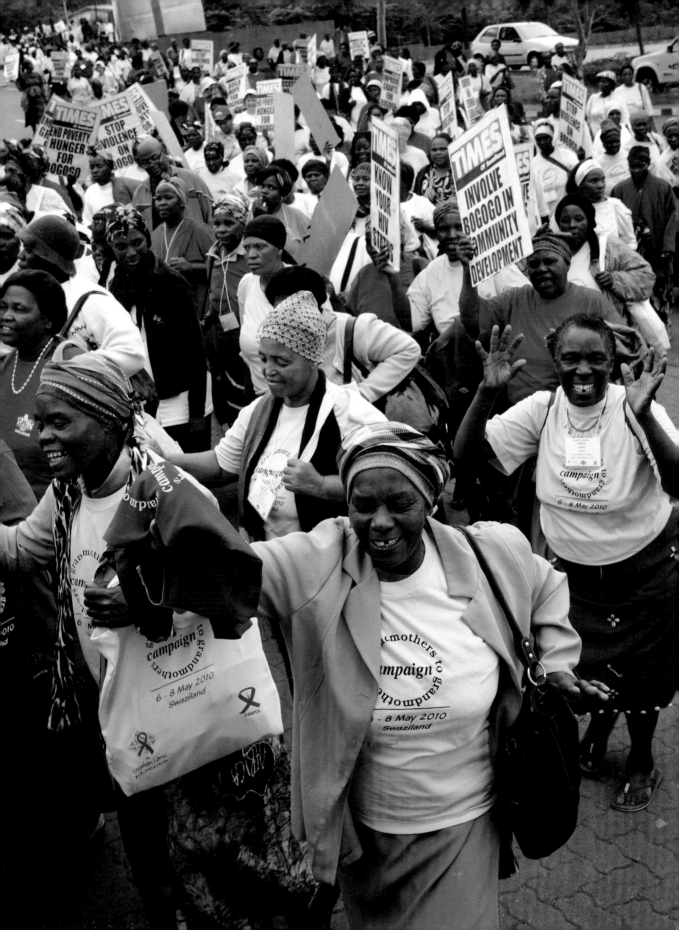

If you talk about real hope, it was there at the Swaziland Gathering. What the African grandmothers have endured, and are enduring, is shattering, but the force, the energy in those women, and the idea that they were doing it all themselves—that was hope. The Toronto Gathering was hopeful, too, but this was on a different level. It felt like I was witnessing a movement starting in Africa.

Donna (Nan Go Grannies), Nanaimo, BC

9

An African Grandmothers' Gathering

From Basic Needs to Basic Rights

FACING: African Grandmothers' Gathering march. *Manzini, Swaziland (with SWAPOL)*

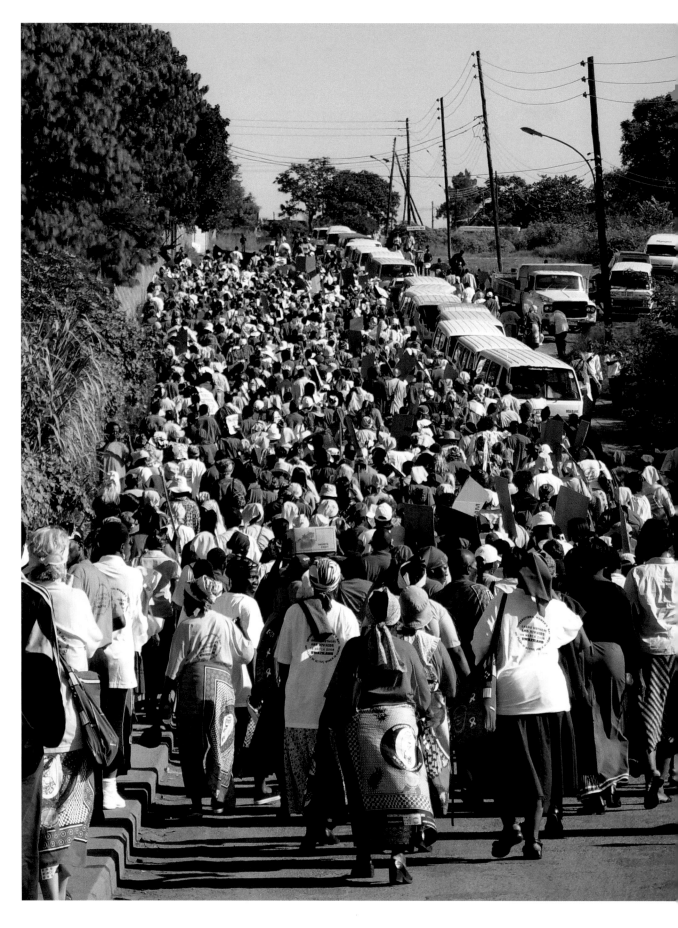

Swaziland Grandmothers' Gathering

On May 6, 2010, African grandmothers reconvened, this time in Manzini, Swaziland, for another grandmothers' gathering. Five hundred grandmothers from thirteen African countries came together for three days of workshops, meetings, activities, and of course, a culminating march.

The gathering in Swaziland had a different focus than the one four years earlier in Toronto. This time it was about African grandmothers coming together to compare notes, network and chart a course forward. This was an international gathering for African grandmothers on African turf.

Canadian grandmothers were also present—42 proud delegates—who had been nominated from groups across the country to represent the thousands of women in the flourishing Grandmothers to Grandmothers Campaign. While the main purpose of the gathering was for African grandmothers to discuss their issues and strategize with one another, the Canadian grandmothers were there as witnesses, rapporteurs, allies, and sisters in solidarity.

A Grand Reunion

Much had changed since the Toronto Gathering, and grandmothers from both sides of the ocean were anxious to meet again.

The Canadian grandmothers were excited to share how their campaign had grown, how much they had personally gained from being in partnership with the African grandmothers and how the pledge they made to each other in Toronto was still very much alive: "We will not rest until you can rest."

The African grandmothers were equally eager to share how far they had come since the first gathering and how much they had done with the financial support that had been entrusted to them. They were women with new roles and responsibilities, new status in their communities, and a sense of possibility.

Their reunion was nothing short of electric.

We were happy to see the Canadian grandmothers there. We were so excited for them to see that there were some actions that were happening since we last met. After Toronto we were able to start doing things, like some income-generating activities, getting our children in school. So we were proud to see them coming, so they can see our progress. Swazi grandmother (SWAPOL), Swaziland

Tinie from Port Perry G-Moms (*Port Perry, ON*)
is greeted by a South African grandmother
from Johannesburg (*with Big Shoes*).

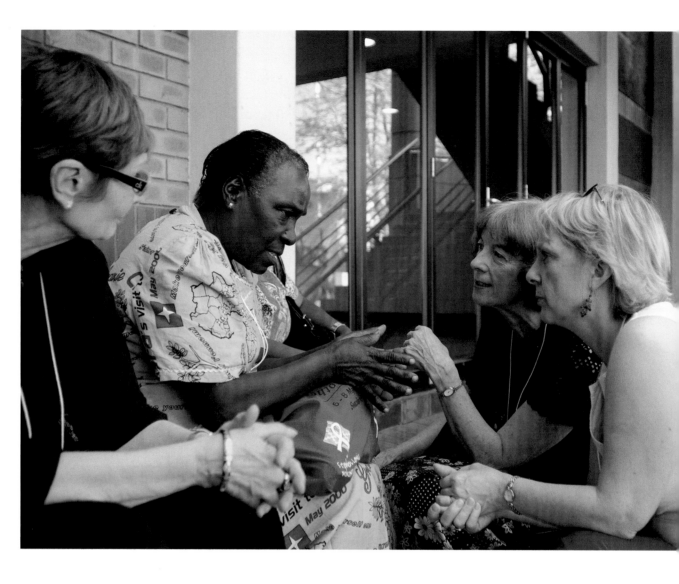

When I left the Gathering in 2006, I was sick inside, literally sick inside, so great were the needs of the African grandmothers and the obstacles in their path. And then when I went to the gathering in Swaziland, I admit, I was a bit afraid that I wouldn't be able to go through that again. But then we got there and they were jubilant and celebrating, and one of the African grannies said, "You see we are different? We grannies refuse to die, we refuse to give up." And I sure could see they were different! Pat (G4G Shellbrook), Shellbrook, SK

Audrey (*Yukon–Northern Lights, Whitehorse, YT*), Jenny (*G4G Saskatoon, SK*), and Yvonne (*Ujamaa Grandmas, Calgary, AB*), at the African Grandmothers' Gathering, Manzini, Swaziland

When we all met together again in Swaziland I think the Canadians were astonished at how far the African grandmothers had come in only four years, and it's funny but the African grandmothers felt the same about them. And they also began to appreciate these grannies from Canada as allies. I could hear comments from them like, "We're in this together, we are actually partners in this. This is different." Mercy Chidi, co-founder and executive director, Ripples International, Kenya

From Basic Needs to Basic Rights

What became clear at the Manzini meeting was that a remarkable transformation was taking place. African grandmothers now had a modicum of resources that allowed them to create some basic, immediate security for their families. With their own burdens lightened, they were starting to grapple with the larger economic and social challenges. This was no longer about the provision of basic needs; grandmothers were starting to talk about how to secure basic rights.

Over these three days in Manzini, the discussion was about the broader social changes needed to improve their access to health care, to ensure children could stay in school, to prevent violence and land grabbing, and to secure adequate pensions. They began to identify the national and international systemic barriers that were contributing to their crisis and standing in the way of their recovery.

The African grandmothers compared how government services differed between nations. Swazi grandmothers were surprised to hear that South African grandmothers were receiving pensions on a regular basis and at twice the amount as the pensions the Swazi grandmothers were entitled to receive (when they did receive them), so they started making plans immediately to bring this issue forward to their own government. Ethiopian grandmothers, on the other hand, were shocked to hear that grandmothers received pensions at all. Ugandan and Tanzanian delegates wanted to understand how land rights were being addressed elsewhere in order to tackle this issue at home.

Canadian grandmothers were doing what they do so well—actively listening, engaging in conversations, building relationships and preparing for the substantive task that awaited them when they got home: disseminating what they had learned to their grandmothers groups and communities, and figuring out strategies to support the evolving work of the African grandmothers. They also assisted with the enormous task of recording every workshop and conversation to feed into the comprehensive Manzini Statement.

It was a whirlwind three days culminating with the grandmothers taking to the street once again—marching and singing, waving placards and fists as they cried out, "*Phezu kom khono!*" ("Raise your arms, women!")

The march—we loved it! We feel like we can do it again. The issues are so serious, and in our culture you won't find gogos marching, this is very rare. So if you find elder ladies with the placards walking like this you know it is a very serious issue and it gets attention. Swazi grandmother (SWAPOL), Swaziland

I was at the march in Toronto as well, but this time, when I saw those grandmothers in Swaziland marching, I was struck with the thought, "These women can overthrow governments, they can do anything." Donna (Nan Go Grans), Nanaimo, BC

At the end of the march everyone gathered one more time. Two grandmother representatives, one African and one Canadian, took to the podium for the reading of the Manzini Statement, their platform of action. Most notably, this statement introduced for the first time the concept that the African grandmothers were moving beyond having their basic needs met and beginning to include demands for their human rights. When they were done, the room roared with cheers, applause and shouts of "Viva grandmothers!"

In both Africa and Canada, grandmothers returned to their homes energized and eager to take their work to the next level. They felt one another's support more strongly than ever before. "We are not alone," once uttered with an air of disbelief, was becoming the battle cry for women who were forging ahead with a common purpose.

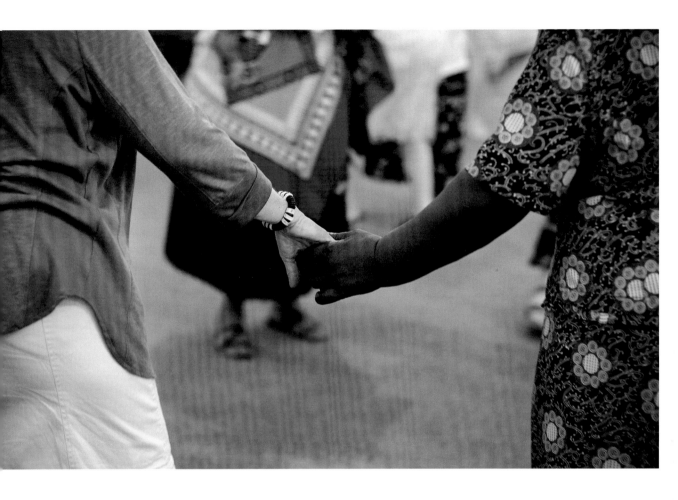

I felt a big responsibility coming back like, "OK, we're all in this together, so let's go!" I started lining up public speaking, I think I did 18 engagements in 14 months, but I loved it. Hilary (Omas Siskona of K-W), Kitchener-Waterloo, ON

We grandmothers were very proud of all we had achieved in our community, but after Swaziland we were feeling that actually we were achieving even something larger—in Uganda, in Kenya, in Swaziland—grandmothers were the ones doing it. This was the message to our group at home, "Look here, grand-mothers, we are not alone, there are so many working—all over Africa, all over Canada. Together big things are happening." Mariam (PEFO), Uganda

African Grandmothers' Gathering.
Manzini, Swaziland

Manzini Statement

WE ARE GATHERED here in Manzini, Swaziland—500 grandmothers from fourteen countries, sharing our experience and knowledge and celebrating our progress in beating back the ravages of HIV & AIDS. In 2006, at the first Grandmothers' Gathering in Toronto, we heralded the dawn of a new movement. Four years later, the strength and momentum of our movement are undeniable. We, the grandmothers of Africa, issue this clarion call to the world.

In 2006 we were battered by grief, devastated by the deaths of our beloved sons and daughters, and deeply concerned for the futures of our grandchildren. We stand here today battered, but not broken. We are resilient and stand unwavering in our resolve to move beyond basic survival, to forge a vibrant future for the orphans and grandmothers of Africa.

We are the backbones of our communities. We form the core of community-based care. With our love and commitment we protect and nurture our orphan grandchildren. Africa cannot survive without us.

Integrity and autonomy are at the heart of our agenda.

We demand the economic independence to support our families, to provide nutritious food; decent housing; access to ongoing quality education for our grandchildren; and a richer quality of life for us all.

We must have the resources to build our own capacity to raise healthy families and assist one another. We call for more training in critical areas such as home-based care, HIV & AIDS education, on parenting orphaned children and adolescents, health care, literacy, and financial management.

We have lived through the enormity of AIDS in our communities and have played our part in helping our nations survive the devastation. Without us, the toll on orphans and our communities would have been incalculable. Equal urgency and passion must now come from our Governments around the provision of services and the guarantee and delivery of our rights. Urgent action must be taken in these priority areas:

1 Violence against grandmothers. These egregious acts, whether domestic violence, elder abuse, or accusations of witchcraft, must cease and be censured.

2 Grandmothers must have meaningful support in the form of pensions and social security.

3 Laws must be passed and implemented ensuring the safety and rights of grandmothers and their grandchildren.

We will continue to provide a protective embrace around our grandchildren and communities. Our hope, indeed, our expectation, is that our governments will provide our families with the social and legal protections—from inheritance laws to educational opportunities for our grandchildren.

To the international community we say: true sustainability is in the hands of grandmothers and other community activists. We call on you to deliver on your promises. We have reached a real turning point in the struggle to subdue the AIDS pandemic. Now we are seeing the growing impact of our joint efforts, the need for increased and consistent resources is greater than ever.

We are leaders in our communities and countries. We have come together in this historic moment to lay the groundwork for greater support from our friends, our governments and the international community. We will continue to come together until such time as we and our grandchildren are secure and able to thrive. We will continue to stand in solidarity with one another throughout Africa and with our Canadian sisters.

We are strong, we are visionary, we have faith and we are not alone. Together we will turn the tide of AIDS.

Viva!

Manzini, Swaziland
8 May, 2010

Mama Darlina at the African Grandmothers' Gathering march. *Manzini, Swaziland (with New Women's Movement)*

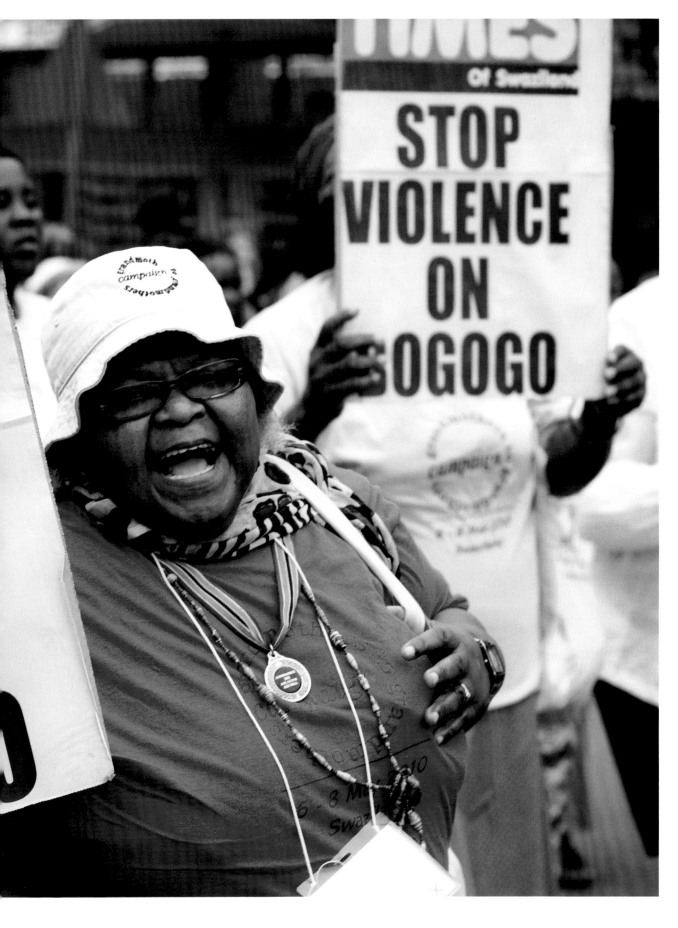

Bringing Manzini Home

The Manzini Statement outlined the priority issues identified by the African grandmothers from the 13 countries represented, and they were surprisingly similar—violence against grandmothers, income security, legal protections for grandmothers and children in their care. However, it was also very clear that the ways these issues manifested in the lives of the grandmothers differed vastly between each country and the strategies for addressing them would also have to be quite different from nation to nation.

Grandmothers realized that they needed to come together at a national level to strengthen their networks and develop country-specific strategies. The idea of *national* rather than *international* grandmothers' gatherings began to take hold.

Bringing all the international grandmothers together in Swaziland was a great start. But truly, now we want to have a national gathering so we can follow up with our government more strongly. We can come together and see what are the action points that we need to be sure the government is implementing, like grants and pensions. The Swazi grannies are feeling that they are coming up now with a voice. We can hold the government accountable. Siphiwe Hlophe, co-founder and executive director, SWAPOL, Swaziland

When we got back to Kenya everyone was talking about wanting to have our own Kenyan gathering. The grannies are saying, "There are one thousand grandmothers with Ripples alone! If the government is coming together, then we must be there to lay out our needs and the issues that we need addressed." Mercy Chidi, co-founder and executive director, Ripples, Kenya

Our grannies are now saying, "We are becoming a strong body and strong voice." They want to be a critical mass across our country so that, for example, during elections when people are going to vote, the grandmothers know that they can determine who can become a leader. Whenever the government is planning, like land rights and health care, they will think to include the grandmothers in the national plan. Justine Ojambo, co-founder and national director, PEFO, Uganda

Prepping for Politics

Before country-level gatherings could take place there was some critical groundwork to cover. The African grandmothers were becoming increasingly aware of their emerging power and began to seek opportunities to use it to prompt substantive change at national levels. And so, work began in earnest to provide leadership and political training.

Training in leadership required little adjustment because the very structure of the grandmothers groups had been nurturing the growth of leadership skills for years.

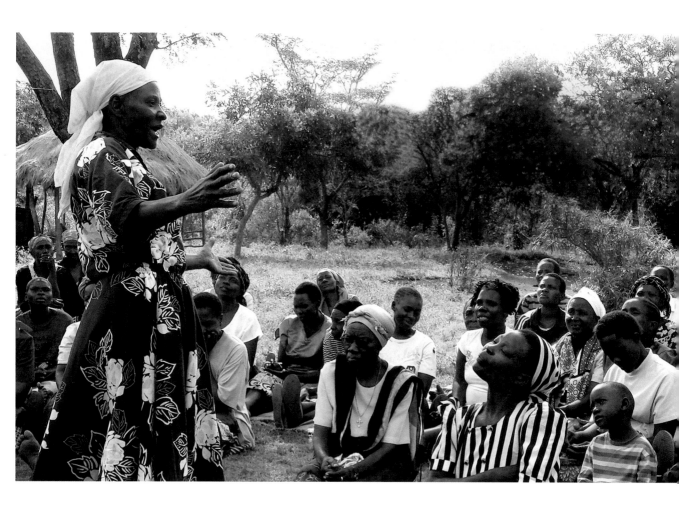

These grandmothers groups were meant to be social support groups, but they also became leadership development groups. This was not our intent, but in these groups the women had to organize themselves. Now they transfer these skills to other community groups, like the church. The grandmothers hear people asking, "Where can we find a treasurer?" and they say, "I can do it because I know how to keep the money." And when they are asking, "Can we find a Chair?" the grandmothers are the ones saying, "I can." Following the gathering in Manzini we started to deliberately nurture this skill among all of our group members because we saw how powerful it was for the grandmothers and how beneficial to the community. Kenneth Mugayehwenkyi, founder and executive director, ROTOM, Uganda

Magret speaks to her community about grandmothers' rights. *Nyanza Region, Kenya (with PENAF)*

We have seen a big change in our grandmothers since their leadership training. If there is a problem in the community, they mobilize, make the call for a public meeting and invite people from outside to come in to discuss the problem they have identified. If there is someone who is sick in the community and not being attended, or a case of abuse, it is the grandmothers who are taking the initiative. Olivia Myeza, chief executive officer, HACT, South Africa

Political training was added to many grandmother programs in order to complement their leadership development. Many grassroots organizations began assisting the grandmothers so they could serve on local councils or run for local elected positions.

We started to look at how we can assist the grandmothers to enter into strategic political positions in their communities. We keep track of all the committees and the requirements to be on them. For example, there's a new HIV & AIDS committee at the sub-county level, and this would be a good place for grannies to be representing themselves. The grandmothers are responding to these opportunities with enthusiasm. Justine Ojambo (PEFO), Uganda

The grannies want representatives of elderly people in local councils, sub-county councils, district councils, and are asking for training on how to run for elections. The decisions made in local councils affect everyone in the village. It's a good starting point. Kenneth Mugayehwenkyi (ROTOM), Uganda

Grandmothers began to win elections and take their seats in local government, but their eyes were on the state as they readied themselves to shake the foundations of complacent governments.

I am 77 years old and I have just won the election and am beginning my role as Chairperson of the Older Persons Committee at the village level. This makes me very proud. It is very important for grandmothers to be involved in politics because we have very pressing issues but the government has left us behind. We are the people now to deliver the older person's issues on the table. I am concerned with health care, and another fellow granny who was just elected to a different committee, she is talking about social assistance and grants for older persons. We believe, if we had representatives at all levels, these issues could be catered for. We hope this is just the beginning.
Mpaata (PEFO), Uganda

Grandmothers for President

In group interviews across the continent, we asked a question that proved especially popular with the grandmothers: If you were elected as president tomorrow what would your first priority be?

Every woman wanted to answer this question and, more often than not, they rose to do it. Some even began to address the room as if delivering their inaugural speech.

When I take my seat as the president of this nation I will support research for HIV & AIDS. I will ensure there is adequate support for all those who are HIV positive, with a special focus on children and those caring for orphans. I will also ensure that these people have access to health facilities and access to free drugs.

Kenyan grandmother

I will ensure that all children go to school and have the supplies they need to stay in school, such as uniforms, along with programs that improve the economic lives of the grandmothers so they do not need to keep their girls home to help them.

South African grandmother

I would provide grants or microloans for women so they can start businesses that will help provide for their families.

Malawian grandmother

As your Madam President I will look into the issue of housing for children without parents. These houses are falling apart and the children are not safe from invaders. It is time to put protections in place for these children.

Swazi grandmother

Older persons are the primary caregivers for the orphans. I would look at financial support such as pensions, grants, and cash transfers.

Ugandan grandmother

I will remember people living with disabilities and those living with HIV. These two groups need grants for food security and access to health care and treatment.

Swazi grandmother

I am a president for the farmers! Farming imports are very expensive and critical in terms of food security. I would provide poor farmers with hoes, seeds, and fertilizer. My government will be subsidising farmers and investing in key infrastructure in rural areas such as irrigation.

Zimbabwean grandmother

I will start with the laws that need to be in place to protect women when they are raped and provide safe places where they can go to report. Old women and young girls are especially vulnerable because no one thinks they have HIV so this actually increases their risk of acquiring HIV through rape. This will change tomorrow.

South African grandmother

Mama Sarah Obama Grandmother of a President

Pendeza Africa (PENAF), Kogelo, Kenya

W E WERE travelling to the village of Kogelo in Western Kenya with Charles Ochome, founder and director of PENAF, to meet Kenya's most famous grandmother: Mama Sarah Obama, the only living grandparent of then American president Barack Obama.

Kogelo is situated approximately 50 kilometres away from PENAF's head office, accessible by a paved highway that was impeccably maintained. PENAF had been working with the grandmothers here for almost 10 years, and Charles was reminiscing about the days when travel to this far-flung area was not so convenient.

It used to take us four or five hours along dirt roads. We had to bring spare tires, usually more than one. When Mama Sarah's grandson became president of the United States, suddenly there were dignitaries and foreign guests wanting to visit her so they paved the road. This was such a benefit for the whole of Kogelo, but, really, we can say that Mama Sarah has been blessing this area for as long as anyone can remember. Long before she became an important lady in the eyes of the world, she was an important and much-loved member of this community.

Charles's vehicle pulled up to the guard-house, in front of the thick gates topped with security cameras that served as entrance to Mama Sarah's compound. Charles shook his head.

They really had to increase security around here. There were actually attempts on her life once Barack Obama became president. So much has changed for her. She's a very busy woman now, and normally you would have to go through months of protocol to formally request a visit—but we are old, old friends.

Sure enough, the guard greeted Charles warmly, opened the gates, and waved us through.

Mama Sarah's lawns were dotted with numerous flowering trees. Chickens wandered freely while a calf frolicked around his mother. In the distance we spotted two women seated under a tall tree on white plastic lawn chairs. Their heads were bent together, foreheads almost touching, like schoolgirls in the yard sharing secrets.

At the sight of Charles, one of the women broke into a wide grin. This was Mama Sarah.

My grandson! You've come to visit your grandmother at last. Welcome!

There was a flurry of greetings and hugging and more chairs were fetched so we could all join her friend and her under the tree. Charles explained his close relationship with Mama Sarah.

I met Mama Sarah when I was in elementary school. She would come and sell small things to the children there: porridge, mangos, guavas. My favourite was her mandazi.* She makes the best mandazi I have ever tasted. She did this for years as a way to form bonds with the children in the village. She would get to know us, check up on us, always encouraging us to keep on with our education. When she could, she would contribute to school fees for some of the poor children. She was an enormous influence on my life. I would not be here today if not for her. Not just me—hundreds, probably thousands of children grew up thinking of Mama Sarah as their adopted grandmother. She has always just had a heart for children.

While he spoke, Mama Sarah had been gazing upon Charles with a look that could only be described as pride. She now joined the conversation.

* A type of fried bread resembling a doughnut.

Sarah Obama and Charles Ochome, founder and executive director, PENAF. *Kogelo, Kenya*

It's true. It has always been in me. I love children. I got involved with the plight of orphans long before the HIV & AIDS pandemic because I wanted to help vulnerable and disadvantaged children to find a means to future livelihood. Then HIV & AIDS claimed so many lives, leaving many orphans behind in the hands of old caregivers. It is a big challenge to many school-going orphans. That's the kind of work I have devoted myself to.

Myself, I graduated from grade zero. I didn't go to school. But my focus has always been education. Through education, an orphan can feel empowered and learn so many things and be independent and in turn, give back to society. So I feel this is the most important thing.

Numerous children have passed through Mama Sarah's life; many have lived with her for a time, including the three currently under her roof (aged 20, 16, and 3), and she says hundreds of others have received some form of financial support for school.

To describe Sarah Obama as striking would be a bit of an understatement. If she hadn't informed us she was 91 we wouldn't have come within a decade of correctly guessing her age. She may not have had any formal education but she was clearly comfortable holding court—she conversed with absolute authority. At the same time, she is impish, punctuating her remarks with small jokes and occasionally wearing the kind of grin that one associates with canary-eating cats.

Our discussion was interrupted by the arrival of a group of delegates from a foreign embassy. Their convoy of sleek black SUVs glided to a stop and men in dark suits poured out. Official guests who had gone through the formal protocols for a visit, they were ushered off to the "waiting area," which consisted of more white plastic chairs lined up under another tree. We felt a bit guilty for intruding on their time. Mama Sarah seemed to be enjoying the situation immensely.

Don't worry about them. It is okay if they wait. It is always men in suits, men in suits. Today I am visiting with friends and men in suits can wait. Besides, we are providing entertainment for them—see?

She was referring to the calf that had wandered over to the visitors and was attempting to lick their suits. She laughed and turned her full attention back to us. It seemed the matter was settled. One didn't argue with Mama Sarah.

She turned the conversation back to Charles and his organization. When PENAF expanded its work into her community more than 10 years ago, she was among the first to get involved, so she could speak to just how much had changed since then.

When PENAF was founded, women came together and I was among them. Charles came with soap and sugar for us so we could sell

them. Later on we were given loans. We would meet as widows and grandmothers. We were discussing the effects of HIV & AIDS in the community, the young children who are left behind to be cared for by the aged. We were learning how to care for the orphans, how to do our businesses, and how to make crafts.

The grandmothers have empowered each other. They started the idea of food banking and they can sell their produce to PENAF. And now there's vocational training at the community centre—there's tailoring and hairdressing classes and there's even computers. Youth who are out of school, they go there and receive training.

Here Charles rejoined the conversation:

When she was part of a group, even then she was a leader, respected by so many women. Then her grandson became a senator in the United States, became president, and things started changing. But she never changed. She just did more and more.

I remember she stood by us in the community during Kenya's post-election violence. There were so many internal refugees in this country—people were chased from the towns. She helped us with food distribution, she helped provide housing. She is just part of us.

Now she has her own organization and she is supporting more than 250 orphans from primary school right through university and has big plans for developing the area. You see the woman sitting beside her?

That is a member of the PENAF granny group. So you see? She became important but she never left us. She is the grandmother to this community. It is no wonder to me that a grandson comes from her family to lead a country that is so powerful in the world.

Mama Sarah, not one to entertain false modesty, simply nodded and added:

It is my heart that Barack and Michelle should be able to help the world, that's what I want. You know, this has come from a long line. His father, Barack Sr., and his grandfather, Hussein, lived to help their community. I also wanted to continue these things. So you can say that there is this spirit in the family. We have that.

As the conversation wrapped up, it seemed fitting to ask Mama Sarah what *she* would do if she were president of Kenya.

My focus would be on pursuing peace. Of course my core interest is to help children go to school so I would focus on education. Teachers would have good salaries and children would have apprenticeships and employment opportunities built into their education. This will also address the unemployment problem in this country.

You know, if you give a child an education anything is possible—maybe they are even going to be the next president. I don't think you can argue with me on that one.

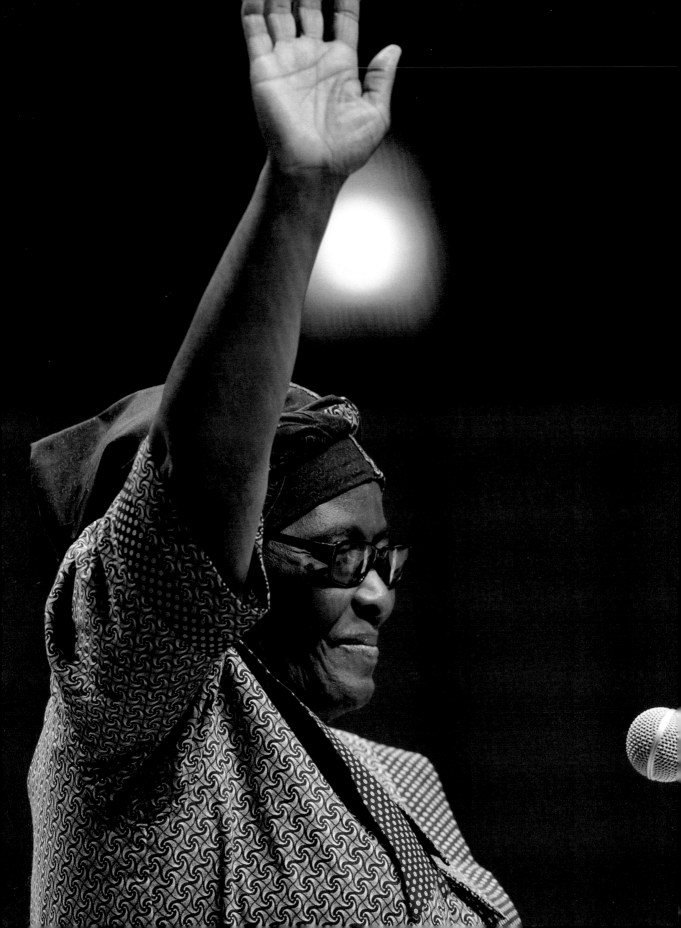

We must come together as one grandmother voice, to demand action from our governments. We are disappearing from their radar. Whether we are asking or demanding, our stories have to be heard. Mariam Mulindwa, African Grandmothers' Tribunal testifier, PEFO, Uganda

10

African Grandmothers' Tribunal

"It's About Rights, Not Charity"

FACING: Zodwa Ndlovu, co-founder and executive director, Siyaphambili, testifying at the African Grandmothers' Tribunal. *Vancouver, BC*

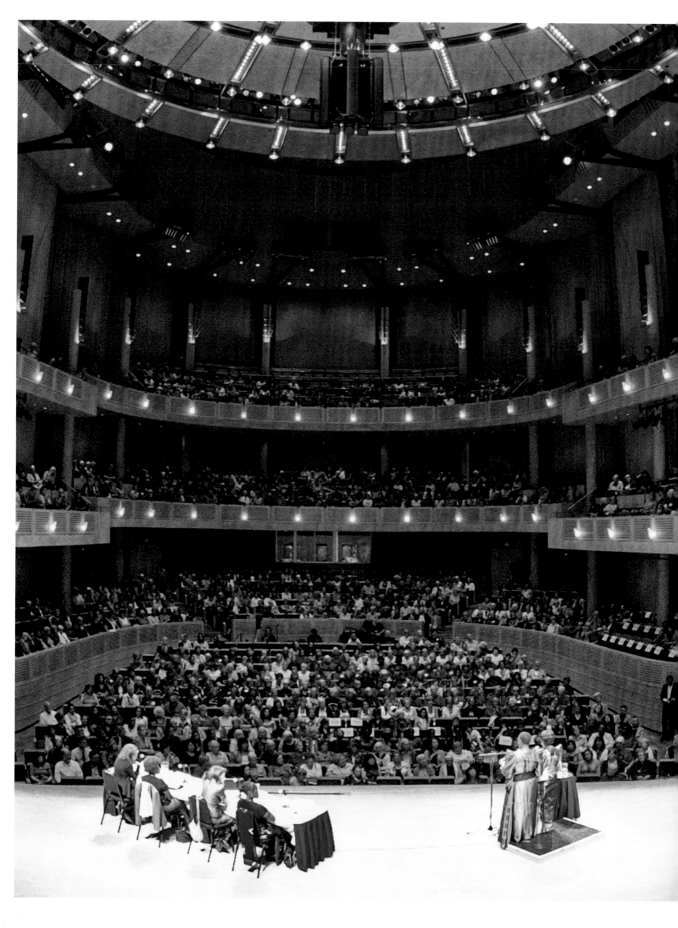

You who are raising the children of the lost—you who are teaching by your lives and by your stories. Perhaps in the future, historians will look back and say: This is when humans re-discovered that we are linked, not ranked. This is when a lethal illness forced females to rebel and males to find their humanity in those who rescued them. This was the time of the grandmothers. Gloria Steinem, feminist, activist and author, African Grandmothers' Tribunal judge

Setting the Stage for a People's Tribunal

For all the progress made by African grandmothers and their newly acknowledged status as elders, leaders, and counsellors, they continued to face injustice in their own lives. And they were still not gaining traction at national and international levels—quite the opposite, in fact.

African grandmothers faced a panoply of tremendous challenges: they were struggling with food and shelter insecurity, having their land "grabbed" by distant relatives, and a woeful lack of access to adequate health care. They were no longer asking for authorities and

FACING: Audience gathers for the Tribunal at the Chan Centre for the Performing Arts. *Vancouver, BC*

governments to be kind to them or to care about them because they were older women who should be supported. The time had come to bravely take the podium as testifiers and witnesses, and claim their human rights. But where to do this? In what international court?

A people's tribunal offered an ideal forum for the African grandmothers to speak out against the transgressions of their rights and name them as human rights violations. Peoples' tribunals such as the Tokyo Women's Tribunal (for women forced into sexual slavery, "comfort women" during the rule of Imperial Japan), the Zambian Women's Tribunal on gender-based violence, and the Global Tribunal on Violations of Women's Human Rights at the UN World Conference on Human Rights in Vienna, have been a powerful vehicle for women to assert that harms and indignities they suffered, which were long-ignored by governments (local and international), were, in fact, violations of their human rights.

The idea that grandmothers deserved better charity was a woefully inadequate and outdated sentiment—what they deserved was justice. What they deserved was their rights. Theo Sowa, chief executive officer, African Women's Development Fund

An African Grandmothers' Tribunal would provide a prominent, international forum for the grandmothers and their organizations to contribute their own testimonies that would illuminate the human rights violations they'd been experiencing. It would provide them with judges' statements (as all peoples' tribunals do) which used real, existing legal frameworks, which they could take home and use in their advocacy work. The tribunal judges would address their conclusions to the world: governments, the international community, and donors.

FACING: Canadian grandmothers provide a warm welcome to the grandmothers testifying at the Tribunal, Vancouver, British Columbia.

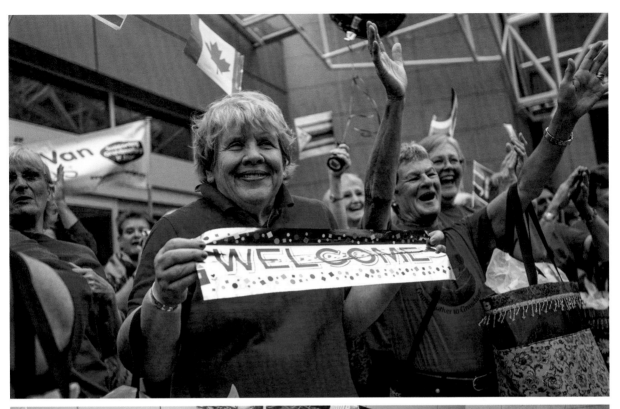

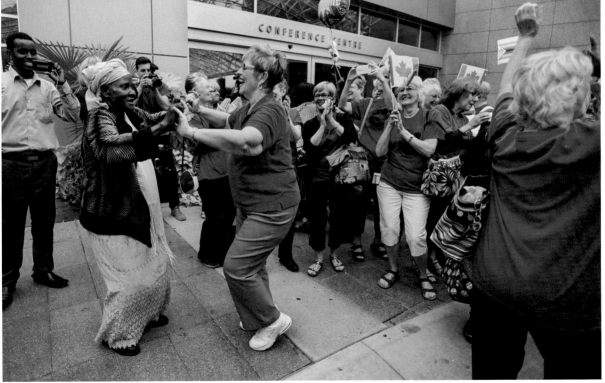

African Grandmothers Take the Stage

On September 7, 2013, five African grandmothers gathered in the wings of Vancouver's Chan Centre for the Performing Arts. With hearts beating fast they waited to take their rightful place at centre stage, to deliver their testimonies.

They had travelled far—from Kenya, Uganda, and South Africa.* They had worked together for a week in Toronto with the Stephen Lewis Foundation and the staff from supporting organizations who had accompanied them on the journey. They pored over their statements, revising, rewriting, reworking, until they were satisfied that every word reflected in an authentic voice their reality and their most pressing issues. The testimonies were as varied as the women who wrote them. They spoke about losing homes to predatory relatives, about sexual violence, and about shouldering what should have been the state's responsibility for the care of orphaned and vulnerable children. They pointed to the astonishing range of rights violations associated with HIV & AIDS that manifested in the lives of their families and communities across Africa.

The Chan Centre was full: the 1,300 people who had come to hear from the African grandmothers included activists and allies, politicians and funders, media, and members of the public—all of whom were led into the auditorium by a procession of hundreds of Canadian grandmothers in matching shirts, brandishing signs and singing "We Shall Overcome." It was a poignant reminder of the thousands of women of the Grandmothers Campaign whose steadfast commitment to their African sisters was equally a part of the history being made that day.

Grandmother after grandmother took the stage and delivered her unflinching testimony. At times the audience wept; at other times they broke out into spontaneous cheers. They listened, spellbound, and roared to their feet with thunderous applause after each speech.

* Missing from their midst was one grandmother from Zimbabwe who was unable to give her testimony in person for fear of backlash from the Zimbabwean government. She prepared a statement, under the name of "Mama F" and it was read on her behalf at the Tribunal.

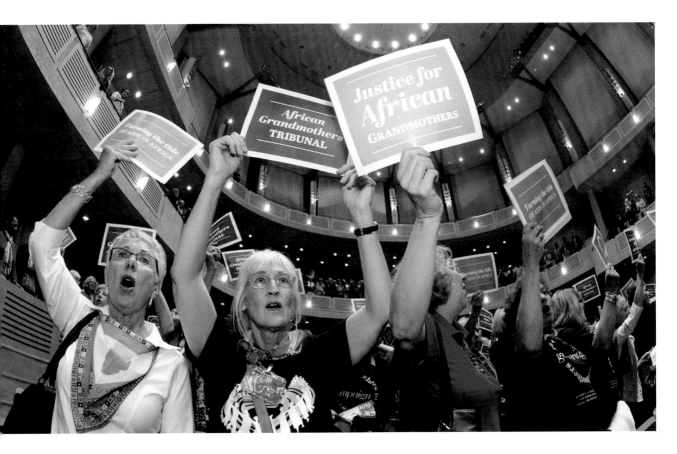

Addressing the audience as expert witnesses were two executive directors from community-based organizations. They spoke about their indispensable role in supporting the grandmothers, asserting that Africa's recovery from the ravages of the AIDS pandemic depended on these forceful and infinitely resourceful women.

Mariam, one of the grandmothers who testified, described her impressions after hearing all of the women deliver their messages:

I felt like I was hearing something for the first time—we grandmothers addressing the world. Behind us on the stage were these big banners that said, "Want to know how to turn the tide of HIV & AIDS in Africa? ASK HER." And I was thinking to myself, "This is true, and this is what is happening here. At last!"

Marg (*Stonetown Grans, St. Marys, ON*) and Donna (*Grey Grannies, Thornbury, ON*) participate in the Grandmothers to Grandmothers Campaign official welcome to open the Tribunal. *Vancouver, BC*

A Taste of the Testimonies

The African grandmothers who addressed the Canadians from the podium were almost unrecognizable from the women they had been seven years ago at the first gathering in Toronto. They delivered their testimonies with resolution and confidence, and they had clear-eyed perspectives on the social and legal obstacles to progress in their communities.

Thulisile (with SWAPOL), testifying at the African Grandmothers' Tribunal. *Vancouver, BC*

I do a lot of advocacy with other women in my community about violence. I am also working as a paralegal, especially for women who are battered. I tell people, "Don't be discouraged, be strong. If you see something wrong, report it." I always tell people they must know their rights. They mustn't be quiet. Mama F, Chiedza Child Care Centre, Zimbabwe

We are advocating with the government... to change the way that grandmothers are being given grants. The grant is supposed to help grandmothers cover the many expenses they have when they are caring for grandchildren. But there's a problem with the law. Right now it says that you have to be at least 60 years old to receive a grant... Women caring for orphans are much younger than 60 and the money comes too late. It is an election year, and we grandmothers are talking to our MPs, letting them know that if they want our votes, they must change the law. Thulisile Dladle, Swaziland Positive Living (SWAPOL), Swaziland

The local government invited me to sit as a member of the Sub-County Land Rights Committee. Since I have joined, all five of the cases we considered, mostly about land grabbing, were decided in favour of the grandmothers. It makes a huge difference to have a grandmother on the committee. Mariam Mulindwa, Phoebe Education Fund for AIDS Orphans (PEFO), Uganda

I'm feeding about 68 orphans every day through a soup kitchen I have set up and the numbers keep going up. I am using my own pension money and the local council still isn't giving any money to pay for the food. I have applied to the Department of Social Development, and they've promised they will do something, but there is nothing yet. Zodwa Hilda Ndlovu, co-founder and director, Siyaphambili, South Africa

It was rousing to hear what these women had accomplished but equally clear that the challenges that now lay before them demanded action at other levels. These were problems that individuals, even ones as preternaturally resourceful and tenacious as these grandmothers, could not solve.

The Judges

The judges for the African Grandmothers' Tribunal were Theo Sowa, chief executive officer of the African Women's Development Fund; Mary Ellen Turpel-Lafond, British Columbia's representative for children and youth; Joy Phumaphi, executive secretary of the African Leaders Malaria Alliance; and Gloria Steinem, renowned feminist author and activist.

In response to the testimonies, all four spoke powerfully and with great urgency about the remedies that must be delivered: to ensure the protection of grandmothers from violence, dispossession, and extreme poverty; to provide decent health care for everybody and education for children; and to ensure food and housing security. Further, they outlined how governments and donors must work to empower grandmothers and community-based organizations to take a leading role in the development of policies and programs to turn the tide of AIDS in Africa.

While their decisions were not legally binding, the judges' recommendations offered something almost as significant for the African grandmothers: a written account of the current human rights violations being experienced by grandmothers along with their demands, bolstered by the authority of an international alliance. It was a powerful tool for every grandmother and community-based organization moving into the realm of advocacy.

Judges' Rulings and Recommendations

The judges' decisions centred on four key areas set out by the grandmothers:*

Income Security
The grandmothers suffer from an extreme depletion of resources, in every sense. They have been emptying their limited savings, farming small plots of land, studying new skills to earn bits of income,

* The following is a summary of the judges' statements. For complete text see: http://africangrandmotherstribunal.org/report/

exhausting themselves with piecework and day labour, and loaning any money they have to each other through table banking. Local grassroots organizations have done whatever they can, whenever they can. It's rarely enough. These families are living precarious lives. And not only are grandmothers given no protection, they have been left to meet the burden of the State's proper responsibilities for the children and vulnerable people in their communities though their own unpaid labour.

Robina Ssentongo, executive director, Kitovu Mobile, speaks as an expert witness to Tribunal judges Theo Sowa, Mary Ellen Turpel-Lafond, Joy Phumaphi, and Gloria Steinem.

Housing, Land, and Property

In cultures where men are the traditional owners of land and property, grandmothers become dangerously vulnerable when their husbands die due to AIDS, or when they are faced with divorce or abandonment. The stories about their relatives' campaigns to grab their land and property are repeated in community after community, across the countries of sub-Saharan Africa, and reflect a pernicious intersection of HIV and discrimination against women.

The challenge that grandmothers are confronting is not simply that they have no legal rights—often it is that these rights are not recognized and enforced in their communities. Many grandmothers are not able to afford the high cost of bringing a legal claim. They also face justice systems that favour people with money. Many are overwhelmed by this many-sided assault and give up—but not all.

Health Care

It's the right time to be seriously reflecting on what the HIV & AIDS response really needs to achieve. HIV & AIDS is a medical emergency only in the immediate sense. At a deeper level it is a profound development challenge and a human rights crisis for the people and communities infected and affected by the disease.

The end point of the response can't simply be seen as "zero new infections." Our goal must be the restored health and well-being of the people who live in countries hardest hit by HIV & AIDS, and the promise of decent futures they can work together to build. Grandmothers are now supporting and caring for a significant percentage of sub-Saharan Africa's next generation. Their continued well-being is essential.

In recent years there has been a dramatic increase in the number of people receiving life-extending, life-saving antiretroviral (ARV) treatment for HIV & AIDS. Unfortunately, grandmothers are not the main beneficiaries of this change. Sex-based and age-based discrimination continue to marginalize them within health care programs.

Violence Against Women

Women living with HIV are more vulnerable to violence. Perhaps hardest for a grandmother caring for AIDS orphans is reporting the violent behaviour of one of her troubled and traumatized grandchildren. Women who must travel long distances to find work, sell their goods, or reach hospitals and clinics for treatment are exposed to attack. Grandmothers, desperate for money to support their families, can be forced into dangerous work, such as illicit brewing and prostitution. Housing that is insecure and in bad shape encourages local men to enter uninvited.

The salient points of the judges' decision included calls for solutions as basic as laws prohibiting domestic and sexual violence, including marital rape, and ensuring that local administrations respect grandmothers' rights in the division of marital property and inheritance. They also put forward more concrete and sometimes innovative solutions, including:

- Compensating grandmothers for their work as community caregivers
- Eliminating school fees and ancillary costs for primary and secondary schooling
- Eliminating harmful traditional practices, such as wife inheritance
- Including grandmothers as a target population in national HIV & AIDS treatment plans
- Making policing and legal aid more accessible and responsive to grandmothers' claims

The Grandmothers' Call to Action

To close the day, testifiers and expert witnesses gathered once more on the stage. Mama Zodwa Ndlovu stepped to the podium once more and read the final statement of the day: the Grandmothers' Call to Action.

With these final words the African grandmothers joined their hands and raised them with a cry:

We shall overcome!
We shall overcome!

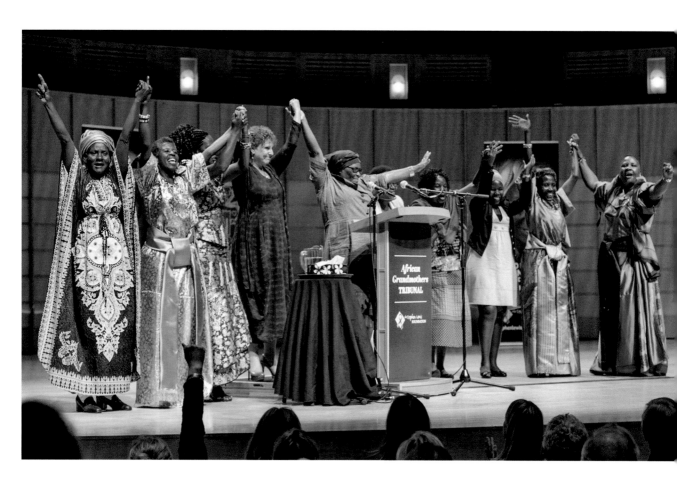

Testifiers and expert witnesses deliver
the Grandmothers' Call to Action

African Grandmothers' Tribunal
Grandmothers' Call to Action

WE RECOGNIZE AND ENDORSE the Judges' statements and recommendations.

They are a true reflection of our concerns and the measures that urgently need to be taken.

Above all what we find true in what the judges have said is that the time has come.

It's time to recognize that grandmothers at the forefront of the HIV & AIDS crisis must have our human rights respected and protected.

It's time to support our organizations fully and put systems in place to address our needs and the needs of the children in our care.

It's time to recognize our contribution to the survival of our communities and the expertise we have developed to do so, by giving us our rightful place and voice wherever decisions are being made.

We, the grandmothers of Africa, speak to you now as the guardians of the future.

Our labour, with all of its struggles, challenges, knowledge and triumphs has gone unheeded for too long.

We will not let the AIDS pandemic defeat us nor destroy our communities, but we cannot prevail alone.

Africa cannot survive without us.

We call on you to act with urgency and purpose to support our efforts to secure justice.

It is time!

Delivered by Zodwa Hilda Ndlovu
at the African Grandmothers' Tribunal
September 7, 2013
Vancouver, British Columbia

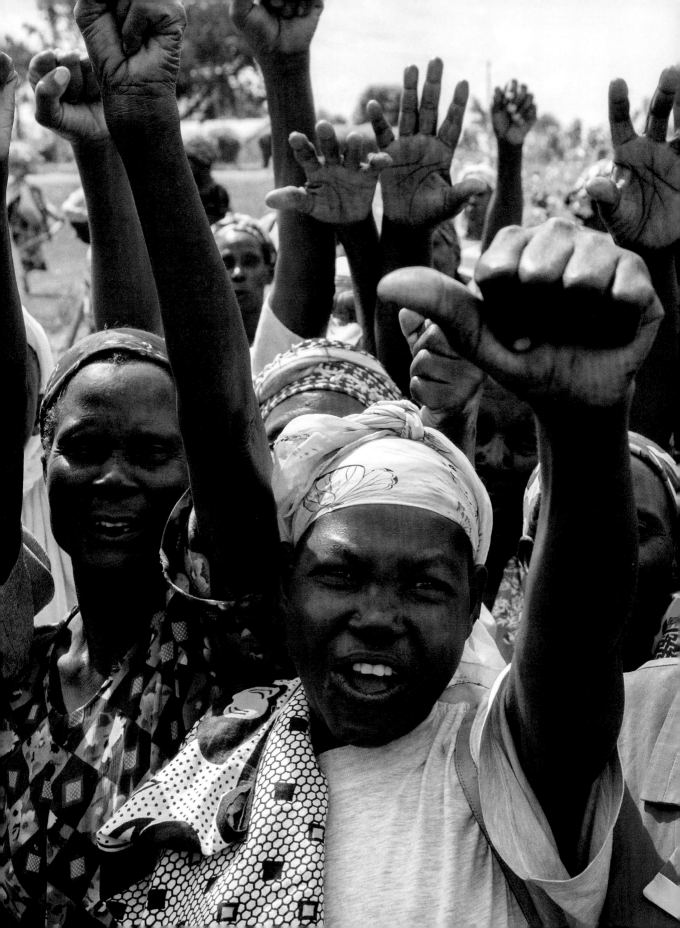

I see the grandmothers as a movement of women working together across the world now. The Canadian grandmothers have empowered us through fundraising and we, the grandmothers of Africa, are good at advocacy and lobbying.

It's older women who've got a lifetime experience of being oppressed. Tell me who has to be stronger on this planet than an African woman? So if you make it to be an older African woman you must be the strongest of all. Mama Darlina, New Women's Movement, South Africa

11
Grandmothers' Rights, Right Now

Claiming Rights, Country by Country

For grandmothers and their support organizations, the time following the Tribunal felt expansive and exciting. The emergence of a rights-based framework, the recognition at an international level of the grandmothers' advancements and their challenges and demands, along with tools to develop their own national strategy—all of this filled out their sails and propelled them along ever more rapidly. The leadership and political training the grandmothers had was benefiting their families and communities tenfold, but it was becoming increasingly clear that if the grandmothers wanted to move into greater avenues of advocacy they now all needed specific training around human rights.

Once more, the grandmothers showed themselves to be astonishingly quick studies.

For all of our grandmothers this was a very new concept. What exactly is a human right? What can that mean for them in their lives? So we had to start at the very, very beginning—around what are rights, what their rights look like in action. We wanted them to understand the role and power of a group in regard to claiming their rights. That was our starting point. It took a bit of time at first and then, suddenly, it all started to click into place. Justine Ojambo, co-founder and national director, PEFO, Uganda

The concept of human rights resonated powerfully for grandmothers. After several months of training, grandmothers began talking about their roles differently; they understood that they were not just providing for their families, they were protecting them.

"Turning Off the Tap"

Human rights training for the grandmothers was setting the stage for them to take on advocacy work, and their community-based organizations, too, began to take on greater components of advocacy.

You know, in truth, we were a little afraid of advocacy. We'd seen other organizations in our country that were doing advocacy, provoking the government, and the consequences they faced. The government here prefers service delivery—that's okay, they leave you alone. But [at the Tribunal] when I saw those grannies giving their testimonies, talking in front of the world like that, I thought, "Why should I fear to go and confront the minister? No! I would be doing a disservice if I just keep quiet, because the grannies are talking about it!" For us, the Tribunal was a push to say, "Now, you cannot afford to sit on the fence, you have to confront." Justine Ojambo (PEFO), Uganda

We were addressing the issue of free primary education on the radio and I heard that the Minister was criticizing me saying, "Oh, Siphiwe has left behind her issues of HIV & AIDS." I responded, "Why should the Minister talk like this?

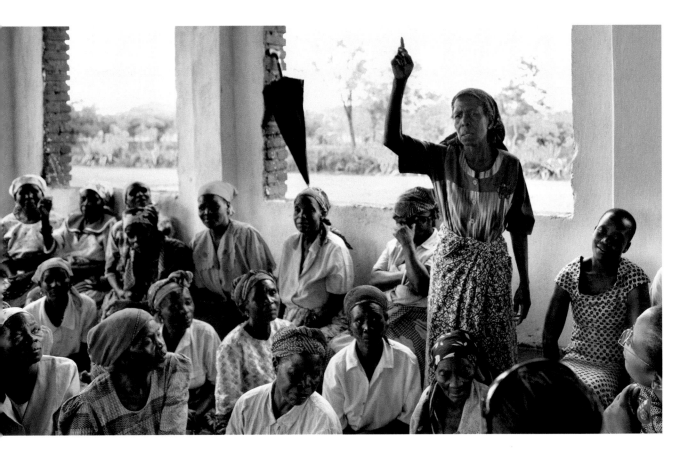

Issues of HIV & AIDS touch issues of education, touch issues of poverty, touch on all the issues that impact grandmothers."

People fail to see that our national advocacy in all of these fronts is HIV & AIDS work. It is grandmother support work. Nothing is more important than African civil society being empowered to do their advocacy with the government that they elected. People fail to see all of these connections. But they will. Siphiwe Hlophe, co-founder and executive director, SWAPOL, Swaziland

We have grandmothers whose granddaughters are being sexually assaulted. There is a need and this need requires us to intervene. But as long as we are just responding to cases of assault, it is like we are just mopping the floor while the taps remain wide open. Advocacy asks the question, "What can we do to turn off the taps so that we stop mopping the floor?" And turning

off the tap is looking at the national and international laws that exist and the rights that exist to ensure the laws are being enforced. It's ensuring the grandmothers know these rights and how to demand them. It's mobilizing to demand changes when the laws are inadequate or abused.

Let us be clear: we are all still mopping, but we are trying to turn off the tap as well. Advocacy complements our service delivery. But let me tell you one thing—it is much harder to find funders willing to support African advocacy. Mercy Chidi, co-founder and executive director, Ripples, Kenya

Setting their Sights on the State

The African grandmothers were ready. Their training in leadership, politics, and rights, along with the advocacy tools and international backing from the Tribunal, had brought them to a place where they were ready to take their rightful place as elder stateswomen in their own countries. It was time at last for country-specific grandmothers' gatherings, which they had requested following the Swaziland Gathering.

After years of ceaseless effort, it was no longer a question of what more the grandmothers or their support organizations could do. Without their own governments stepping in to take up their cause, it would never be enough. Indeed, it was the State itself that now presented the biggest barrier to maintaining their forward momentum.

Grandmothers needed access to health services, legal systems, financial systems and markets—services and systems that already existed in their countries and that they were entitled to but were frequently denied. Grandmothers needed to confront the politics of exclusion—in every national initiative, developed or adapted, their voices needed to be heard. They needed recognition and protection of their rights.

The first national gathering of African grandmothers took place in Uganda and signalled the moment that the African grandmothers' movement was truly moving from local to national, and to the highest echelons of power.

We Know Our Rights

During a group interview at Phoebe Education Fund for AIDS Orphans (PEFO) in Uganda we asked the grandmothers if training in human rights had made a difference in their lives. Here is a sampling of their answers:

We have been abused, our children have been abused, but we did not know what to do. We didn't even know when to report. Now we are empowered and know our rights. If our children are raped, we know where to go and what to say.

Zaituna

When we fall sick, we are also people, we need treatment. They can no longer chase us away at the health clinic. We know what is ours.

Aida

When you get married to a man, you work together with him over your life and acquire assets, but at any time he can beat you and send you away with nothing. You have to leave everything behind like your home and land. But now we know our rights. We can go and demand what is ours. What is more, no man who beats a woman should get away with it; now we report him to police.

Robinah

Knowing my rights has made me a person, has given me respect among people in the community. Nowadays my granddaughter goes to fetch water and no one touches that child. They know she is under the protection of our grandmothers group and if they touch her they will be arrested. Nowadays the fear is no longer there—no one touches my children, no one touches me.

Monica

Kenneth Mugayehwenki
"A Fire across Our Country"

Founder and executive director, Reach One
Touch One Ministries (ROTOM), Uganda

KENNETH'S THREE phones were ringing all at the same time. He stared at the screens, perhaps trying to determine which call was the most urgent. By the looks of things, they all were. It was the day before the first Ugandan national grandmothers' gathering, and as the Chair of the National Organizing Committee, he was in the thick of it.

In addition to managing the media deluge, Kenneth's organization, ROTOM, was overseeing the transportation of almost 100 grandmothers from districts across Uganda—some coming in buses from more than 10 hours away—to the conference centre in Entebbe. The other five organizations collaborating on the Gathering were doing the same. Collectively they were bringing together more than 500 grandmothers, which meant a steady arrival of travel-weary women needing meals, hotel rooms, and access to phones to check on grandchildren back home.

The timing for their country-level gathering was strategic.

You know, this event is taking place around the time of our national elections. We did this deliberately because politicians will be more prone to pay attention if they realize this is a major portion of the voting population and the rest of the world is watching.

Kenneth said he sees the Ugandan Grandmothers' Gathering on a "natural continuum."

In Swaziland there were discussions around the systems and barriers that kept our grandmothers from moving forward—what was different between countries and what was the same. The Tribunal shifted our work into the arena of human rights reclamation, where it belonged, and provided us the tools we needed for formulating our own targeted national advocacy strategies. This gathering is the next step.

The five other groups involved—St. Francis Health Care Services, Reach Out Mbuya, Phoebe Education Fund for AIDS Orphans and Vulnerable Children, the Nyaka AIDS Foundation, and Kitovu Mobile Limited—are, like ROTOM, among the earliest partner organizations of the Stephen

Lewis Foundation. They had specific goals for this gathering. Kenneth outlined them:

Our first goal is the launch of an advocacy campaign nationwide. We have already set up and registered the Grandmothers' Consortium, which shall be a vehicle for the delivery of the advocacy agenda. It will be launched at this gathering. Our brothers and sisters from South Africa and Kenya are here also because they, too, are planning their own national gatherings in the near future so perhaps we will strategize for an advocacy campaign that is regional as well as national. We shall see.

Second: bringing all these grandmothers from our country together will allow them to create one voice. This will allow them to pursue their own advocacy. These grandmothers are ready to speak. They want to be heard, especially by their politicians.

Third: we have invited grandmothers to this gathering who are not beneficiaries of our programs but who are influential grandmothers, leaders in their community and in the country. We believe when they hear the stories of their sister Ugandan grandmothers who are less fortunate, it will inspire them to stand in solidarity with their fellow grannies. I hope the presence of the grandmothers from Canada and the UK can serve as an inspiration, offering a model of what solidarity in action looks like to these Ugandan grandmothers who have access to resources and power. That really would be like a fire across this country.

Kenneth's phone rang again, as it had throughout our conversation, but this time when he glanced at the screen, he paused, then looked back at us, with a mixture of apology and excitement.

It's the BBC calling me back. They are sending a film crew, I'm sorry but I must take this one…

And then he was off, striding across the lobby of the conference centre. We could see (and hear) the three busloads of Ugandan grandmothers who had just arrived. As they tumbled out to find bathrooms and stretch their legs, they were singing, expressing the joy of their arrival. The Canadian and British grandmothers who had been milling about sprang forward to greet them. There was hugging, crying, ululating, dancing, singing. The Gathering was beginning.

Ugandan Grandmothers' Gathering

October 5-7, 2015: five hundred grandmothers from across Uganda made history in Entebbe as they came together for the country's first national grandmothers' gathering.

I know if we have our voices heard we can do something. We're here to tell the government, "Here we are. We are here for our rights. We need health care for our children and ourselves, we need land rights to include us and we need to be recognized as a special group." Mariam (PEFO), Uganda

In our meetings and workshops you could hear something new that we had not heard in the previous gatherings. The women were taking time to address solutions with big vision. I could hear them saying to each other, "These things we are saying now, will the time come when they can be real? Who will help us? Is it Kitovu Mobile, is it PEFO?" But other grannies were answering them, "No, this is why we have come together—to find a solution ourselves." Ugandan grandmother (PEFO), Uganda

The Canadian grandmothers were also in attendance and just months away from their own watershed moment: the 10th anniversary of the Grandmothers to Grandmothers Campaign. Joining them, for the first time, were delegates from the United Kingdom—evidence that the Campaign was gaining a foothold internationally. Grandmothers from newly established groups in Australia were preparing to attend the next national gathering, in South Africa. As their own movement was spreading and evolving, the grandmothers of the Campaign recognized the importance of returning to listen to their African sisters.

I'm here to learn and to listen. This has always been the foundation of the Grandmothers Campaign. Each time we meet with the African grandmothers, there has been a change; we hear something new. They are not standing still. This is why it is so important for us to constantly return to the first principle of active listening. We need to stay on course with them. We can never assume we know what they will come up with next. Jo-Anne (Toronto Grandmother's Embrace), Toronto, ON

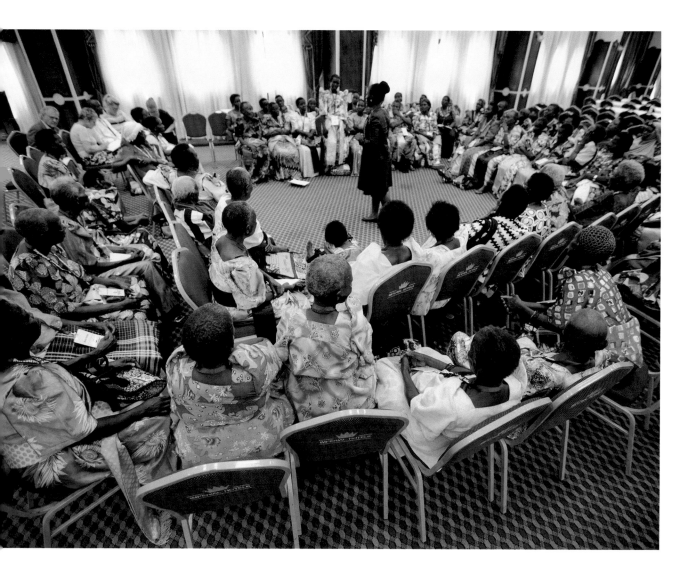

This is my first gathering and I've just been recording everything. My book is absolutely full of notes and I can't wait to bring this back to my group. They need to know this, too. Everyone needs to know this! Jane (Township Grandmothers), Sutton, QC

It has been amazing to get to know the African grandmothers. It's fired me up and it will keep me going and going because I just feel like we have to get bigger! Val (Guildford and Godalming Grandmothers' Group), Surrey, UK

Workshop at Uganda Grandmothers' Gathering. *Entebbe, Uganda*

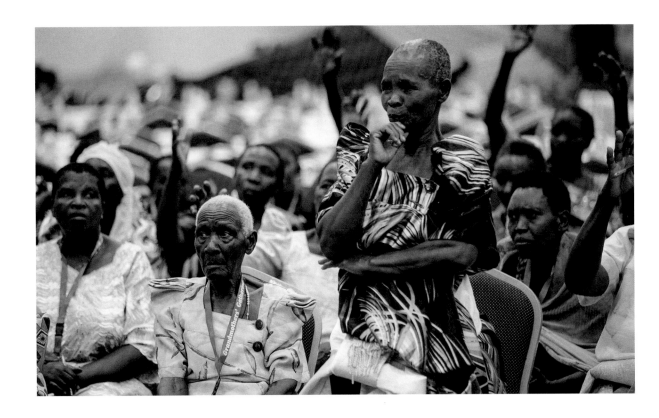

We Have a Few Questions

On the final day of the Gathering, the grandmothers of Uganda, at long last, had the opportunity to talk directly to a high-level representative of their government.

The best thing now is that Ugandan grandmothers are learning how to demand what they need. But the bad thing is that they don't have access to reach those offices where they have to demand their rights from. Like health care—you see a granny with sick children, she has left her home and come so far, she is already so tired and yet they can't treat her like she is a priority. Why? If we could at least meet with a minister—but they are nowhere to be seen. Here at this gathering we will have a chance finally to meet some of these people and we are ready to say what needs to be said. Mariam (PEFO), Uganda

Grandmothers have questions for the
Ugandan Minister of Gender and Social
Development after his keynote address.

The Ugandan Minster of Gender and Social Development had provided a keynote address for the grandmothers and remained behind afterward for a question-and-answer session. This unprecedented moment was a long time coming, and the questions tumbled forth:

> Why is it that there are no legal provisions for those that are widows, even though they have so many responsibilities?

> I'm a pensioner. I wonder why I don't get my money for some months, and when they pay September they don't pay July and August?

> Is there a way the government can support the elderly and widows to make sure they can get titles on the pieces of land where they have lived for years?

> When a husband dies leaving a custodian, the custodians won't release the land to the ownership of the widows and children. They hold on to it for 10 years. Who is going to support us to resolve these issues?

It wasn't the smoothest of exchanges. The minister seemed caught off guard by the sophistication and tenacity of their questions and grew progressively more defensive and angry. The grannies, for their part, were frustrated by the platitudes he delivered. No promises were made, and many questions went substantially unanswered. But this was nonetheless the beginning of a vital conversation, and the grandmothers were elated.

I'm blown away by the African grandmothers—the insistence, persistence and assertiveness of their voices and questions, by the way they kept hammering that minister and insisting to be heard and challenging him to make a commitment. This was one of the most exciting things I have ever witnessed! Cheryl (Kelowna Grandmothers for Africa), Kelowna, BC

You know we have never had this chance to speak like this before. These are the issues that are really important to the grandmothers but Ugandan politics are blocking us. We are so happy because we saw grandmothers exercising our strength. We wanted our voices to be heard. I am sure they were! Mariam (PEFO), Uganda

Beyond Reclamation: Forging a New Future

These three invigorating days ended the way all grandmothers' gatherings end: with a triumphant demonstration march, complete with a marching band leading the way. This was ROTOM's youth marching band, part of its program for vulnerable teens. Several ROTOM grannies proudly pointed out their grandchildren.

You see that horn player? That is my grandson. Today he said, "Jjaja, I am proud to march with you because it is us teens who will be marching tomorrow."

At the conclusion of the march, they stood together to read their culminating statement—addressed to their own government, the private sector, and beyond—sending a volley straight into the highest levels of power and a clear message that they weren't going away anytime soon.

You know, now we have the Statement, and if it can reach the office of the President he will have to make a change. That Statement was really our voice.
Sylvia (St. Francis Health Care Services), Uganda

The air was charged with future plans and possibilities.

This is like a dream come true. I remember when grandmothers felt hopeless, like they were nobody. Now in the village where we work—they are the leaders. This grassroots mobilization has given grandmothers back their lives. In fact, it is even giving them more than they had before. You see, before HIV there was still poverty, there was still gender inequality that was repressing their lives, keeping them down. You could hear them saying things like, "You know the men are repressing us, we are struggling, we have no property, but we have sons and daughters." Most of these women were only hanging on the string of their children. Then when their children died they had to rebuild completely different lives. So you see, this goes way beyond recovery, way beyond reclaiming what was lost. This is something brand new these women are doing. Something entirely brand new that the world has never seen before.
Kenneth Mugayehwenki, ROTOM, Uganda

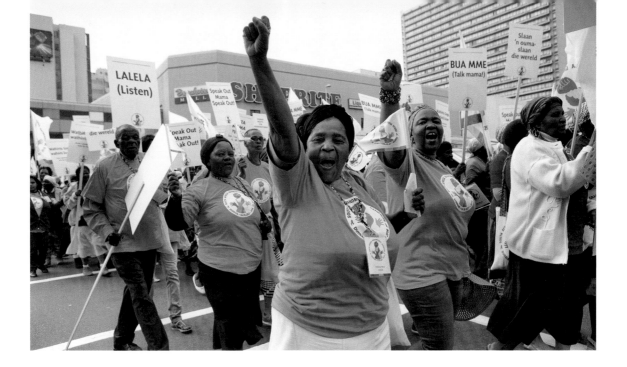

Marching Into the Future

Only months after the grandmothers' gathering in Uganda, two thousand South African grandmothers held their national gathering and marched to the doors of the XXI International AIDS Conference in Durban. They were met by throngs of press and the UNAIDS executive director Michel Sidibé and Conference co-chairs Chris Beyrer and Olive Shisana, and here they admonished those holding the reins of decision-making power as they declared:

> To the international community we say: remember—nothing about us without us. To our own government we say: it's time to do right by your grandmothers!

The grandmothers of South Africa and Uganda, along with the grandmothers of Tanzania and Kenya who are busily preparing for their own national gatherings, vividly exemplify exactly where the grandmothers of Africa are headed into the next decade. Theirs is a mobilized movement, both internationally and nationally, with networks of community-based organizations marching in step.

South Africa Grandmothers' Gathering march. *Durban, South Africa, 2016*

Ugandan Grandmothers' Statement

WE, 500 GRANDMOTHERS from every region in Uganda, have come together for three days in Entebbe for the first ever National Grandmothers' Gathering. We are celebrating our triumphs over the devastation that HIV & AIDS has wrought: over the painful losses of our loved ones, over stigma and discrimination, and over the threat to our very survival. Our love and labour has sown the seeds of new hope for our grandchildren, our families, and our communities.

Our journey has been a long one, but our strength has been growing. We joined with other grandmothers in Toronto in 2006, breaking through silence and stigma. In Swaziland in 2010, we looked toward the future. Now, united in Uganda, we are claiming that future.

We have done our part. We care for the sick, we work the land, we hold our collective memory, and fuelled by our love we raise the next generations, provide food, schooling, homes, and security.

For far too long we have not been counted, we have not been valued, we have been made invisible. It is time for our contributions to be recognized and our rights to be protected.

Health care services must respond to the needs and realities of grandmothers and the children in their care, including: accessible grandmother-friendly HIV related services, specialized clinics, and mobile care.

We must be protected from land grabbing and our property and inheritance rights guaranteed—not just on paper but in reality.

We demand an end to violence against grandmothers, whether it is domestic violence, elder abuse, or rape.

We are productive members of our society, and every government program and policy should be designed with us in mind. But that is not enough, concrete action must be taken to ensure we can access them.

Our efforts to secure livelihoods for our families must be supported. Economic opportunities should be expanded for those of us still able to work, and social benefits extended to those who cannot.

Protection from theft is essential, as well as greater access to credit and markets.

We are raising generations of grandchildren ruptured by trauma, and require financial assistance and psychosocial support.

While we welcome the commitment to move the provision of social pensions from 15 to 40 districts, we urge our government to reach all of the grandmothers of our nation as soon as possible.

To our government, the private sector, civil society, media, UN Agencies and members of the international community—the grandmothers of Uganda have a powerful vision for a future in which our families and communities are thriving, and have left the ravages of AIDS behind. With the support of our community-based organizations we have made huge strides, and we know a vibrant future is possible, but we cannot do it alone. To our Canadian sisters in the Grandmothers to Grandmothers Campaign, you are an important part of our story, and we feel your solidarity as we build momentum.

We are 500 grandmothers here today, but we represent millions more. We are not young, but we are strong. We want the world to know how much we have achieved and how much we have overcome.

We have breath to sing and energy to dance.

We are moving forward! Join us!

Grandmothers' Gathering, Entebbe, Uganda
October 5-7, 2015

South Africa Grandmothers' Statement

WE STAND HERE today as the guardians of our country's future. For years, we have struggled to raise our grandchildren, and hold together our families and communities. We came together in groups, supported by our community-based organizations, and found strength in unity. Our love has transformed the devastation of AIDS. We thought we were doing our duty. We knew we were demonstrating our love. In fact, we were raising a nation.

And we are not alone. Grandmothers across Africa have been gathering for the past ten years. From Canada, to Swaziland, to Uganda and now in South Africa, we have moved from mourning to a movement. We have been doing our part, and have become experts on how to survive and thrive in the midst of the AIDS pandemic. It takes so much more than ARVs to resurrect a community. South African grandmothers spent two days together in Durban as the world prepares for the International AIDS Conference, 2016. Today we come to insist that we receive increased support and to have our expertise counted.

We have learned how to be parents to orphaned children in a time of crisis, developing new strategies to help them stay safe, heal their emotional wounds, and regain hope. Yet these youngsters are your citizens, and they deserve more, including good quality education that feeds their souls as well as their minds, protection from violence, and opportunities for decent, safe employment. Our government must help nurture these children and youth who will lead Africa out of the AIDS pandemic.

Our country created protections for grandmothers. There are pensions, foster care grants, and stipends for home-based care workers. To see these measures put in place to protect our rights, gave us hope that our burden would be less heavy. But they are not working. When it can take years for a foster care grant to be processed, when grandmothers have to travel long distances to visit government offices who turn them away again and again, when pensions are hopelessly inadequate and don't start until 60, then we are dealing with a system that is in desperate need of change.

As older women, we face challenges that are still ignored. The health system is failing us and HIV-positive grandmothers have special needs that are not met. We wait in lines at clinics for hours, meet with health care workers who are often uncaring and do not have the medication we need. Violence is a constant threat, whether it is rape and assault on our bodies, or physical abuse and intimidation from family members and loan sharks who are after our small savings. We suffer without protection. And when we look to Parliament, there is no one who stands for our interests, no one who speaks for us. We are pillars of our communities, and we live our lives as examples, we are caring for so many children, but who is caring for us?

We will continue to struggle, and we will not give up the fight against HIV & AIDS. We will never give up because this grandmothers' movement is powered by love. But we should not have to do this alone.

To the international community we say: you have overlooked us for far too long. Remember—Nothing About Us Without Us. To our own government we say: It's time to do right by your grandmothers!

Africa cannot survive without us. We are not asking for charity, for pity or for favours. Access to health care, protection from violence, political representation, food security, shelter—these are our human rights. We have come to claim them.

Amandla!

Durban, South Africa
16 July, 2016

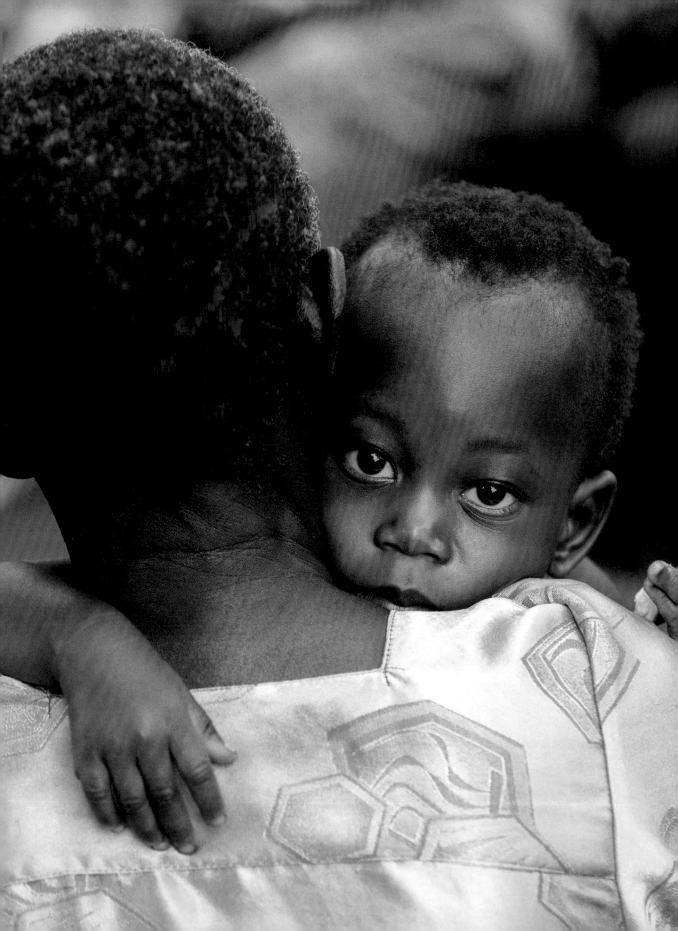

Ten years is not a joke. Ten years of support means lives can actually be rebuilt, systems can actually be changed. This is what it takes. This is not a quick fix—but that is not to say we have been moving slowly! It took 10 years for the grandmothers to recover, reclaim their voice, reach this point where they can claim their rights, pressure their governments. Maybe I should say "only ten years." So now this is the next chapter on HIV & AIDS in Africa. Grandmothers of Africa will be writing it. But this is the beginning again. We can't stop here. We won't stop here. We hope you will stay with us.

Siphiwe Hlophe, co-founder and executive director, SWAPOL, Swaziland

12
The Decade Ahead

FACING: Francis with granddaughter.
Jinja, Uganda (with PEFO)

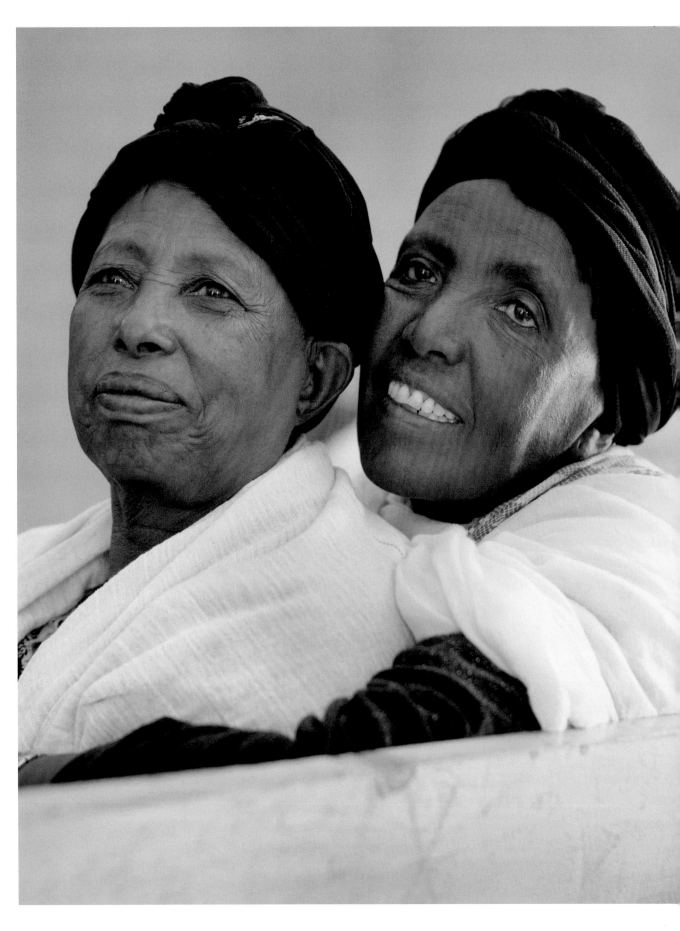

Feet Forward, Hands Reaching Back

African grandmothers have travelled an astonishing distance over the past decade, but certainly not all African grandmothers. It has been a modest but critical mass throughout sub-Saharan Africa who have been the recipients of consistent, sustainable support from community-based organizations. Even without all of their needs being met, this steady support has allowed them to reclaim lives, rebuild resilience, and look outward.

But for all these gains, there are still as many grandmothers, in fact more, who are just trying to survive while raising their orphaned grandchildren. The AIDS pandemic is far from over, and with a million new

deaths from AIDS each year the number of orphaned children continues to mount. The community-based organizations have the expertise and the networks to reach these vulnerable families, but not the financial capacity. And grandmothers who are receiving support still require assistance as their grandchildren grow. Parenting is a lifetime commitment, as is treatment of HIV. AIDS is still very much present and the grandmothers cannot relax their vigilance if they do not wish to raise a second generation for the grave. In this very moment, they face a conundrum: the world's funding channels are beginning to run dry as attention is diverted elsewhere.

The grandmothers forge on. New groups are still forming and must continue to form. The women and their community-based organizations have pledged that they will not rest until there are no grandmothers left behind.

Maimuna and Robina. *Jinja, Uganda (with PEFO)*

No Grandmothers Left Behind

Developing Families Together (DFT), Debre Sina, Ethiopia

WE WERE travelling to the small community of Debre Sina, deep in the mountains of Ethiopia, with one of the SLF's partner organizations, Developing Families Together (DFT).

Based in the capital, Addis Ababa, DFT had a small satellite office in Debre Sina overseen by a dedicated 23-year-old woman named Beza, who had been working with the grandmothers in this area for only a couple of years. At the time of our visit, DFT were working with 50 grandmothers, providing basic food and household supplies, school support, income-generation training, and safe housing. But their work was still on a one-to-one basis with the most vulnerable grandmothers. They were not yet in a group, though this was about to change.

As with any community hit hard by HIV & AIDS, silence and stigma was the norm. Beza was unsure how comfortable the women would be discussing their private lives in front of strangers, or even each other.

You mustn't be surprised if they don't mention HIV. They will say that their children died, yes, but probably not say how. These things are generally kept safe within the four walls of their home.

As we arrived, the grandmothers were waiting. They greeted each of us in turn, clasping our hands and then pulling us in for an embrace. The mood was warm and receptive as we sat down in a large circle to talk. We asked a simple question to break the ice: How many of you were born in this region?

A grandmother rose to her feet to respond.

My name is Etabezahu and I have survived an avalanche of days. I have buried three of my children due to HIV. My daughter left a grandchild that I raised as my own. She, too, died of HIV. Now I am raising her daughter, my great-grandchild.

In the stunned silence that followed, a few of the grandmothers stared at Etabezahu with open astonishment. She found her breath and continued:

My sister died and I took in her child, too. I have five children in my home. My grandson burned down our house in the middle of the night three days ago—we escaped unharmed but my home is destroyed. I could not have survived these hardships without DFT.

Then she sat.

It was still a moment longer and then a collective release rippled across the room. Several women stood up all at once and began speaking over each other—the original question completely forgotten. These grandmothers wanted to talk, and they rapidly began sorting out a speaking order among themselves. Once this was complete, a second woman remained standing to speak:

I lost my son to HIV, and I inherited the children that he left behind. It was a situation of starvation for myself and my grandchildren. But DFT came along and made it possible for me to not only carry these children, but also I was able to begin to get over my bereavement for my son. Now I engage in productive activities and we have enough food. My grandchildren are able to keep clean and clothed and also to attend school. This is what would have been possible for me if my own son had lived.

Again, the grandmothers listened as if spellbound. The third woman stood and began addressing the room. As she told her story her voice rose and fell with the singsong pitch of grief. She swayed as she spoke, at times she wept, and then collected herself and forged on.

It is very hard. My story is very hard to tell, and if I start telling it, I am afraid I will lose it. But then, my story is the story of a woman who has buried eight children due to HIV, and then my husband shortly after that. I was not able to move out of bed at one point; I was beginning to rot there. But I was left with three grandchildren, one only a month old. I was not able to breastfeed the child, so what I did was to squeeze some liquid out of sorghum and I wet their mouths with that. I began to develop health problems—ulcer, kidney problems. I was about to follow everybody else to death.

As she spoke the room was intensely quiet. A couple of women covered their eyes and shook their heads, but they stayed with her. The heartache seemed to move from her, across the room. The grandmothers seemed to be shouldering her load even while making room for their own surfacing grief.

When she finished speaking, we gently suggested we take a break for coffee and gave everyone permission to change the tone or format of the interview, if they wished.

As coffee was being served, the women brought out a wheel of bread the size of a truck tire. "How big is your oven?" we marvelled. One grandmother, brandishing

an equally substantial knife, stepped up to the serious business of cutting the oversized loaf. As she did she reflected aloud:

You know, I want to have talking groups with grandmothers. We would love to meet in the context of this setting. It would be better, if it was possible, for us to meet weekly, or fortnightly, or once a month, to also come together like this to talk. This is an arrangement for living and life. And we want this to continue to be stronger.

There was a chorus of agreement.

Coffee was finished and we settled back into the interview. We began by checking in to see if the group wished to return to a question-and-answer format but were interrupted by an overzealous grandmother who sprang to her feet, announcing loudly, "It's my turn now!" She laughed at herself and others chuckled, too. There was no stopping the momentum in the room.

One after the other, the grandmothers stood and delivered their stories to the room. They all spoke of loss of children from HIV, stress-related health complications, and feelings of isolation and extreme hopelessness broken only with the emergence of DFT in their lives. They spoke of their love for their grandchildren and also of the tremendous difficulties inherent in raising traumatized youngsters who

Left to right: Enani, Mulu, Alemayehu, and Beshewa. *Debre Sina, Ethiopia (with DFT)*

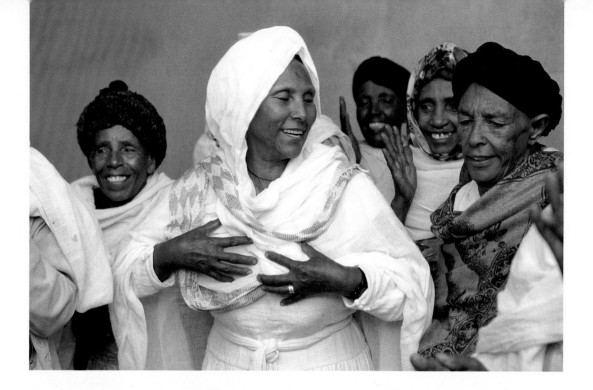

sometimes resented their grandmother's inability to replace lost parents. Some spoke at great length, others briefly. All spoke with raw intimacy and stunning honesty and, in turn, were heard in the same way. It felt like an explosive release of pent-up grief. Near the end of the day one woman stood and simply sang a verse composed in the moment:

I am a cotton spinner.
When I spin my thread I sing my hymns
of sadness.
I sing the loss of my sons and daughters
into my cotton.
And I wrap my pain upon the spool.
My song is long and so is my thread.
I sing and spin away my tragedies.
This is how I go on.

At the end of the interview a new kind of quiet settled on the women, part heaviness, part relief. Etabezahu, the woman who had opened the conversation, jumped to her feet and assumed the role of Master of Closing Ceremonies as well.

Meetings cannot end with bereavement!

She rallied the women to participate in a mini-drama to illustrate how women help comfort and distract each other during times of grief. She gestured to two women sitting close together: "Watch. When they aren't looking we tie their wraps together." With this she joined the tail end of their shawls. "Then we lure one with bread and when she stands…"

The woman stood and pretended to be surprised that they were tied to together and everyone laughed.

Etabezahu leads the grandmothers in a dance to close their first meeting. *Debre Sina, Ethiopia (with DFT)*

"Or we do this…" She tied a small coffee cup to the end of someone's shawl. "Then we call her outside and she walks out not knowing this is there… then we all accuse her of stealing."

The group was in full swing by this time.

"*We draw straws…*" she shouted over the din as she handed out pieces of straws. "*Those who draw the long straw have to do various things.*"

She deliberately held back the long straw and slipped it into the hand of the woman who had wept while telling her story before the coffee break. "You have the long straw, now you must laugh without stopping until everyone else laughs."

We watched as the grandmother who was given the long straw—who had never quite recovered from her earlier breakdown, whose inner grief kept showing up in spasms on her face throughout the interview—began to laugh. She laughed, and laughed, and a few started laughing in response.

"You're not done!" they called encouragingly. She redoubled her efforts and bent over laughing for all she was worth and her face transformed. It was contagious. No one could resist it.

Finally, when the din had settled and Etabezahu now deemed it a permissible environment to end the meeting, she left us with one final thought:

You see, we are not always sombre; we try and tease back at life. We try to create fun and laughter even in the most oppressive situations. It helps us bear, because you cannot return the people who have been stolen. You know, these are not things you can forget. How can I forget my daughter? So it's not about forgetting, it is about bearing the pain with the help of others.

Here it was, happening again, tucked away in the mountains of Ethiopia—the story of grandmothers coming together the way hundreds of thousands already had, over the years and across the continent. Here was the same impetus, the same explosive energy, the same profoundly inspiring courage, the same magnetic pull toward each other—these grandmothers, already so in sync with a movement that they didn't yet know existed.

Etabezahu began to sing and the others joined in. They danced together in the traditional style of their region, rapidly moving their shoulders in a rhythmic shrug. Their faces, many still streaked with tears, were shining with open delight in each other. There was a magic in the room. It was anyone's guess where this electrifying energy, this new connection to one another, would take them all. But for now they were dancing—collectively lifting their shoulders and bearing that heavy weight. Bearing it together.

Reaching New Members for the Decade Ahead

Irrepressible growth—one group sparking into life from another's heat—is the hallmark of this movement outside of Africa, too.

We met with Maggee Spicer, co-founder and co-chair of a brand new group leaping into action 800 kilometres north of Vancouver, in Prince George, British Columbia, and asked what motivated her to start a group. She, like so many others, spoke of the perfect combination of timing and relationships in her life.

My sister Sandra was a collector of the beautiful. She loved beautiful clothes. She loved precious stones. She had bookshelves stuffed with books and a collection of things gathered from the forest. She lived out near Salmon Arm, BC, and her home was just a maze of wonderful things.

In the summer of 2012 I got a call and she told me that she had cancer. I went to see her and it was evident right away that it wasn't good. She died in just one month. But over the course of that month she began to sell her treasures and all the money was going to the Grandmothers to Grandmothers Campaign.

My sister was part of a grandmothers group, and I got to know those women. When she died we only had a small amount of time to clean out her apartment, and the people from her community all came to help including, of course, her grandmother community. They helped to organize and collect all her things and sell them and the money went to the SLF for the African grandmothers—just as my sister wanted. A few months later I got a letter from the SLF thanking us and honouring my sister's wonderful life. And that always stayed with me.

And then after a little while, I became a grandmother. And it's just amazing how your heart opens when you have a grandchild. And it was just that love that you experience as a grandparent—coupled with the realization that there are grandmothers out there who are losing their children and raising their grandchildren—that just brought it all together for me. Life and death. I found meaning in that. It felt like the right thing to do. It felt beautiful.

At a meeting of her group in Prince George, the conversation showed how quickly this fledgling group had grasped the essence of the Campaign:

African grandmothers are on the ground. They are the ones raising the next generation, they are the ones poised to make the greatest impact. It just makes sense that the resources should get to them directly and they should be the ones determining their own priorities.

You can't have someone sitting in an office in Toronto making the decisions of what's best for them! How ridiculous is that?

Most development agencies have recently expended exhausting efforts trying to undo the deeply ingrained imbalance of power between donors and recipients. That imbalance notoriously skews decision making and produces solutions that rarely provide what real people really need. Unlike more conventional organizations, however, the grandmothers groups instinctively see the flaws in that old model of philanthropy and respond instead to the idea of egalitarian partnerships—whether they've been at it for ten years or ten minutes.

Members of G2G PG with visitors Ida Nambeya, Senior Advisor to the Grandmothers Campaign, and Siphiwe Hlophe, co-founder and executive director of SWAPOL. *Prince George, BC*

It's not so surprising that this fresh approach has a powerful appeal to the young. Increasingly, teens and young adults are being drawn into the energy of the Grandmothers Campaign.

Lydia Ahn launched a Granddaughters to Grandmothers group in 2014, when she was just 14 herself. We grabbed a moment to chat with her two years later at the 10th anniversary gathering of the Campaign, organized by the Greater Van Gogos. Lydia was 16 years old and in grade 11 at the time.

I first heard about the Grandmothers Campaign from my own grandmother, who knew I had an interest in human rights. My friends and I came up with the idea to form a Granddaughters to Grandmothers group. We liked the idea of forming our own group because it represented a deeper commitment— something that was ours and something we could share with people our age.

Our favourite fundraiser so far is our #loveyourgogo campaign. You take a picture of you and your grandmother and write a little blurb about your favourite thing about her, a favourite memory, and you post it, and then you

Mariam (with PEFO) and Lydia at the British Columbia "Super Gathering." *Vancouver, BC*

can donate to the Grandmothers Campaign on a page on our website. We thought that if you connect with your own grandmother, then you will think about how much she means to you and consider all of the other grandmothers in the world. We have someone in London, England, who started a group, and we would love to continue to spread Granddaughters to Grandmothers throughout the world.

For me, connecting is at the heart of all of this—with other granddaughters and also across generations. We are always talking about the grandmothers of this campaign in our group. The thing that we find the most motivating and inspiring is how much they connect with the grandmothers in Africa and how they are doing such amazing, groundbreaking things. Any generation can contribute, although we aren't always told that. And that's an example to us, in the younger generation. We can contribute, too.

I want a world of equality. It's a big world and if we all come together and contribute, we can overcome any challenge.

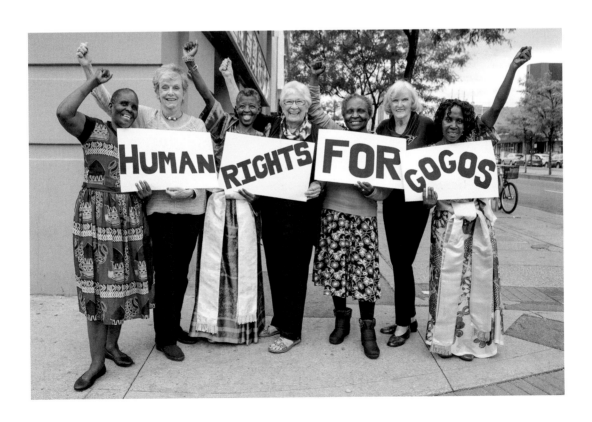

Regina (*Mavambo Trust, Zimbabawe*), Linda (*Burlington Ubuntu Grandwomen, Burlington, ON*), Mariam (*PEFO, Uganda*), Marg (*Grandmothers and Friends for Africa, Guelph, ON*), Maude (*Mavambo Trust, Zimbabwe*), Elizabeth (*Burlington Ubuntu Grandwomen, Burlington, ON*), and Immaculate (*Kitovu Mobile, Uganda*) in Toronto, ON

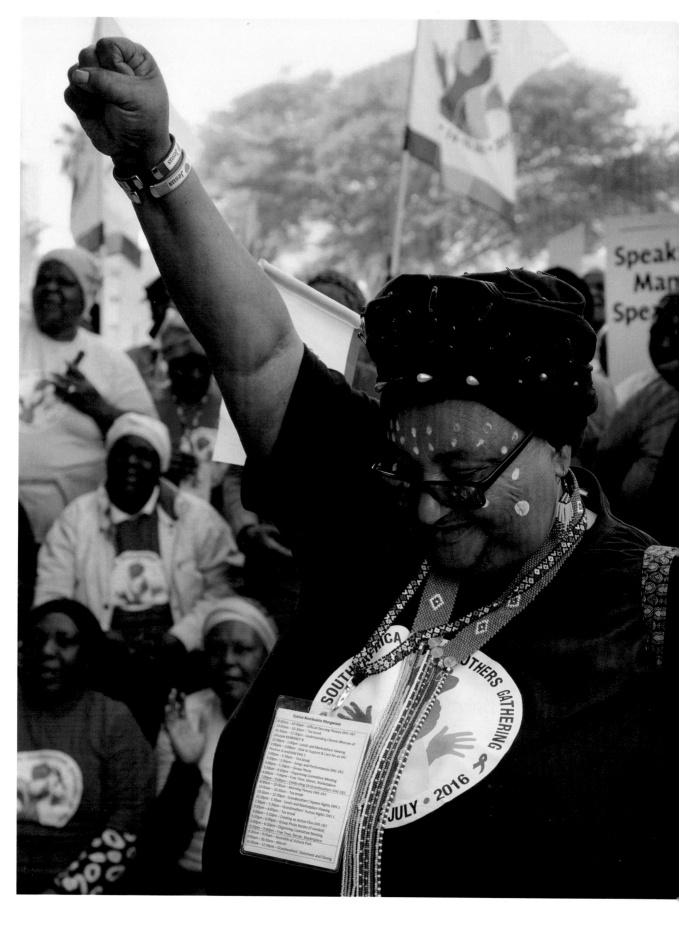

"We Will Never Give Up"

It bears repeating: in 10 short years the African grandmothers moved from living lives of isolated survival to collective action. And within a decade a national campaign ballooned into a global movement led by older women in Canada, the United Kingdom, Australia and the United States—blazing a new path in the field of international development, one directed by social justice, sisterhood, and authentic solidarity. All of it fuelled by love.

Love is not always a word associated with power, and certainly not in the context of Western society. But the African grandmothers tell a different story. It's what kept them alive in their most desperate hours, drew them together, propelled them forward, and kept them reaching ever outward.

The love that the African grandmothers invoke is not sentimental; it is substantial and powerful. In the hands of grandmothers, it is a catalyst for social transformation. Over time, the grandmothers of the Campaign also began speaking of love differently—with less apology and more defiance— joining their voices with their African sisters.

The emergence of a global grandmothers' movement is on the horizon. And their message is crystal clear:

We will not give up the fight against HIV & AIDS.
We will never give up because this grandmothers' movement is powered by love.

FACING: Eunice (with Keiskamma Trust) at South Africa Grandmothers' Gathering. *Durban, South Africa*

Acknowledgements

With full hearts we honour and thank the grandmothers of this movement—every single one of you has contributed to and is part of this ongoing story. Thank you to all the staff and volunteers of the African community-based organizations with whom the Stephen Lewis Foundation partners and who have worked tirelessly alongside the grandmothers in your communities for years.

Hundreds of grandmothers were interviewed for this book, one on one and in group settings—from Debre Sina, Ethiopia, to Victoria, Canada. They opened their homes and hearts and shared the most intimate, precious parts of their lives. We can never hope to express the full measure of our gratitude for this gift.

We wish to thank the African organizations that hosted our visits, organized interviews, and followed up with every grandmother appearing in the book to be sure her words appeared exactly as she wished. We are forever indebted.

Ethiopia
Developing Families Together (DFT) ·
 Addis Ababa/Debre Sina
Negem Lela Ken New HIV Positive Women Support
 Organization (NLK) · Addis Ababa

Kenya
Pendeza Africa (PENAF) · Kisumu
Ripples International · Meru
Young Women Campaign Against AIDS
 (YWCAA) · Nairobi

Malawi
Hope for the Elderly (HOFE) · Lilongwe
Women's Legal Resources Centre
 (WOLREC) · Blantyre

Namibia
Catholic AIDS Action (CAA) · Windhoek

South Africa
Grandmothers Against Poverty and AIDS
 (GAPA) · Khayelitsha
Hillcrest AIDS Centre Trust (HACT) ·Durban
Keiskamma Trust · Hamburg
Siyaphambili HIV and AIDS Support Group · Umlazi
Tateni Community Care Service · Mamelodi

Swaziland
Swaziland Positive Living (SWAPOL) · Manzini

Uganda
Kitovu Mobile Limited · Masaka
Phoebe Education Fund for AIDS Orphans and
 Vulnerable Children (PEFO) · Jinja
Reach One Touch One Ministries (ROTOM) ·
 Mukono/Kabale

Zimbabwe
Chiedza Child Care Centre · Harare
Mavambo Trust · Harare
Midlands AIDS Service Organisation (MASO) · Gweru

Deepest thanks to every member of the Grandmothers to Grandmothers Campaign across Canada, the UK, and Australia. Your lives and stories are woven into this extraordinary and groundbreaking movement. Special mention to the groups who contributed material for the making of this book: photos, written submissions, media clippings, and, of course, home and group interviews.

Alberta
Grandmothers of Alberta for a New Generation
 (The GANG) · Edmonton
Grateful Grannies · Camrose
Eastside Grannies · Sherwood Park
Rayanna's Hope for Africa · Stony Plain
Ujamaa Grandmas · Calgary

British Columbia
Abbotsford Area Gogos · Abbotsford
Burnaby Gogos · Burnaby
Can Go Grannies · Kamploops
G2G PG · Prince George
Glacier Grannies · Comox
Gogo Grannies of Cranbrook · Cranbrook
Greater Van Gogos · Metro Vancouver
Hornby's United Grandmothers & Grand Sisters
 (HUGGS) · Hornby Island
Kelowna Grandmothers for Africa · Kelowna
Merville Grand Mothers (MGMs) · Merville
Nan Go Grannies · Nanaimo
Nelson Grans to Grans · Nelson
Oceanside Grandmothers to Grandmothers · Parksville

Richmond Gogos · Richmond
Royal City Gogos · New Westminster
Salt Spring Island (SSI) Grand(m)others to
 Grandmothers · Salt Spring Island
South Fraser Gogos · Ladner/Delta
Sunshine Coast Grandmothers and
 GrandOthers · Gibsons
Tikun Olam Gogos · Vancouver
VanGogos · Vancouver
Victoria Grandmothers for Africa · Victoria

Manitoba
Grands 'n' More Winnipeg · Winnipeg

New Brunswick
Grandmothers Helping Grandmothers · Fredericton

Newfoundland and Labrador
Terra Nova Grannies · St. John's

Nova Scotia
The Bay Grandmothers · St. Margarets Bay
Supporting African Grandmothers' Efforts
 (SAGE) · Lunenberg

Ontario
Blooms for Africa · Hamilton
Brookbanks for African Grannies · Toronto
Bruce Peninsula Grandparent
 Connection · Tobermory
Burlington Ubuntu Grandwomen · Burlington
Capital Grannies · Ottawa
Espanola and Walden Grannies · Espanola
GranAurora · Aurora
Grandmothers and Grandothers · Barrie
Grandmothers by the Lake · Harrowsmith
Grandmothers Embrace South Simcoe · Alliston
Grandmothers of Steel · Hamilton
Grannies in Spirit · Toronto
Grassroot Grannies · Ottawa
Guelph Gogo Grandmothers (4G's) · Guelph
In Grandmothers' Hands · Huronia
Lakehead Grandmothers for Africa · Thunder Bay
North Bay Grandmothers for Africa · North Bay
Omas Siskona of K-W · Kitchener-Waterloo
One World Grannies · Ottawa
Oomama · Oakville
Ontario Regional Resource Group (ORRG)
Petawawa Grannies · Petawawa
Quinte Grannies for Africa · Belleville
Stonetown Grans · St. Marys

The Grandees · Chatham-Kent
Toronto Grandmother's Embrace · Toronto

Prince Edward Island
G'Ma Circle of Summerside · Summerside
G'Ma Circle of Charlottetown · Charlottetown

Quebec
CFUWSD Grannies · Sherbrooke
Grannies for Good · Montreal
Townships Grandmothers · Sutton
Wakefield Grannies · Wakefield
West Hill Grandmothers · Beaconsfield

Saskatchewan
Grandmothers 4 Grandmothers (G4G)
 Regina · Regina
Grandmothers 4 Grandmothers (G4G)
 Saskatoon · Saskatoon
Grandmothers 4 Grandmothers (G4G)
 Shellbrook · Shellbrook

Australia
Ranges Aid · Victoria

United Kingdom
Guildford and Godalming Grandmothers' Group (4Gs) ·
 Guildford/Godalming

Our thanks to the cadre of photographers who contributed their time and talent: Cathie Archbould, Dave Barbour, Max Bastard, Peter Bregg, Mandisa Buthelezi, Zanne Cameron, Andrea Chow, John DiCostanzo, Edward Echwalu, Jane Farrow, Buffy Goodman, Sharon Henderson, Margot Henny, Jaime Hogge, Ricki Horowitz, Bob House, Henry King, Donald Kirya, Kristina Laukkanen, Liz Marshall, Anne McCarthy, Scott Morgan, Kibuuka Mukisa Oscar, Emmanuel Museruka, Meaghen Simms, Tom Thorne, Hartley Wynberg, Hannah Yoon, and Micol Zarb.

It is most unusual to have private-sector sponsorship for a book. This project would not have been possible without the generous support of CIBC, who provided financial backing for the book—with special thanks to Joan Peters; and AIMIA, whose Aeroplan miles made the travel possible—with special thanks to Alden Hadwen and Kevin O'Brien; and the Slaight Family Foundation—with special thanks to Donna and Gary Slaight.

Powered by Love seemed to magnetically attract giants of the book-producing world, who provided their guiding hands and formidable skill to bring this project to fruition.

Our admiration and thanks to:

Our formidable, passionate, and tireless editors: Michele Landsberg and Sarmishta Subramanian, Michelle MacAleese (structural and copy editing), Janet Morassutti (copy editing), and Laura Keating (proofreading);

Our designer Peter Cocking, whose truly inspired vision elevated both form and content beyond our wildest imaginings;

Our agents, the powerhouse tag team of Sam Haywood and Trena White of Transatlantic Agency;

Our publishers, Goose Lane Editions, with special thanks to Susanne Alexander and her dedicated team: Jill Ainsley, Martin Ainsley, Kathleen Peacock, and Julie Scriver;

And of course, Sara Angel, who stepped in countless times through the development of the book and offered exactly what was needed at the time it was needed.

Special thanks to Theo Sowa and Stephen Lewis— we have always sought your insight and guidance for this and every other ambitious project the Stephen Lewis Foundation dreams up.

Thank you to the staff and friends of the Stephen Lewis Foundation (especially the Programmes and Grandmothers teams), who contributed their time and talent to the making of this book. Special thanks to: Jonea Agwa, Sarah Annis, Angela Ashaba, Stephanie Beattie, Andrea Chow, Carrie Chun, Graham Coultas, Alannah Delahunty-Pike, Monica Drenth, Jane Farrow, Amal Ga'al, Cathy Gowen, Felicity Heyworth, Mary Higgins, Kellie James, Megan Karges, Ky'okusinga Kirunga, Sarah Layton, Susan Mahachi, Deb Matheson, Gill Mathurin, Megan McCafferty, Sydney Oastler, Leah Odle-Benson, Olivia Penner, Asmita Persaud, Chloe Shatz-Hilkes, Gabriella Silano, Janet Solberg, Leah Teklemariam, Healy Thompson, and Margaret Wright.

Alexis would like to thank those in her life who have focused their loving and supportive 'lens' on her.

Ilana would like to dedicate her role in this book to her precious grandmother, Lee Landsberg, who still guides her in all things.

Joanna would like to personally thank: My brother Josh and sisters Keri and Jennie, my companions from the very start. We have been rocked by loss and held by love. You see, and are, the best part of me. Love to Tracey, my sister-in-law (and "in-spirit") and all the young ones who have enriched and enlivened my life: Abby, Chloe, Ella, Esther, Jacob, Lily, Yoav, and Zev. Finally, to my "Book Support Dream Team"—Ilana, my guide; Cara, my mirror; Yasmina, my inspiration; and Ihab, anchor and keeper of my heart—my deepest love and forever thanks.

Edited by Michele Landsberg, Sarmishta Subramanian and Michelle MacAleese
Cover and interior design by Peter Cocking
Cover photos by Alexis MacDonald

All interior photos by Alexis MacDonald, except: Cathie Archbould: pp. 242, 244, 247, 249, 250, 253, 256 · Dave Barbour: p. 133 · Max Bastard: p. 292 · Peter Bregg: p. 138 · Mandisa Buthelezi: p. 80 · Zanne Cameron: p. 101 · Andrea Chow: p. 218 · John DiCostanzo: pp. 66, 69, 79, 83 · Edward Echwalu: p. 260 · Jane Farrow: pp. 98 (knitted dolls and dammit dolls), 106 (bottom), 108, 143, 144 · Buffy Goodman: pp. 117 (bottom), 155 · Sharon Henderson: p. 130 · Margot Henny : p. 98 (sock monkeys) · Joanna Henry: p. 232 · Ricki Horowitz: pp. 76, 216 · Bob House: p. 111 · Henry King: p. 81 · Donald Kirya: p. 173 · Kristina Laukkanen: pp. 125, 204, 221, 222, 225, 228–29 · Liz Marshall: pp. 30–31, 62, 70, 84 · Anne McCarthy: p. 109 · Scott Morgan: pp. 64, 75 · Kibuuka Mukisa Oscar: pp. 152, 269, 270 · Emmanuel Museruka: p. 184 Tom Thorne: p. 105 · Hartley Wynberg: p. 72 · Hannah Yoon: p. 90 · Micol Zarb: p. 41

Printed in Canada

10 9 8 7 6 5 4 3 2 1

Library and Archives Canada Cataloguing in Publication
Henry, Joanna, 1974-, author

Powered by love : a grandmothers' movement to end AIDS in Africa / Joanna Henry with Ilana Landsberg-Lewis; edited by Michele Landsberg; photographs by Alexis MacDonald.

ISBN 978-1-77310-021-0 (softcover)

1. Grandmothers—Africa—Portraits. 2. Grandmothers—Africa—Biography. 3. AIDS activists—Africa—Portraits. 4. AIDS (Disease)—Africa. I. Landsberg-Lewis, Ilana, 1965-, author II. Landsberg, Michele, 1939-, editor II. MacDonald, Alexis, illustrator IV. Title.

HQ759.9.H46 2017 306.874'5096 C2017-903205-4

The publisher acknowledges the generous support of the Government of Canada, the Canada Council for the Arts, and the Government of New Brunswick.

Goose Lane Editions
500 Beaverbrook Court, Suite 330
Fredericton, New Brunswick
CANADA E3B 5X4
www.gooselane.com